Common Ground

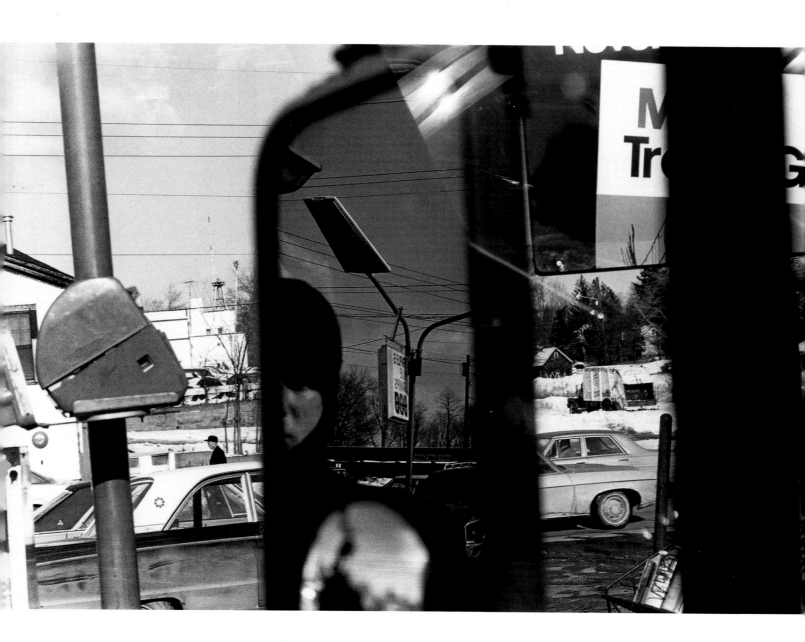

Lee Friedlander, *Hillcrest*, 1970

4

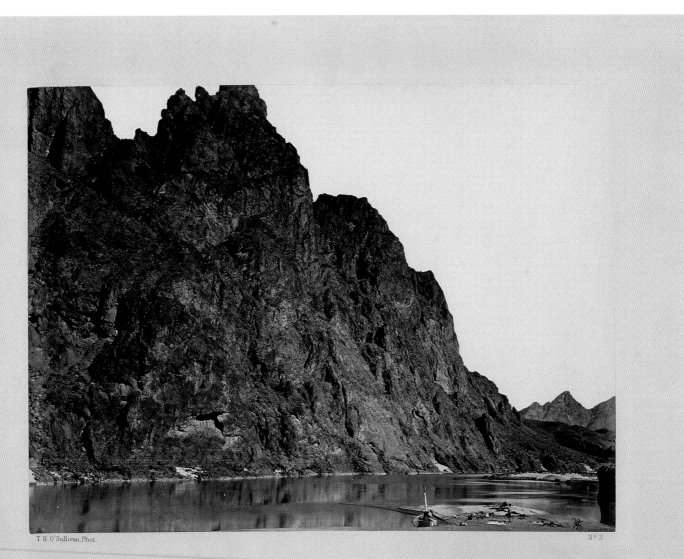

T. H. O'Sullivan, Phot.

No 3

BLUFF OPPOSITE BIG HORN CAMP, BLACK CAÑON, COLORADO RIVER.

Timothy O'Sullivan, *Bluff Opposite Big Horn Camp, Black Cañon, Colorado River*, 1871

Abelardo Morell, *Camera Obscura Image of the Grand Tetons in Resort Room*, 1997

Ray K. Metzker, *Untitled*, from the series *My Camera and I in the Loop*, 1958

Sally Mann, *Easter Dress*, 1986

William Gedney, *Kentucky*, 1964

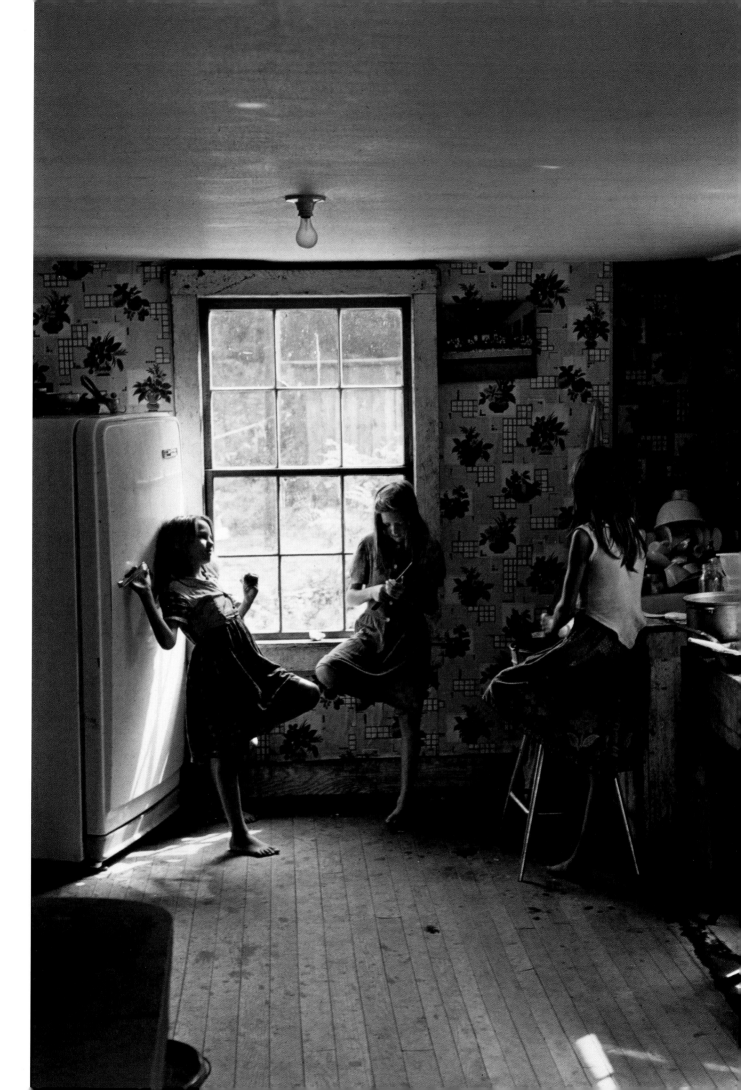

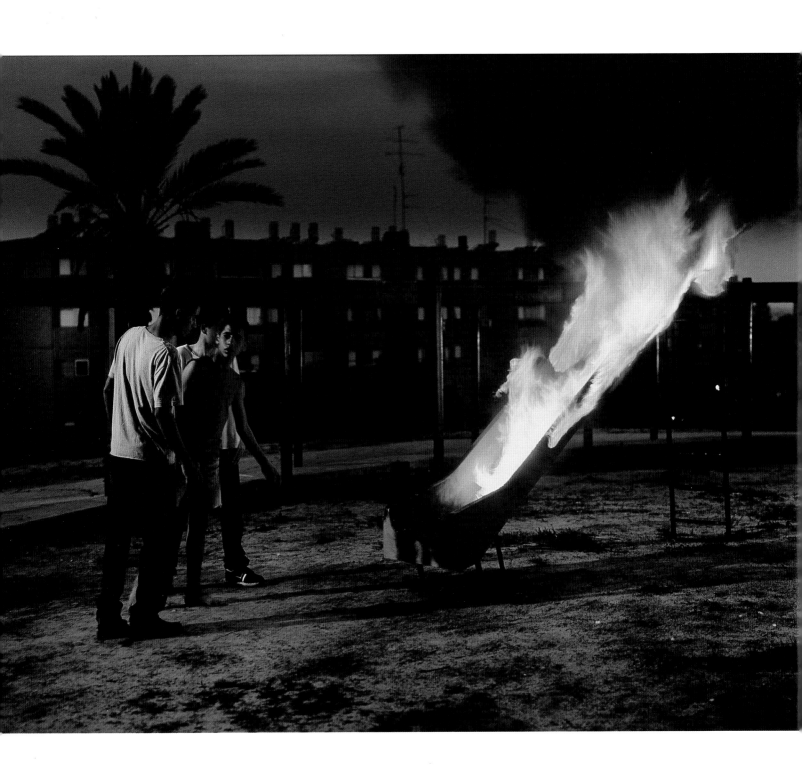

Adi Nes, *Untitled*, 2000

Adi Nes, *Untitled*, 2000

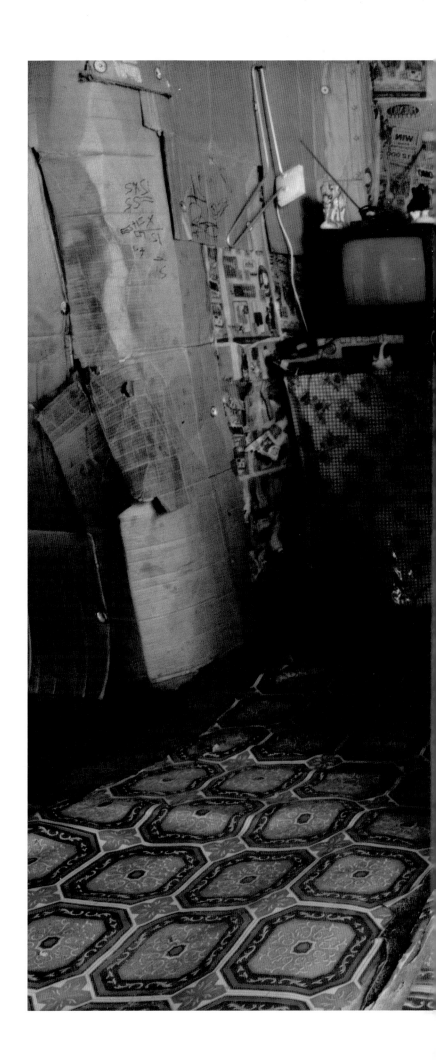

Zwelethu Mthethwa, *Untitled*, 2002

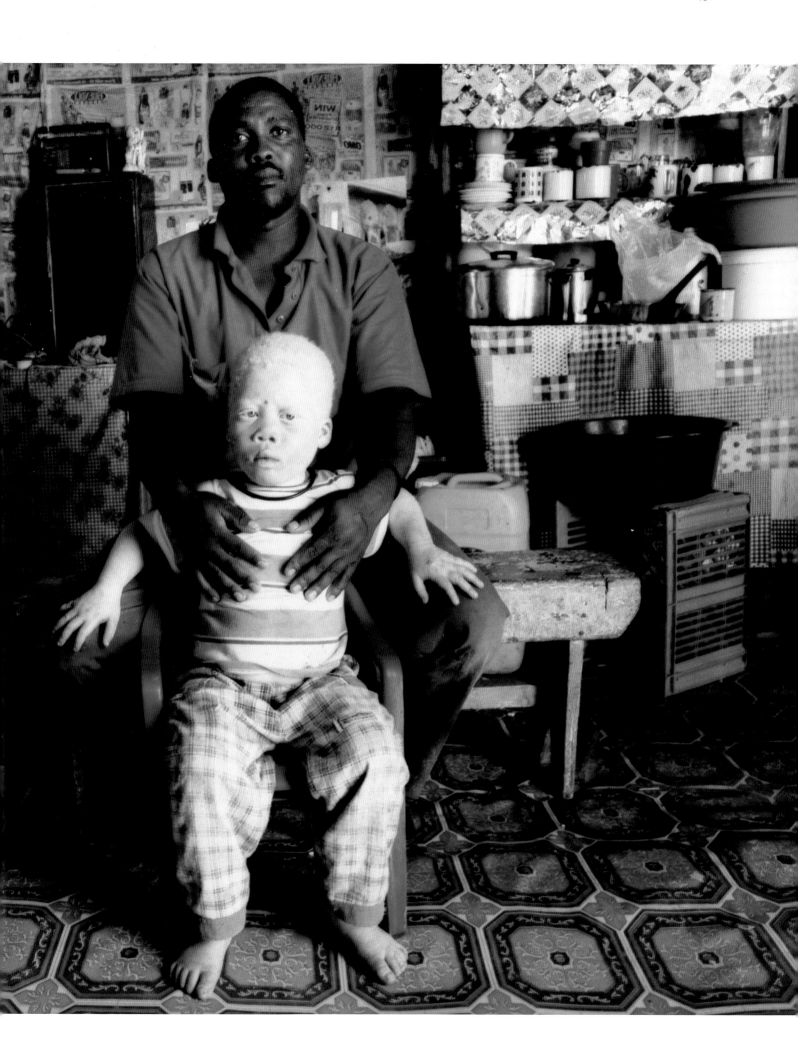

14

Mark Mann, *Screen*, 2001

Common Ground

Discovering Community in 150 Years of Art
Selections from the Collection of Julia J. Norrell

Philip Brookman
Jacquelyn Days Serwer
Merry A. Foresta
Paul Roth
Julia J. Norrell

Foreword by Bill Clinton

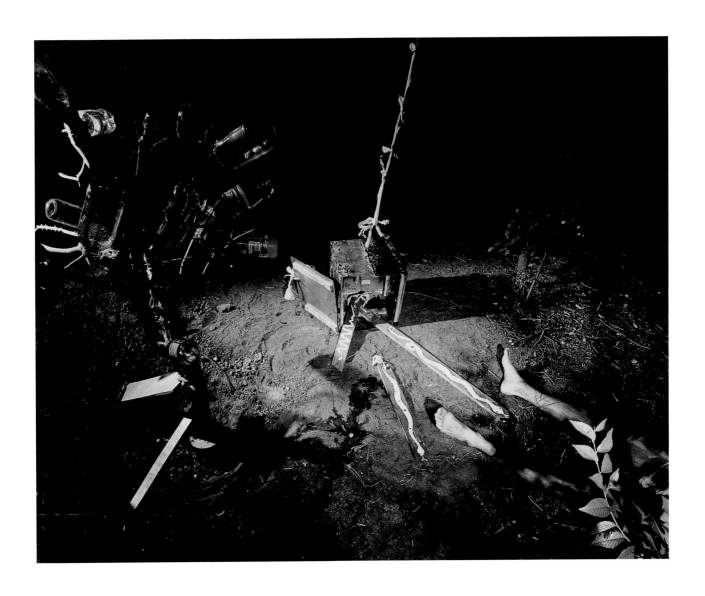

Elijah Gowin, *Bottle Tree at Night*, 1995

Contents

Linda Connor, *My Hand with My Mother's*, 1987

Foreword
Bill Clinton

It is with loving pride that I write this foreword for *Common Ground: Discovering Community in 150 Years of Art, Selections from the Collection of Julia J. Norrell.* I have known Judy since I was a young man. And for as long as I have known her, she has devoted much of her boundless energy to watching out for others.

Born in the South and a witness to the heartbreaking acts of racism and discrimination that occurred there, Judy adopted the progressive politics of her activist family. In the span of her remarkable life, she has remained committed to civil and human rights work, animated by the vision of a world in which opportunity and fairness are accessible to all.

The art that Judy collects is a reflection both of what she believes and of her perception of the world. She knows that there is always beauty in truth—even if that truth momentarily seems harsh. She understands that our life experiences—churchgoing, work, a loved one's funeral, our rituals—draw us closer together rather than move us further apart. Judy is inspired by the imagination of artists who revive our spirits and challenge us to look outward and inward for the ties that bind us. In this powerful exhibition and book, Judy, her collection, and the Corcoran Gallery of Art exhort us to celebrate our common ground and rediscover the sorrows and the sweetness that make us part of the human community.

Consider it a rare privilege to walk into a world guided by the hand and heart of Julia J. Norrell.

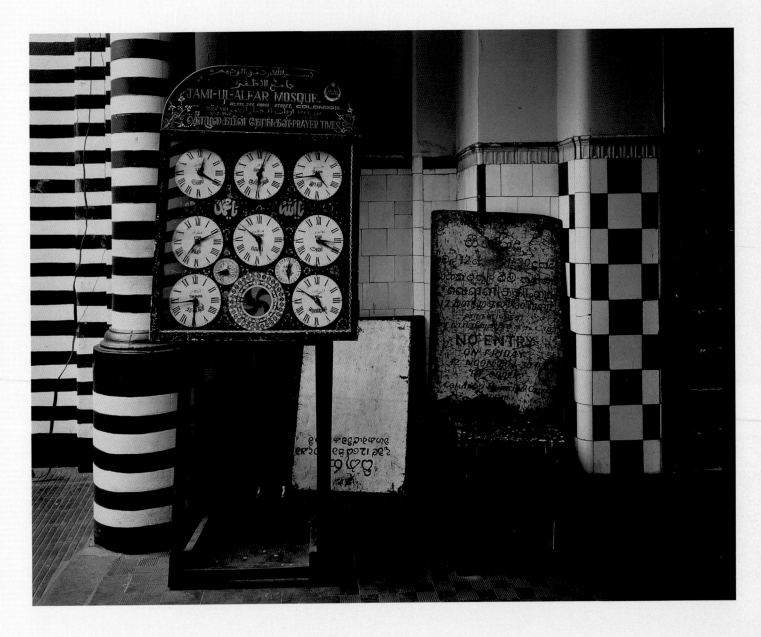

Virginia Beahan and Laura McPhee, *Times for Call to Prayer, Jami-ul-Alfar Mosque, Petlah, Colombo, Sri Lanka*, 1993

Past and Present

Doctors use a stethoscope to diagnose their patients, but they do not use the same tool to heal. While both stethoscope and camera diagnose conditions, I find that the end product of the camera, the photograph, offers a different aspect to healing. Doctors depend on the dispensary and pharmacist to heal patients, whereas the camera diagnoses the condition with a photograph and immediately begins the healing process.

Zwelethu Mthethwa

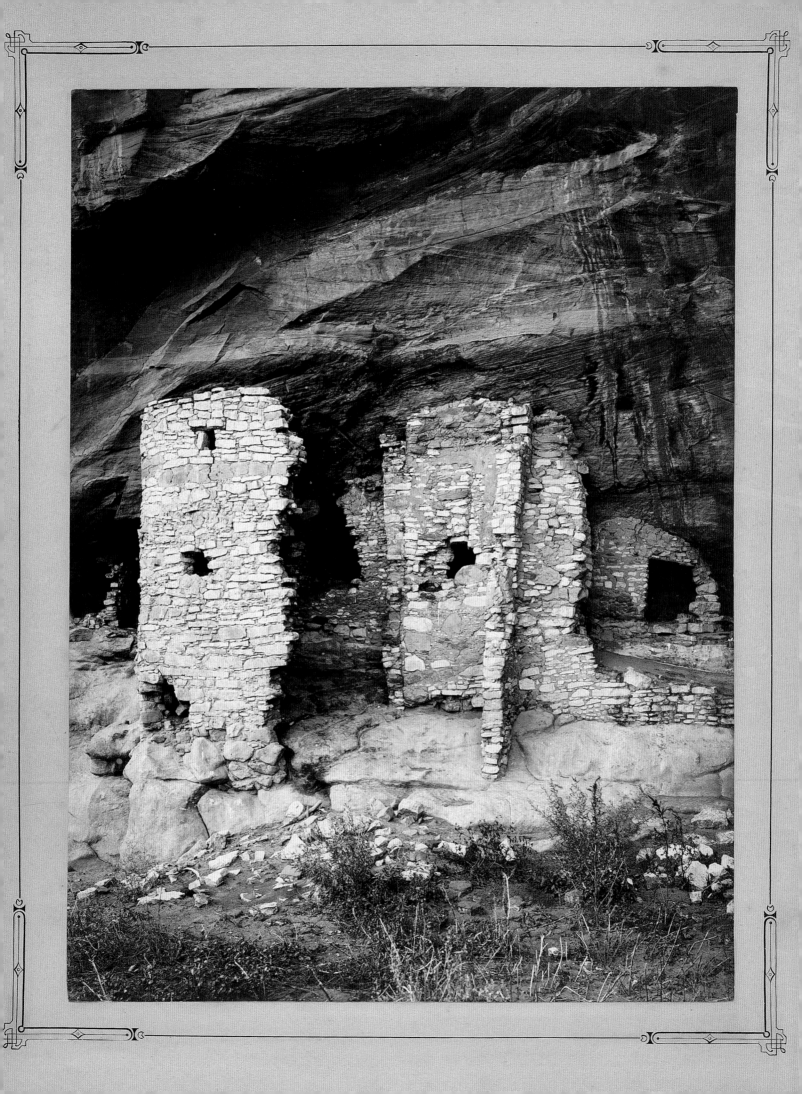

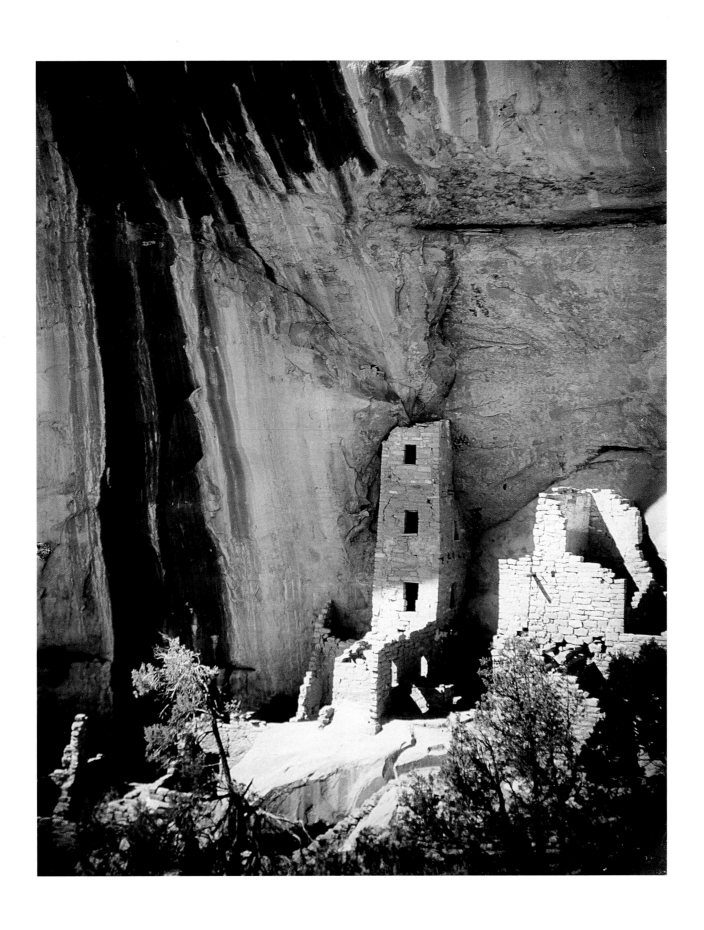

John K. Hillers, *Ruins near Fort Wingate, c.* 1880 (opposite)
Laura Gilpin, *Untitled (Square Tower House, Mesa Verde National Park, Colorado)*, 1925 (above)

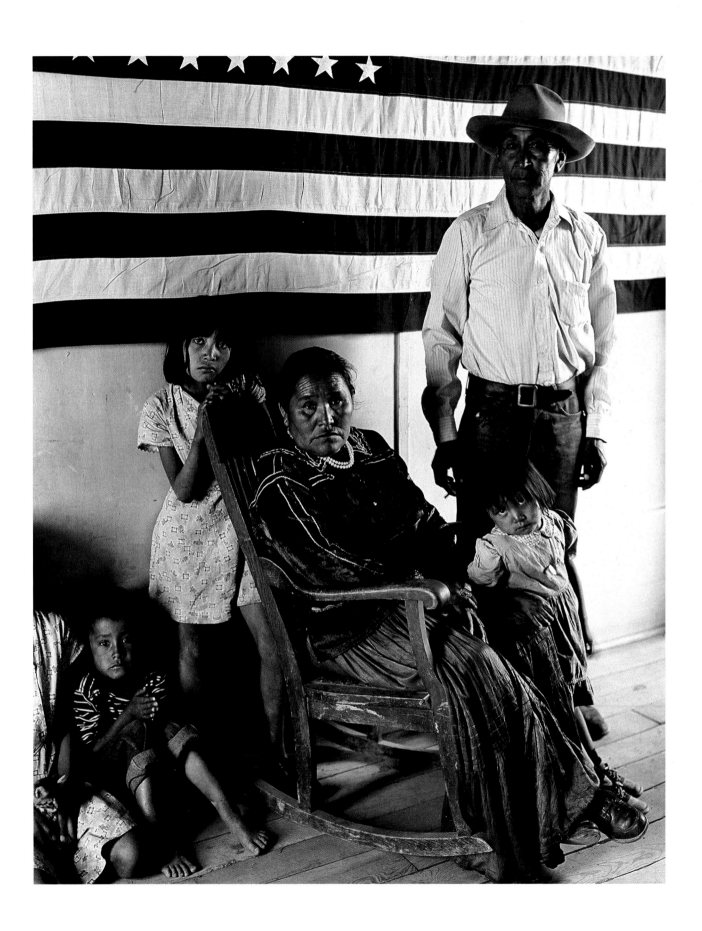

Laura Gilpin, *Navajo Family (Francis Nakai and Family, Red Rock)*, 1950

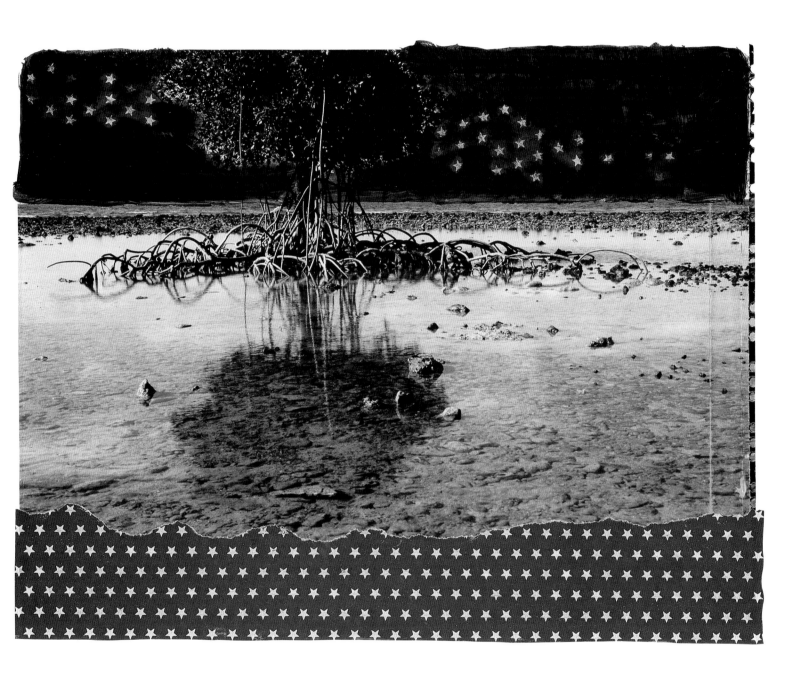

Victor Masayesva Jr., *Night and Day*, 1993

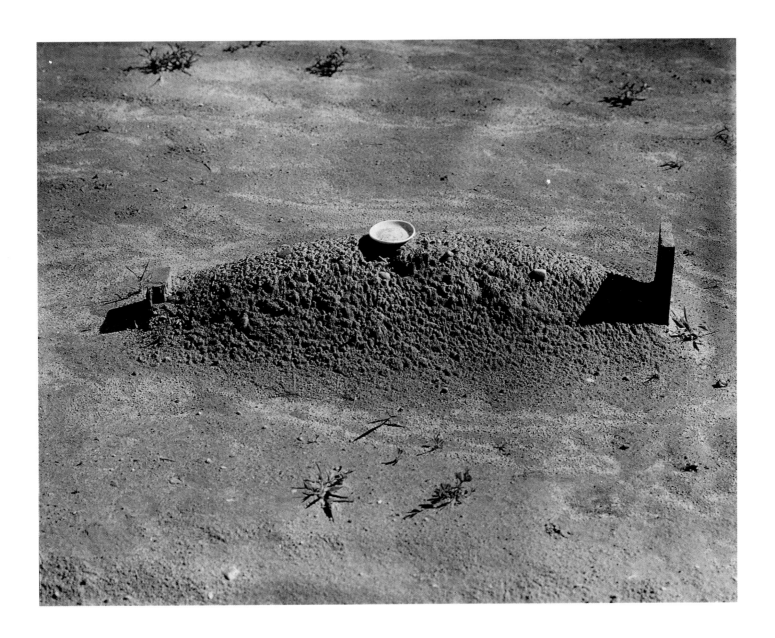

Walker Evans, *Child's Grave, Hale County, Alabama*, 1936 (above)
Robert Frank, *South Carolina*, 1955 (opposite)

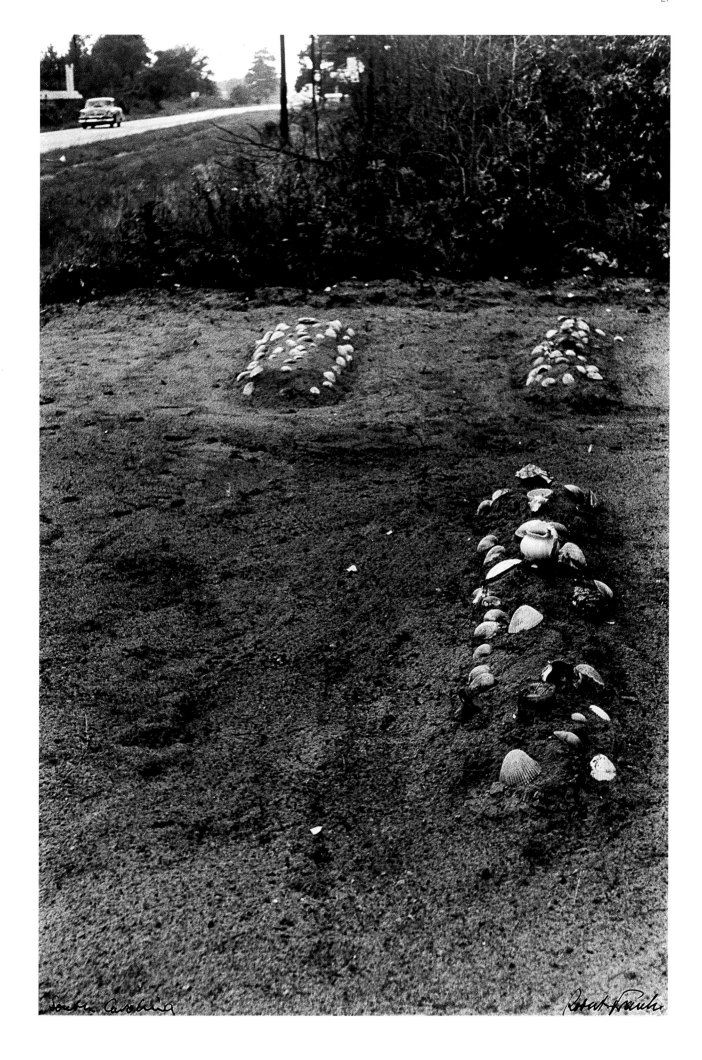

South Carolina Robert Frank

Roman Vishniac, *Side Entrance to the Jewish Quarter, Bratislava*, 1939

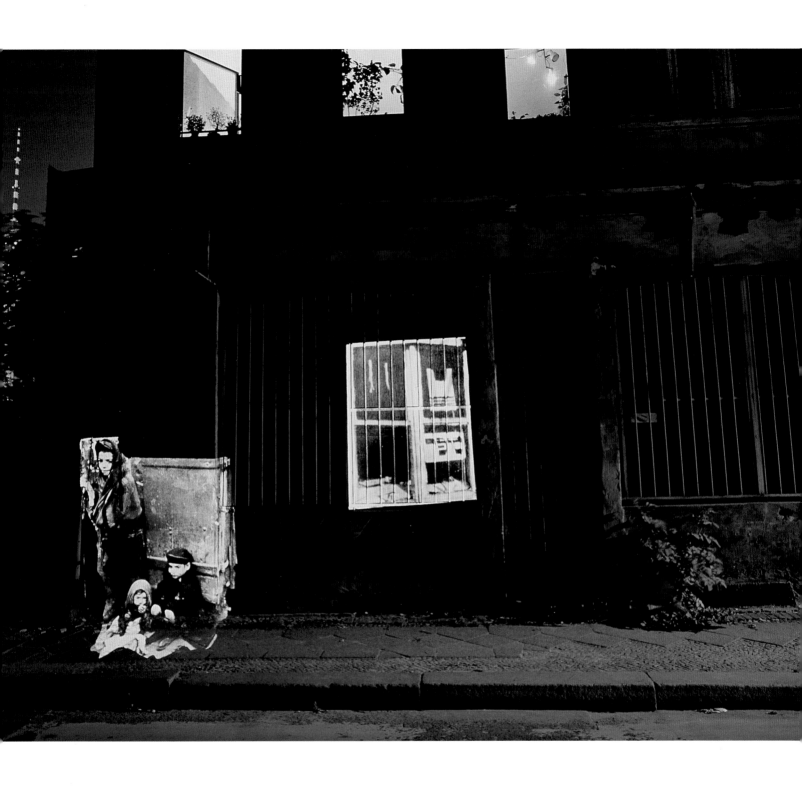

Shimon Attie, *Mulackstrasse 32: Slide Projections of Former Jewish Residents and Hebrew Reading Room, Berlin (1930)*, 1993 (above)
William Christenberry, *The Bar-B-Q Inn, Greensboro, Alabama*, 1964–91 (overleaf)

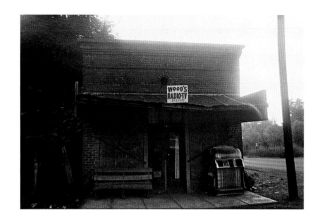

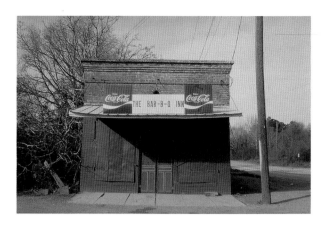

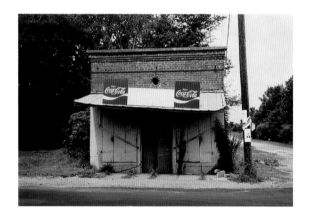

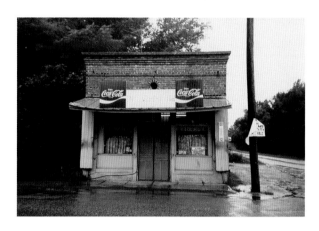

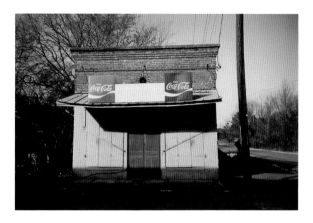

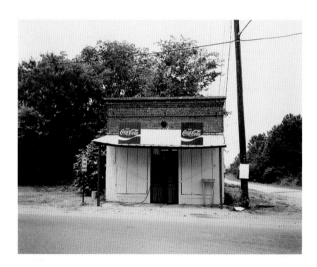

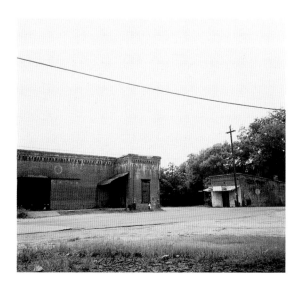

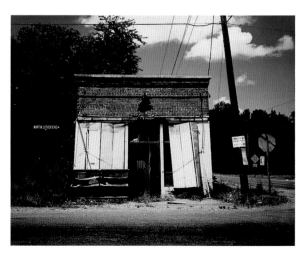

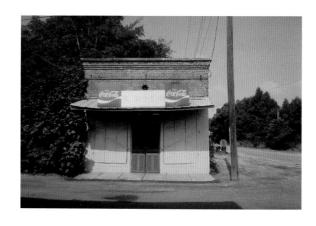

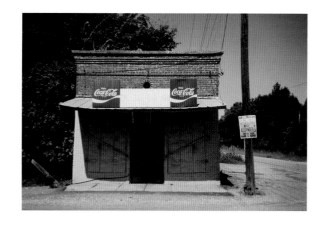

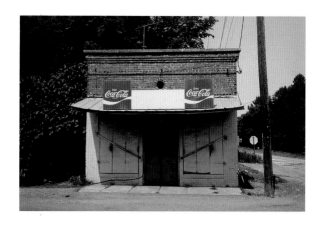

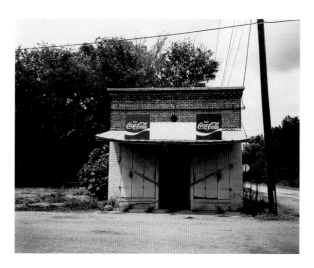

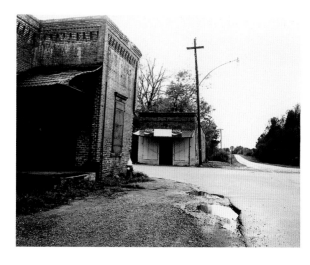

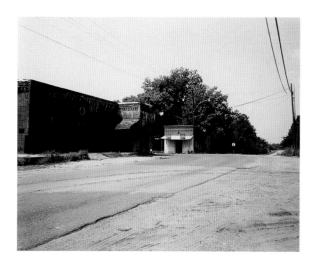

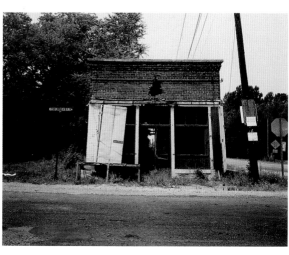

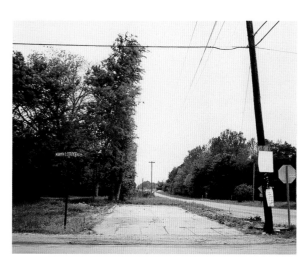

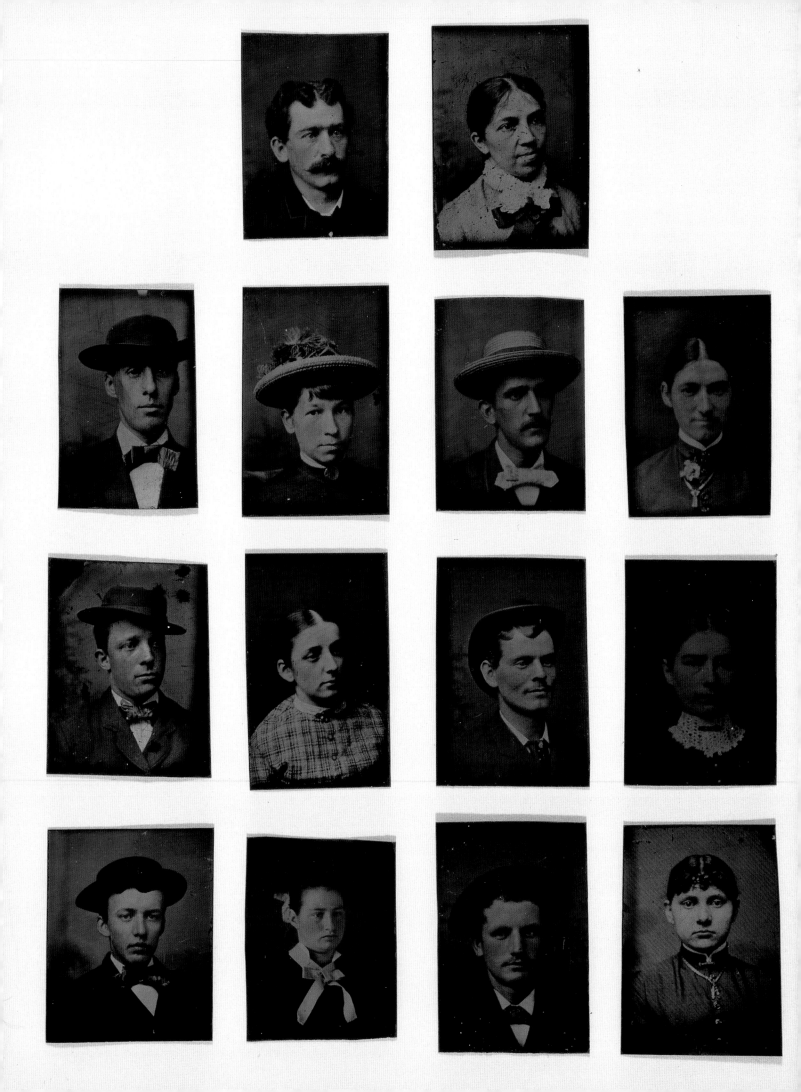

Discovering Community in 150 Years of Art
Philip Brookman

There's nothing here that depends on memory for the telling. With a story like this you want an accounting to occur, not a recounting, and a presentation, not a representation, which is why it's told the way it's told.

Russell Banks, *Continental Drift*

Art can tell many kinds of stories. An artist can conjure a narrative about something imaginary, made up from pieces of our experience or the real world; these truths and testaments burrow their way into a fictional construction that serves as an allegory for what we know. A collection of such work can refocus our thoughts about the issues we face in our daily lives. This can be thought of as a diverse scrapbook or family album, formed of fragments brought together to tell something of how our many stories fit together. While the different works may at first seem distinct, upon closer inspection we see connections, intricate patterns that entwine the threads of what we know and that reveal some of the mysteries embedded in issues that are invisible to the eye. Like the mythologies evoked by a constellation of stars in the night sky, or a configuration of tesserae that coalesce to recount historical narratives in a Byzantine mosaic, artists can embrace and assemble the unvarnished accounts of our individual lives to help us define ourselves and our communities.

The imagery in this exhibition—covering a range of 150 years of art making, and including aged photographs found at a weekend flea market, old advertisements fallen from rural roadside buildings, the etched, inquiring faces of inmates incarcerated in the Louisiana state penal system, the inventory of an African portrait studio, and a picture of a grave site by the side of a road—provides traces to help us connect to the communities from which the works are drawn. And through such aesthetic associations, it is possible to form relationships with diverse communities, to enter symbolically into them. In doing so we are then invited to find things in common with our own world. This common ground is both familiar and foreign, like

fragments of our own home movies projected on to moving water. We see our community and ourselves illuminated by the light of a different sun. It's a different kind of story from what we know; it creates a tension that resolves itself through the inquiry of artists.

How do artists define the idea of community? A community can be many things. It can be a group of people affiliated through some common attachment or goal: a society, a neighborhood, a church, a political group, a club, or a family. A community might also represent a set of people brought together by the situations of history, whose common bonds are circumstantial rather than conditional: a nation, a state, an ethnic group, an immigrant group, or the dispossessed who struggle together to cement new connections, reclaim the past, or celebrate diversity. This is a process that can also be quite personal. In a world in which communities are often dispersed, as we search for meaning and roots within our own lives we may discover connections that stretch the boundaries of our individual ties. We cross over oceans—following currents, tides, and the wind gusting across mountains and shifting political borders—to reclaim the attachments and stories that have made us who we are. In this way, the notion of community broadens to include genealogies that may yield a palimpsest of images and connections that form new links to the makeup of a person. We can better define who we are through a personal search than through what we already know or are told to think.

To define itself, a community must recognize and see itself emerging and fully formed, both in mirrors and through windows that reveal its past and present in a variety of ways. Mirrors reflect what we see and know; windows account for how these realities came

Unidentified photographers, *Untitled, c.* 1880

Danny Lyon, *Knoxville*, 1967

James VanDerZee, *Untitled*, c. 1920

about. Definitions then materialize from a recording of faces, clothing, toys, tools, architecture, and the like. Artists have often played significant roles in illuminating this prerequisite.

But how do we succeed in defining ourselves through art? How can we capture and record the flow of time that gives a community its traditions and purpose? How can we reconstruct and interpret these moments that combine like the still frames of an epic movie to ensure movement, continuity, and progress? Really to characterize the notion of community and its spirit, we need to have a means of recording its history. Words and pictures can provide some of the essence of past and present, some of the insight and connectedness that allow people to come together with a purpose. And that process of coming together—establishing the common ground and shared goals of kinship—induces the stories we tell. The past becomes present, the present, past.

Signs and Symbols

Entering the studio of artist William Christenberry, we pass easily into a world constructed from his memories and the many objects he accumulates to recall the past and the passage of time. One large wall is covered with the old signs he began collecting in 1964. These well-worn artifacts—hand-lettered, rusted, and pocked full of bullet holes—once called out to sell soda pop and redemption from Alabama roadsides: "Coca-Cola," "Enjoy Grapette Soda," "From One Sabbath to Another Shall All Come to Wash Up." Christenberry confesses, "I care so much about that landscape and I have such strong sentiments about time passing. I am driven to say something about it in my work." He goes on to say, "These signs show the aesthetics of the ageing process. The more weathered, the more bullet-ridden they are, the better as far as I'm concerned. I want to show the effects of time on the memory of that place." Christenberry's *Wall Construction V* (cat. 29; pages 50–51) is an architectonic collage of building and advertising materials. It is an example of how an artist can recycle the materials of his personal landscape and assemble them into an aesthetic construction, one that refers symbolically to the chattels of that place.

The Pop assemblages of artists such as Robert Rauschenberg and Andy Warhol and the documentary photographs of Walker Evans inspired Christenberry and others of his generation to deal with real, vernacular objects that revealed their history. Evans had trod some of the same ground with writer James Agee when they visited rural Alabama in 1936. The

work they created together became a model for future historians who were to grapple with the idea of a documentary art, one that creates something true from the fragments of experience. Although they were outsiders, Evans and Agee looked deep into the red southern landscape, and their book, *Let Us Now Praise Famous Men* (1940), describes real beauty in what must have seemed to them a far distant point of the universe. Like entomologists making lists of bugs in the grass, they described the smallest details of what they saw, reflecting their observations back in the mirror of everyday life.

Agee shaped an image of the poverty-stricken world of Alabama sharecroppers by metaphorically plowing the Depression-dry fields with his eyes and ears, seeding them with words, and nurturing their meager offerings with memorable, impressionistic imagery loosely based on his actual experience. But as Agee himself admits, "A piece of the body torn out by the roots might be more to the point…. If I could do it, I'd do no writing at all here. It would be photographs; the rest would be fragments of cloth, bits of cotton, lumps of earth, records of speech, pieces of wood and iron, phials of odors, plates of food and of excrement." In *Let Us Now Praise Famous Men*, Agee was struggling to put into words his emotional reaction to the very time and place of Christenberry's birth: the Alabama Black Belt farm country of Hale County in 1936.

In his photographs, on the other hand, Evans perfectly evoked the quiet symmetry of desperation and dignity during the Depression, and then connected this to history and art. These images are still and spiritual, like the hush one feels in the air before a terrific thunderstorm. Yet when their sequential meaning is unleashed—some of his southern images were published in his groundbreaking 1938 photographic narrative *American Photographs*—they have gathered such force that they simply explode. In Evans's photograph *Child's Grave, Hale County, Alabama* (cat. 50; page 26), a depiction of a small mound rising from the bare earth, he reveals no horizon, no sense of space; a few scattered weeds are the only living presence. But like an offering from the heavens, a sun-drenched dish sits atop the mound, the only precious object a family might still hold to mark the passing of their child.

As Agee and Evans knew, much of our impression about the nature of a community comes from our senses, from the particulars of sight, sound, touch, and smell. These may be communicated visually by moving in close to isolate details that convey something of how things feel, triggering memories that

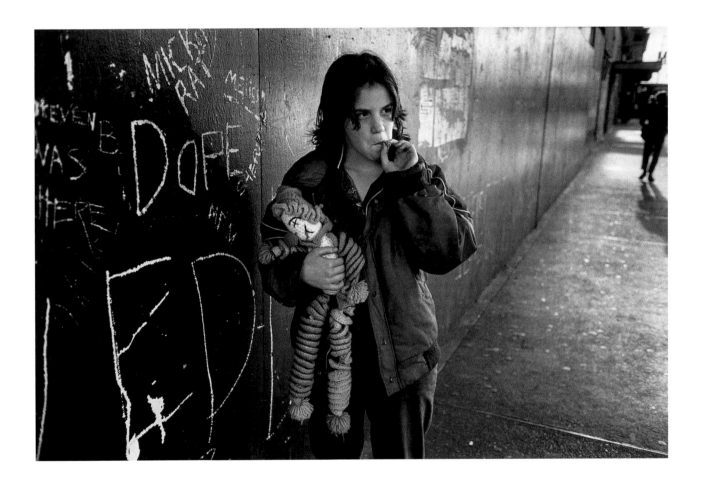

Mary Ellen Mark, *Lilly, Seattle*, 1983

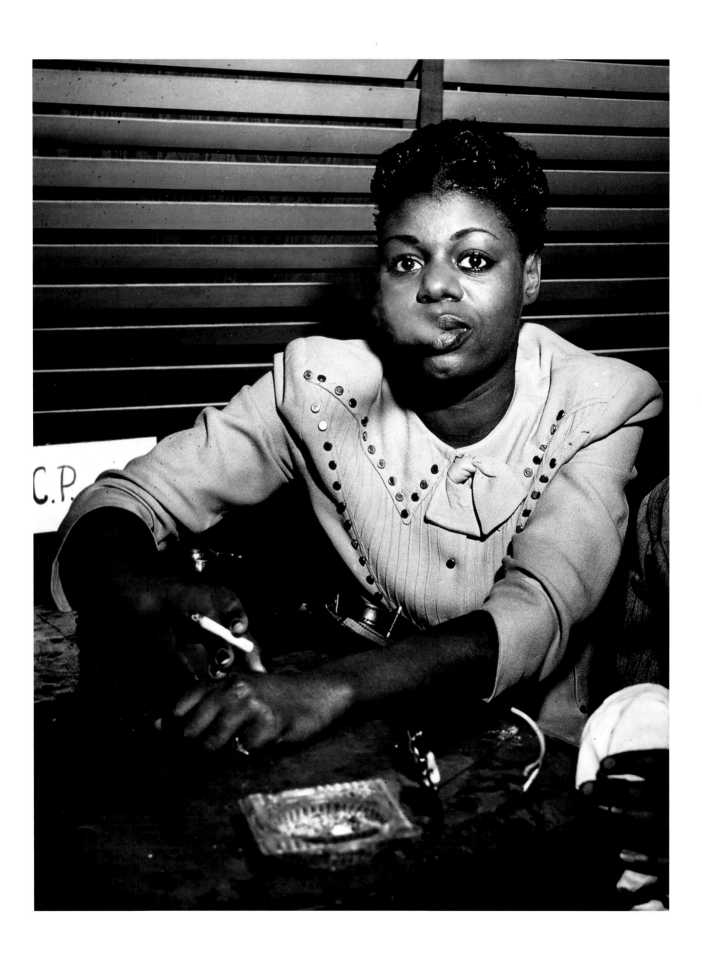

Weegee (Arthur Fellig), *NAACP, c.* 1943

bring us into a world we do not intuitively know. For example, Ben Shahn's *Cotton Picker, Arkansas* (cat. 135; page 53) telescopes our view to focus in on a worker's feet. Here Shahn evokes the feeling of standing barefoot on a rough wooden-plank stairway. Harshly lit by a low, sultry sun, the work expresses in a documentary manner the difficult life of the laborer. Shahn's use of a skewed, diagonal composition and truncated appendages revealed in close-up creates a tense, unsettled sentiment. In their work for the Resettlement Administration during the mid-1930s, Shahn and other photographers, including Evans, Dorothea Lange (cat. 88), and Arthur Rothstein (cat. 128), often employed such sophisticated narrative and compositional tools to report for the government on the difficult life of American farmworkers.

Such photographs navigated the rising and falling tide between documentary and literary depictions. Evans in particular was interested in the signs and symbols that reflect community patterns—buildings, streets, automobiles, architectural elements, and billboards, for example—as well as the complex, metaphorical narratives propelled by the relationships between visual elements in his pictures and between the pictures themselves. In the 1950s and 1960s, younger photographers such as Robert Frank (cat. 54), Lee Friedlander (cat. 57), Ray Metzker (cat. 110, 111), and Danny Lyon (cat. 101) picked up where Evans and others left off, exploiting the native tension between symbol and chronicle to address community and national issues such as race, politics, religion, and a growing sense of dislocation and commercialism in the United States. Frank's 1955 photograph of a grave site situated beside a highway, *South Carolina* (cat. 54; page 27), shows three graves covered in dirt, rocks, and shells. These fill the foreground of the image, recalling age-old African American coastal traditions of physically connecting or reuniting the earth and sea with the body and spirit of the deceased. Yet a car interrupts the sacredness of this scene by abruptly entering the upper-left corner of the photograph, tearing open the space of the picture and revealing the horizon and ribbon of highway that represent the outside world. Here Frank superimposes the roar of automobile wheels on pavement over the silence bestowed on the dead. This is very much an image about its time, the 1950s, when highways began to connect the outposts of the country with mainstream culture.

Made about one hundred years before, an anonymous daguerreotype (cat. 164; page 104) also depicting a graveyard is another image about the passage of time. It records a moment that becomes timeless once memorialized, merging a group of tiny mourners and a tall grave-marker with an open, tree-filled landscape, thus connecting a community to its eternal resting place. The human figures are so small in the frame that it is impossible to distinguish any features or to know who they are. The light coming through the trees illuminates them from behind as if they stood on a mountaintop, the sky ablaze with nothing beyond but the heavens. As a document, this cased image becomes a keepsake, a mirrored shadow of an event intended to keep alive the memory of the deceased. It could be carried from place to place and stored with a family's heirlooms. Like the monument it depicts, the image itself serves as a memorial that would last for generations, rather than a simple document of an event. Such personal art forms can help provide a sense of history and continuity for communities. They create an historical record and bring the past forward into the present, so that we do not forget what came before us.

Time and Space

Artists may address ideas about history by looking at the notion of place and how things change. When photographer Timothy O'Sullivan documented the western landscape for the United States Geological Survey in the early 1870s, he encountered an unmapped land. His photographs of vast landforms, such as *Bluff Opposite Big Horn Camp, Black Cañon, Colorado River* (cat. 124; page 4), tell more about geological time than the sort of time that can be measured in human terms. High cliffs eroded by the river over eons hover like an unmoving sentinel over the flowing, reflective water. The tension between these static and temporal elements gives the scene an unearthly calm. The jagged bluff cuts across the sky like lightning, etching its unique physical shape against a celestial white void. We sense the eternalness of it all, how the water has cut through the mountain over so many millions of years and how this seemingly immovable presence is constantly changing as the water does its work. Time and change are relative here. Yet the presence of O'Sullivan's tiny boat beached on the river's shore introduces modernity into the picture; its sense of "now" appears very much in contrast with the sense of "forever" imposed by the landscape, perhaps presaging a future in which the natural balance between rock and water would be distorted by the presence of people.

Years later, Laura Gilpin would place people in the context of this western landscape, exploring spiritual connections to nature and the formation of local and

national identities. Like John K. Hillers (cat. 78) in the 1880s, Gilpin photographed the remains of indigenous architecture hugging the rock walls of remote mesas. In *Untitled (Square Tower House, Mesa Verde National Park, Colorado)* (cat. 61; page 23), the sunlit masonry materials of the dwelling merge coherently with the texture of a dramatic cliff face, on which ancestral Anasazi inhabitants constructed their villages for protection and to maximize their access to desert resources. The resilience of the man-made structure in relation to the natural world is a testament to its timelessness. Decades later Gilpin photographed *Navajo Family (Francis Nakai and Family, Red Rock)* (cat. 63; page 24), depicting an assimilated Pueblo family against the backdrop of an American flag. The family projects a strong sense of self-respect and dignity, with Nakai's wife seated in the center, surrounded by children. The whole family looks right at us through Gilpin's lens; it seems an unspoken acknowledgment of their perseverance and connection to a new national identity. Their lives and those of their ancestors have changed dramatically in the eighty years since O'Sullivan took his photograph of the Colorado River; this community changed forever in a relative blink of an eye, when compared to the geological time etched by the river.

Contemporary artists have since explored more complex strategies to engage viewers in their images of place. When Hopi artist Victor Masayesva Jr. photographed a barren patch of reservation land in sober black-and-white (cat. 108; page 25), he subverted the traditional aesthetic notion of the beautiful western landscape. Here he was concerned with the representation of Native American culture, or how the media has customarily portrayed his own community. By focusing on a detail of the landscape, where beauty may indeed be inferred in the soft, wavy reflection of a ghostly tree in water, Masayesva pushes this subject to the surface of his art. He refuses to allow a view of the horizon by painting the sky in deep, textured ultramarine, with collaged stars peeking through to the surface of his image. The foreground, also made of pasted paper stars, creates a kind of illusionary window between sky and surface through which to view his highly personal impression of the landscape. The stars also echo those of the American flag, symbolizing the dominant culture overlaying the land.

In his collage of multiple Polaroid and 35 mm photographs called *103 Degrees—Troy, Alabama* (cat. 64; pages 98–99), Jim Goldberg uses his title to present the heat of summer as a symbol for strife at a particular time and place. By combining a number of images, he creates a narrative about a community, its people, and their struggle with anti-Semitism. The sequence begins with photographs of driving through the landscape. These are rough images full of technical flaws. In the Polaroids, hands and heads are cut off at the edges of the pictures; fragments are taped together spontaneously like a jaunt to the corner store. This offhandedness adds to its authenticity. As though carrying us into a different world, the pictures shift from black-and-white to color, and we meet the "different folks," Sue, Rachel, and Wayne, who are Jewish. This collaged juxtaposition of images, laid out as a grid, deepens the story; the pictures together mean far more than they do individually. Goldberg's combination of portraits of this family with landscapes, gestures, details, and everyday scenes reads cinematically. The kids are playing innocently, while clues to their hardship unfold through words and fragments of sentences written across the pictures: "Jews," "cigs," "Christ is king of," "Welcome to Alabama," "This is a Christian state," "July 4, 1998," "103 degrees." As in Masayesva's collage, we encounter the stars and patchwork details of the American flag, which here merge with the abstract glory of Independence Day sparklers, a fragile, skittish dog, and a depiction of a man and his daughter who are isolated for openly expressing their religious beliefs. In Goldberg's art, his representation of community is fragmented and incomplete, expressing a dissonant conclusion. The form of this work fluently reflects its challenging subject.

Portraiture

To account for a community's common ground as well as for its diversity, artists have often used portraits to present and describe its human face. The features and expressions of its people, their manner of dress, and their context within the environment can well describe aspects of a place, its politics, its aspirations, and its history. Making a portrait is always, in some way, a collaborative process between the artist and subject. There is a tension between the two, in which the artist's vision and the subject's understanding of that, in relation to their own purposes, come into play. In the nineteenth century, photographic portraits were often used to type or stereotype people. On the other hand, family albums established a means of pictorial genealogy, which could, like a road atlas, record lineage as well as milestones and places that were important to remember. Today artists may use portraits, sometimes culled from historical albums, to reconstruct and study our connections to communities—to each other—and to ourselves.

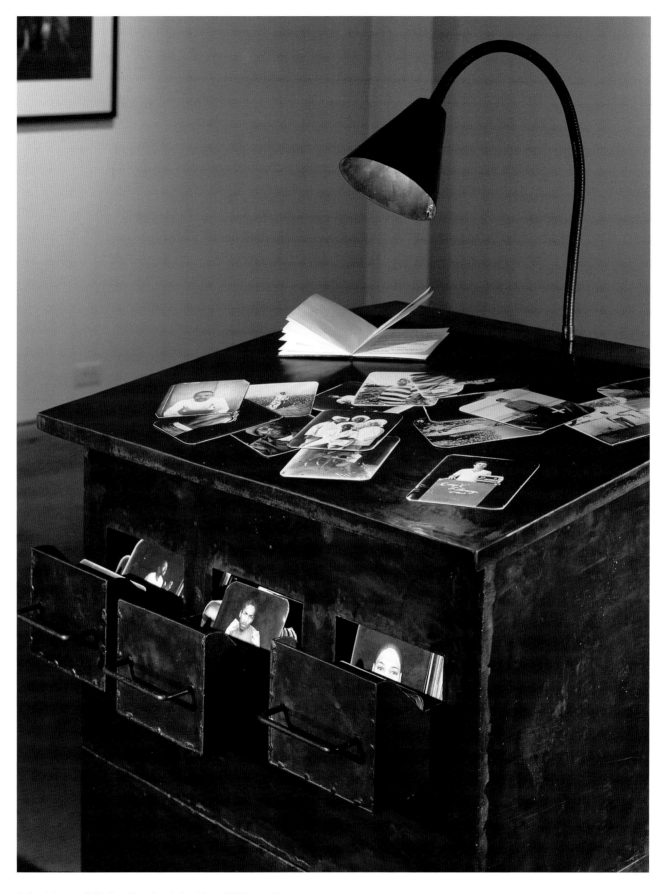

Deborah Luster, *Phillip Ray Allen, Angola, Louisiana*, 1999 (page 42)
Deborah Luster, *"Count", Angola, Louisiana*, 1999 (page 43)

Deborah Luster, *One Big Self: Prisoners of Louisiana*, 1998–2002 (above)

Weegee's photograph of a heroic-looking black woman seated at her desk (cat. 173; page 39) in an office of the National Association for the Advancement of Colored People (NAACP) is striking for its modern look. The woman posing for the camera, caught blowing smoke from a cigarette, is clearly serious in her work for the emerging civil rights movement. In contrast, Whitfield Lovell's charcoal sketch on assembled wooden planks, *Cage* (cat. 97; page 71), is a drawing based on a found photographic portrait— probably a family photo—of a woman posed formally for the occasion. These two portraits are both arresting in their confrontational poses, with both women looking directly at us. Weegee's documentary realism is stark in its flash-lit severity, whereas Lovell's metaphoric style is layered and ambiguous. These are both images about freedom. One woman is working for equal rights in a society that won't yet accept women or African Americans in its professional ranks. The other, a dignified, well-dressed woman, is juxtaposed with an actual weathered, antique birdcage that hangs off the front of the work. Lovell's concept of the absent bird represents the woman's spirit; an empty cage remains.

In some communities, portraits are made to carry around, to hold, to send by mail, or to pass out to friends and acquaintances. In today's electronic culture, they circulate by e-mail or cell phone. Like calling cards of the past, portraits can announce a birth or a rite of passage. They are as ubiquitous in our schools as holiday pageants, yellow buses, and report cards; photographs trace our lives from birth to death like a storybook with a plot that lasts a lifetime. In Africa, as elsewhere, portrait photographers have sometimes been called upon to help write the story by staging elaborate poses in a studio setting. Malick Sidibé has photographed both individuals and groups representing the youth culture of the streets in his studio in Bamako, Mali, since the early 1960s. He understands that some people who come to him want to see themselves as filtered through their desires and dreams. He is able to animate his subjects, embellishing their poses with studio light and simple props to connect people to community aspirations. Sidibé sometimes presents his images as small, handmade prints, exactly as he would give them to a client. Some, such as *Sitau Caulibaly—Vues de Dos* (cat. 142; page 149), have joyous, hand-painted decorative frames that counter the solidity and realism of the figure and place it in the context of Sidibé's world.

South African photographer Zwelethu Mthethwa photographs people in Paarl, Cape Town, in shantytowns at the edge of a changing urban culture.

His portraits allow his subjects to present themselves in their own homes, as they would like to be seen. This calls attention to their environment: televisions, radios, and items of a multicolored consumer culture are stacked against newspaper- and cardboard-covered walls and patterned cloths and carpets. It's a mixture of images that resonates with the notion that, within the shifting economy of South Africa, when people migrate from rural to urban areas for work, they assemble their lives in an aesthetic way from the materials at hand. They are surrounded by brightly colored media images from the TV and newspapers. Mthethwa uses these richly saturated interior spaces to frustrate our ability to create stereotypes. The vibrant intersection between the environment and the personality of its inhabitants gives these pictures their substance. In *Untitled* (cat. 119; pages 12–13), a man holds his albino boy in his deep-brown arms. It's a loving embrace; the two seem to be protecting each other as they look out of the room into Mthethwa's camera. A bright light comes from the side, illuminating their faces, setting the figures apart from the space and accentuating their tender relationship in the context of the makeshift setting. This work combines the tradition of documentary representation with the Post-modern concept of separating subject and context in order to enhance our connection to a work's humanitarian intent.

Deborah Luster has explored the expressive potential of portrait photography, imposing narrative possibilities on her images by printing her subjects on small aluminum plates that imitate the look of nineteenth-century tintypes. Between 1998 and 2002 Luster photographed inmates in Louisiana state prisons (cat. 100; opposite). These pictures are both delicate and playful; except for their highly polished lighting and technical bravado, they are radiant with the intimacy of family photographs. As in Mthethwa's images, Luster asks these inmates to present themselves as they would like to be seen by others. She gives prints back to them, and then she presents her portraits as an archive, an accounting of what she saw and experienced. It is an interactive arrangement in which her finished portraits are secreted away in the drawers of a black cabinet, like a warden's files. In this way she asks us to open the drawers, remove the images, and handle them, to hold in our hands these numerous representations of incarcerated people with data about their birth dates, number of children, and prison work assignments etched on the back. It's an accounting of a community that we can visit and enter into as we rifle the drawers of the cabinet. Even when they don't show their faces,

these inmates allow us to imagine their features through gestures, poses, and props. Here the issues of struggle, transcendence, and healing—common to much of this work—are all present in their portraits.

In the poem "Faces," Walt Whitman wrote a litany of remarkable imagery describing the human face as our primary connection to god and nature, love and art. Embedded in his masterpiece, *Leaves of Grass* (1855), this poem describes the face as the connecting tissue between one's inner being and the mysteries of the outside world. First, he lists a variety of expressions and appearances that connect people: "friendship, precision, caution, suavity, ideality." He goes on to animate them, comparing different faces to "a dog's snout, sniffing for garbage" and "a haze more chill than the arctic sea." For Whitman, these are all expressions of people's character. He then wonders how we judge people from their outside appearances:

> These faces bear testimony, slumbering or awake;
> They show their descent from the Master himself.
> Off the word I have spoken, I except not one—
> red, white, black, are all deific;
> In each house is the ovum—it comes forth after a
> thousand years.

In Louis Stettner's photograph of a woman sitting on a train, *Penn Station* (cat. 149; opposite), the light escapes from the window of the coach car as if carried by a mythic spear that has been shot straight from the sun. It's not a reflected light; it's emitted from within. The woman is deep in thought or lost in a daydream. Her white-gloved finger touches her face like a hummingbird gathering nectar. Its motion is at once graceful and utterly mysterious. We could almost imagine that she is at church, her seat a pew and her rest a sort of rapture. Stettner's image captures that very human moment when the face is perfectly at rest and there is an equal balance between our awareness of the outside and inside worlds, that moment in which, in Whitman's words, "faces bear testimony." Here the artist's observation of equipoise is mirrored in his photographic style. Whitman, who had inspired Stettner's powers of observation, found such a balance in the smallest details of everyday life, and he connected this to our ability to envision an inner life, to see into "the old face of the mother of many children." In Stettner's photograph we see into the woman's face, imagining her burdens fleetingly released by the touch of her light-filled finger.

Such a simple gesture is a universal one, with meaning in every culture. Stettner, like many artists,

is always searching for this kind of graceful common touch, one that is recognizable across cultural and community boundaries. There are many different ways in which artists have explored the nature and diversity of "community" during the past 150 years: as a sense of place or common ground, and as a concept that defines our bonds with the outside world. This is always a process of discovery, one that emerges from relationships established between artists and communities. The concept of "common ground" is a complex one; an idea that one person may consider to be communal may be irrelevant to another. Yet in seeking shared objectives, artists have developed new strategies to transcend traditional barriers. Their responsibility has not been simply to observe or document the world we know, but to create from their observations new and progressive ways for us to see into universal human experiences.

Louis Stettner, *Penn Station*, 1958

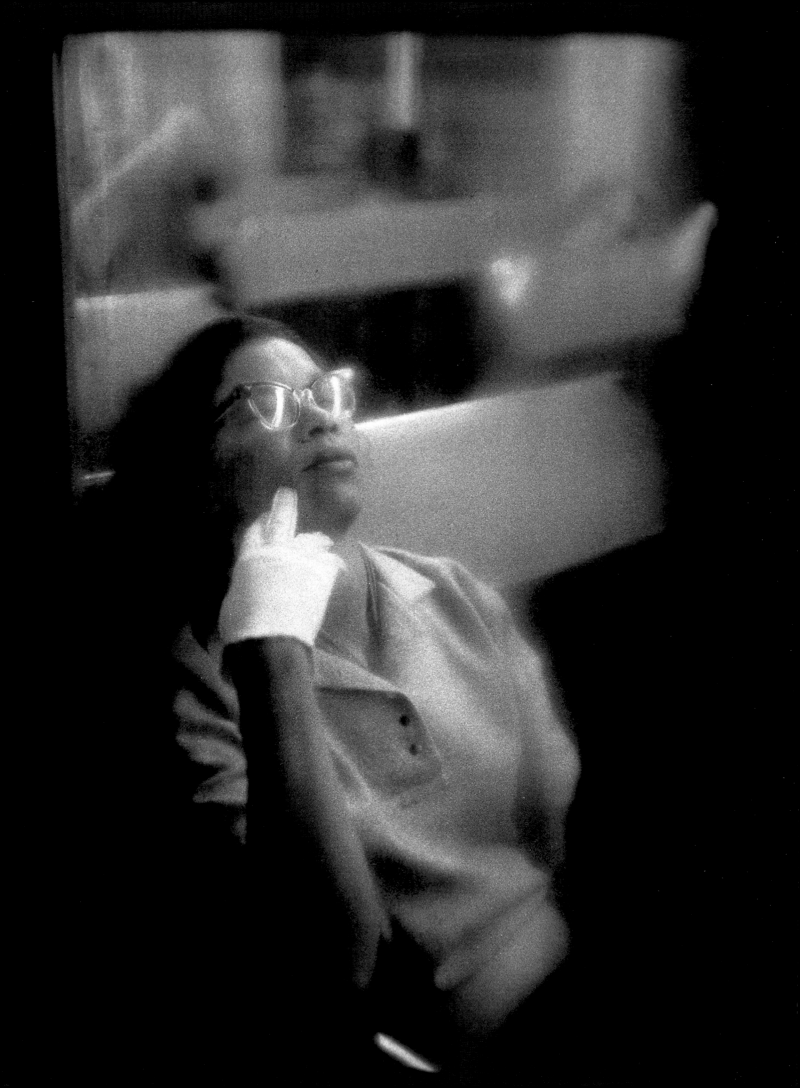

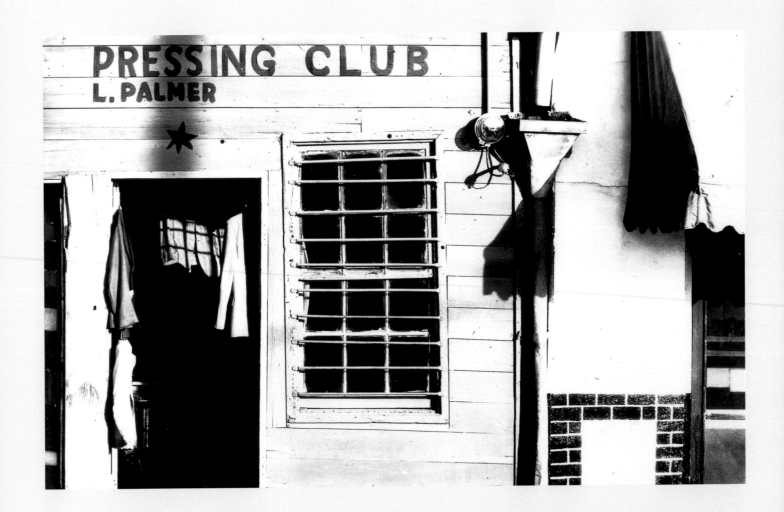

Walker Evans, *Star Pressing Club, Vicksburg, Mississippi*, 1936

A Sense of Place

All seemed impossible until I remembered
that I HAD spent time in a house like this and
had had the best fried chicken of my life, and
saw stars through the roof. There are things
absent like the kerosene lamp, and the bed
jar with a lid, and the stove with an outside
pipe just clearing the long-gone chimney.
Things, therefore, are reminders of what it took
to survive.

Beverly Buchanan

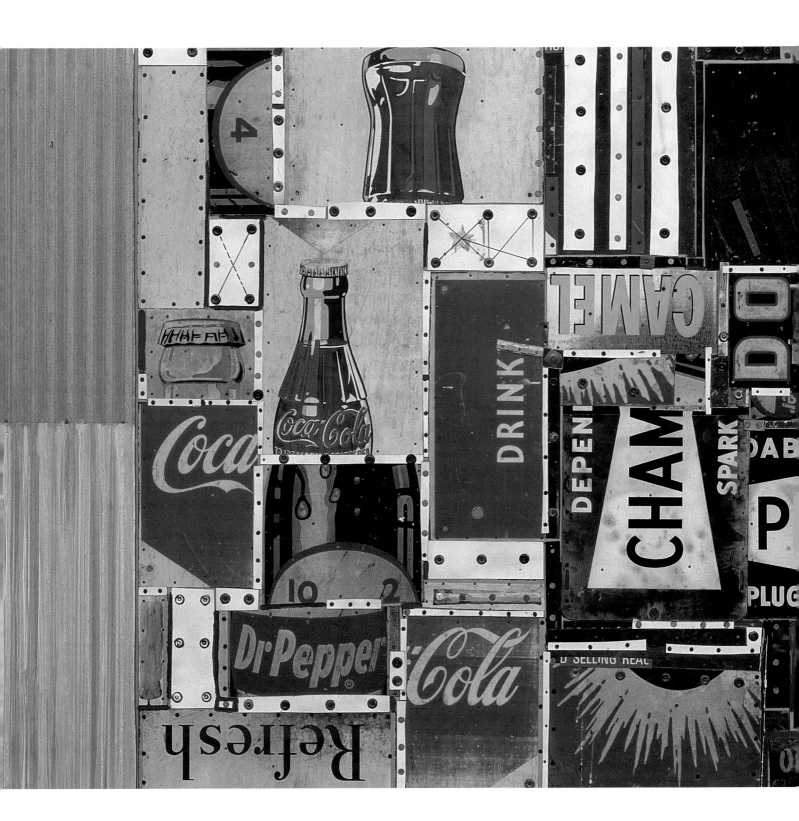

William Christenberry, *Wall Construction V*, 1985

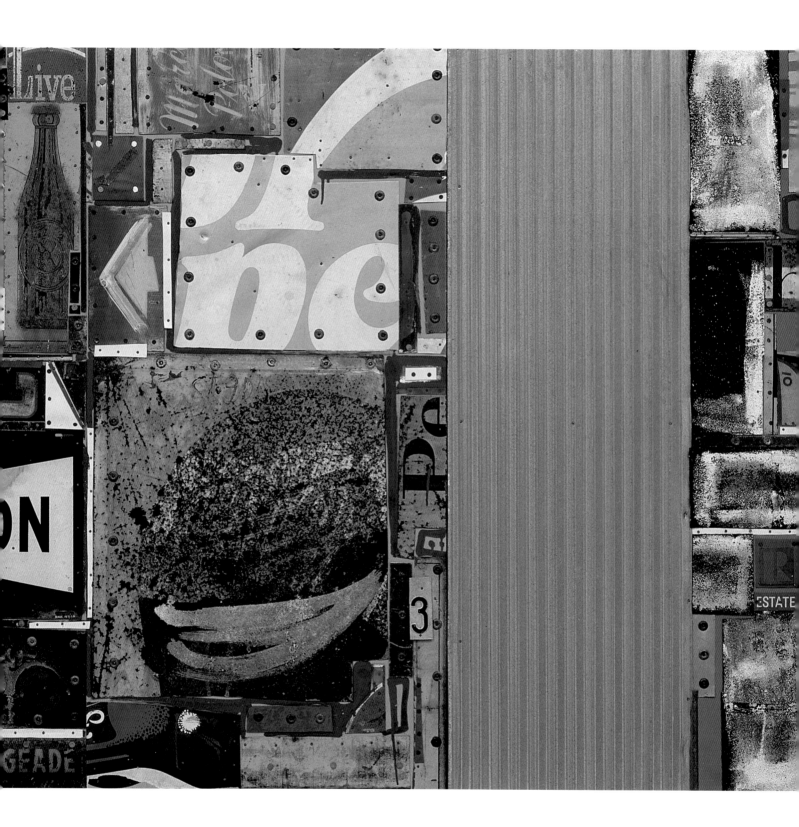

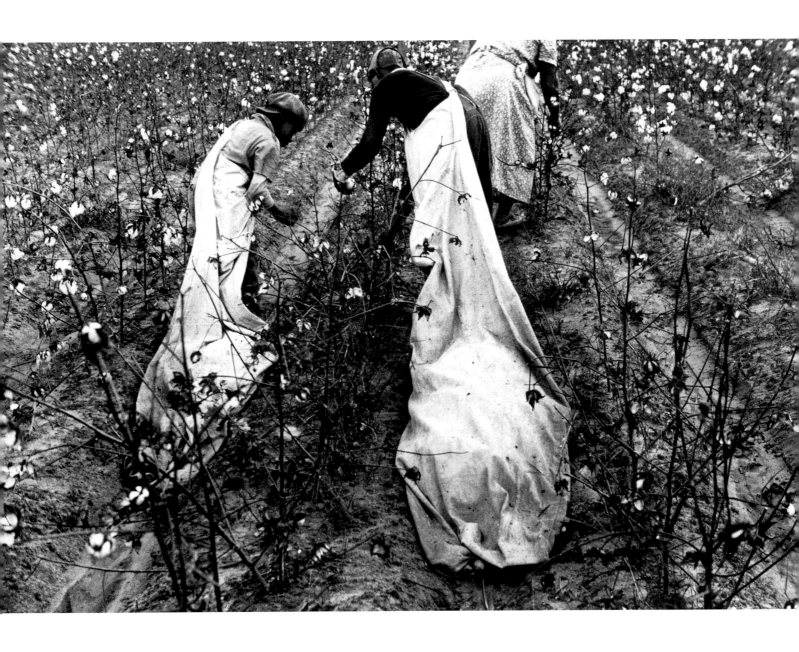

Ben Shahn, *Day Laborers Picking Cotton near Lehi, Arkansas*, 1935 (above)
Ben Shahn, *Cotton Picker, Arkansas*, 1935 (opposite)

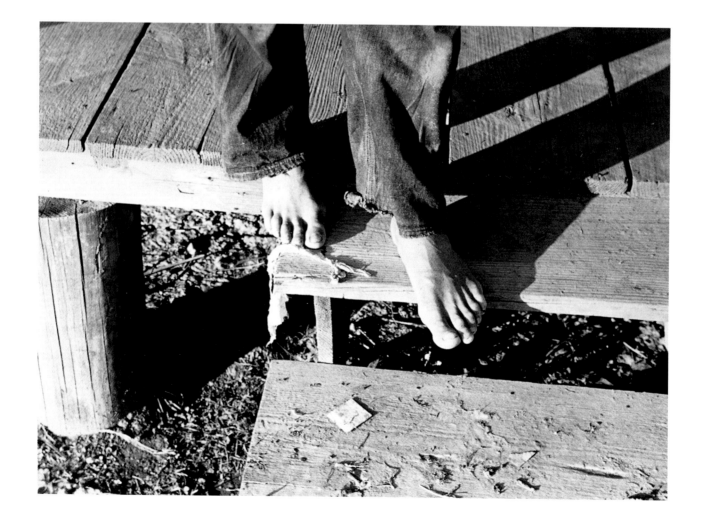

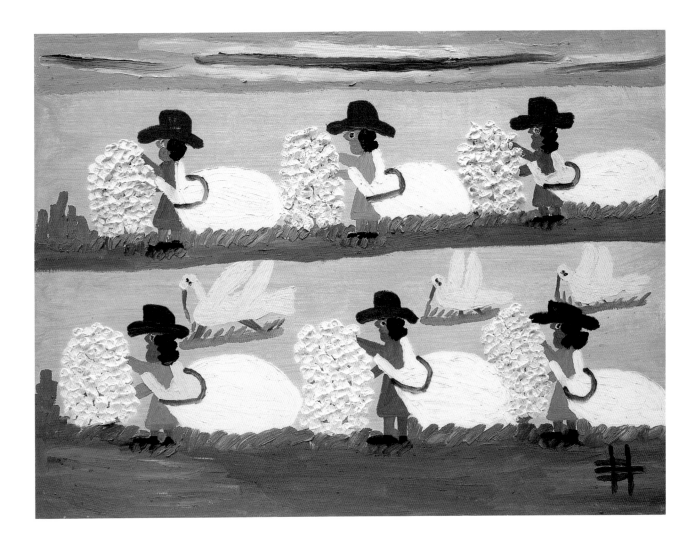

Clementine Hunter, *Cotton Pickers*, n.d.

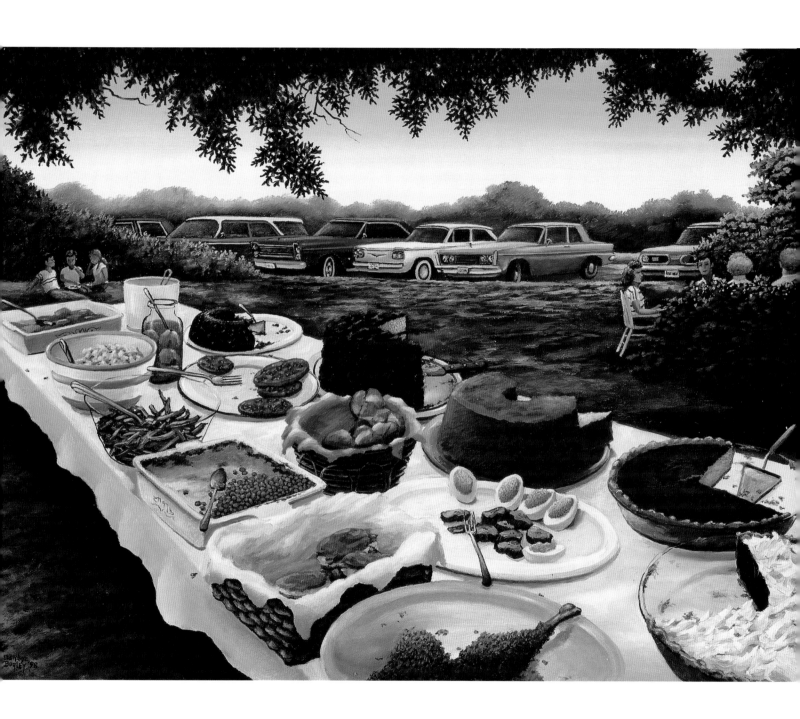

Eldridge Bagley, *Reunion Table*, 1998

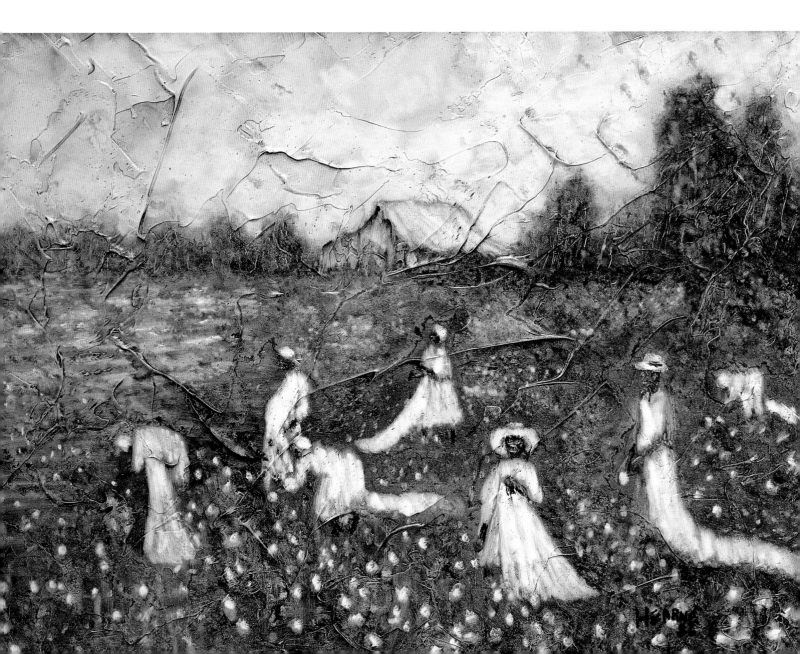

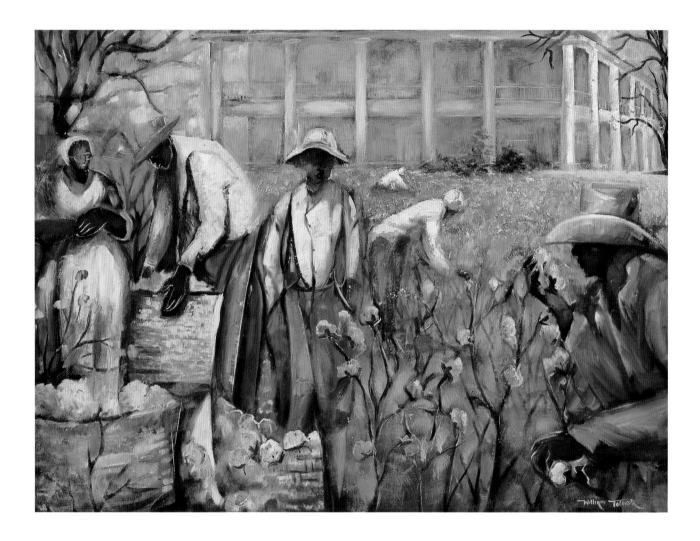

Mary Hearne, *Cotton Picking*, 1986 (opposite)
William Tolliver, *Cotton Picking*, n.d. (above)

Walker Evans, *Room in Louisiana Plantation House*, 1935

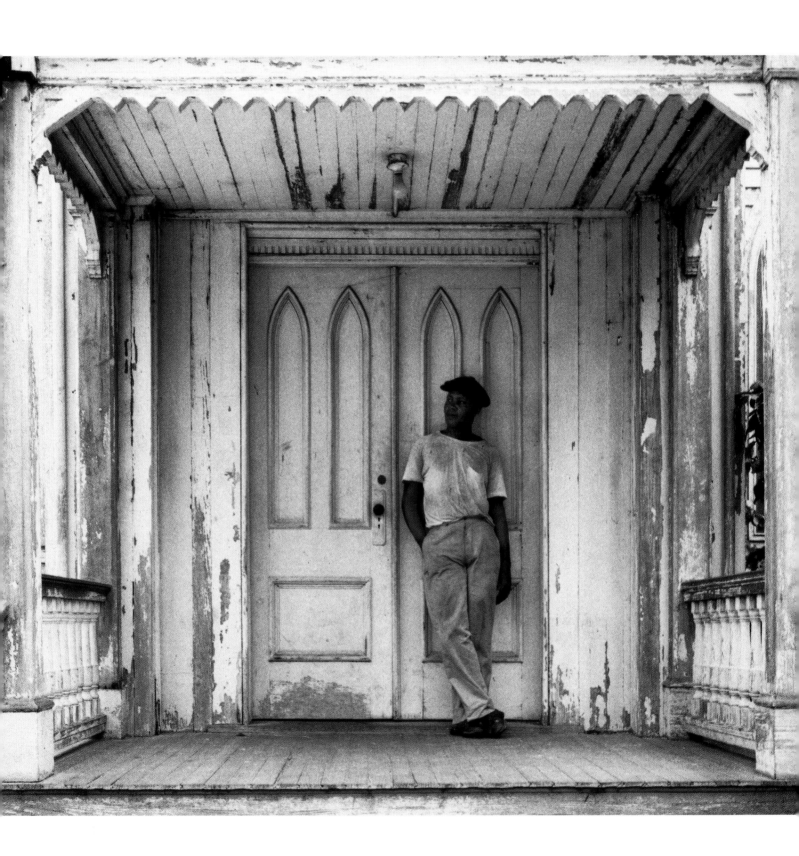

Arnold Newman, *Man in Church Doorway*, 1940

Gordon Parks, Dirt Road near Paoli, Lancaster County, Pennsylvania, 1946

Graciela Iturbide, *Mississippi at Memphis, Tennessee*, n.d.

Beverly Buchanan, *Chair*, 1988

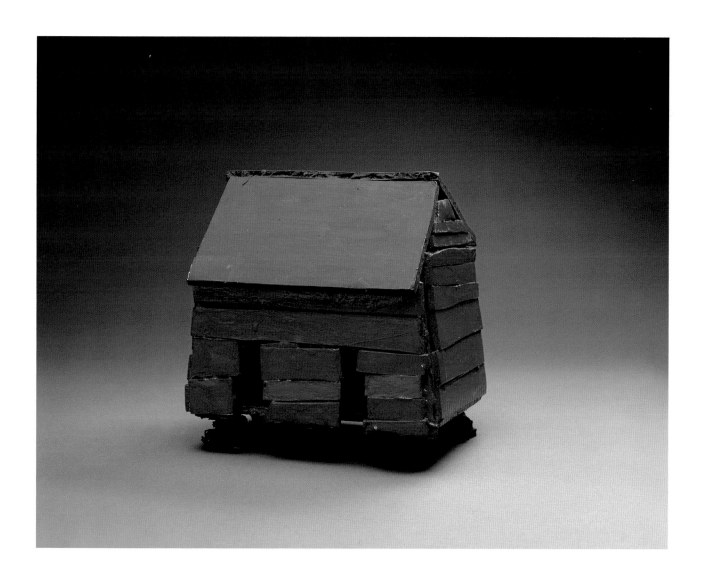

Beverly Buchanan, *Small Red Shack*, 1997

William Dunlap, *Dog Trot*, 1984

Manuel Carrillo, *Perro viendo a su amo Zihuatanejo, Guerrero*, n.d.

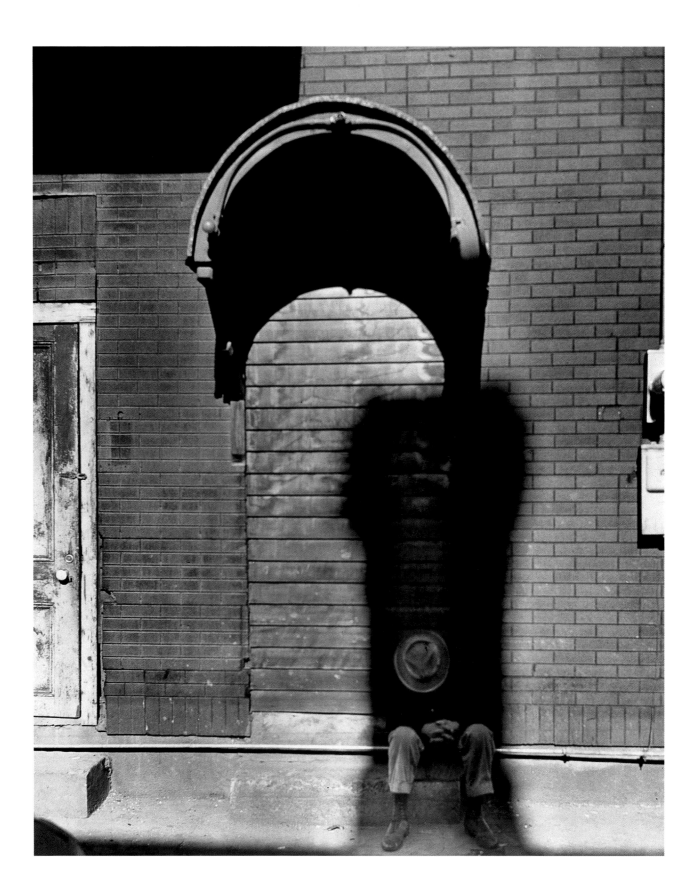

Clarence John Laughlin, *In the Spell of the Shadow*, 1953

Ties that Bind

Jacquelyn Days Serwer

The emphasis on memory, place, dreams and visions provides an unrecognized common ground between vernacular and high art.

Lucy R. Lippard[1]

The Julia J. Norrell Collection brings together photography, folk art, and mainstream contemporary art in a vivid illustration of art historian Lucy Lippard's observation that vernacular (or folk) art and "high art" share important areas of convergence. The seemingly disparate works in the Norrell Collection live together like a happy family in an egalitarian world; each piece retains its individual significance, yet is enhanced by the relationships and connections that the collection as a whole provides. Paintings by self-taught artists feel at home with vintage photographs and twenty-first-century assemblages and drawings. Although this diversity might strike some as eclectic, many of the works share a visionary quality, and all bear witness to the lessons and traditions of the past, providing evidence of lives that otherwise might have gone unnoticed. This imperative to bear witness links the works in the Norrell Collection, giving it both shape and coherence.

The collection's unusual dynamics reflect Norrell's own approach to collecting. An independent thinker, she has rejected the usual hierarchies and categories favored by the art world. Instead, the works she chooses cluster around themes and meanings that mirror her background and interests. Works celebrating southern life and culture, the cycle of life, and religious traditions provide opportunities to contemplate Lippard's areas of common ground— memory, place, dreams, and visions. The juxtaposition of works within the collection offers a worldview that encourages familiarity with the past as a means to interpret the present.

Norrell's biography is pertinent. The daughter of two Members of Congress from Arkansas, she was brought up in both Monticello, Arkansas, and still-segregated Washington D.C. during the 1940s and 1950s. After graduating from Ohio Wesleyan University in Delaware, Ohio, she spent a year in India on a Fulbright fellowship and immersed herself in the culture and religions that surrounded her there. These two spheres of experience—growing up in the South and living abroad—have largely shaped her art interests. Beginning with her first serious acquisition while still an undergraduate, paid for with money earned expressly for that purpose, her collecting activities have extended for more than four decades and continue unabated. For many years folk art and photography dominated Norrell's collecting, but in recent years she has demonstrated a growing involvement with more contemporary material.

Memory

The issue of memory—collective, rather than specific—permeates the Norrell Collection. Eldridge Bagley's paintings of life in rural Virginia (cat. 6–8; page 55), with their emphasis on traditional family gatherings and rustic scenes embellished with old cars, strike a strong nostalgic note. William H. Clarke's *Church of Francisco* (cat. 32; pages 68–69), depicting a large crowd gathered in front of a church for a community event, and his painting *Midnight* (cat. 31; page 135), showing a lynching and a cross burning, provide powerful reminders of southern practices that marked an earlier era. William Christenberry's spare drawing *K House* (cat. 30; page 134) also recalls an ominous aspect of the American South's troubled past. In contrast, Jonathan Green's *The Passing of Eloise* (cat. 69; page 114) reminds us of the importance of faith and family devotion among African Americans in small communities, such as those in South Carolina's Low Country, where Green grew up.

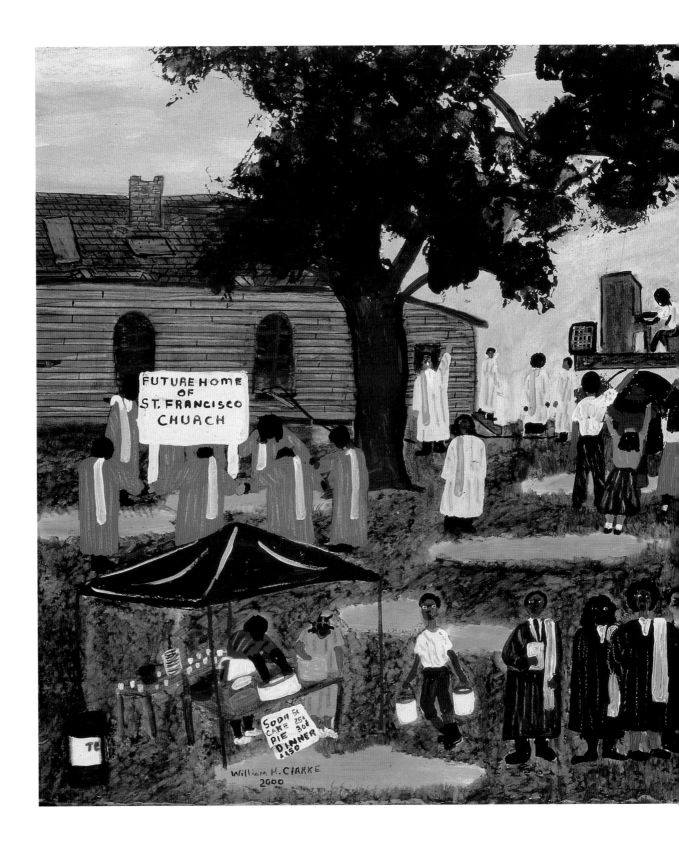

William H. Clarke, *Church of Francisco*, 2000

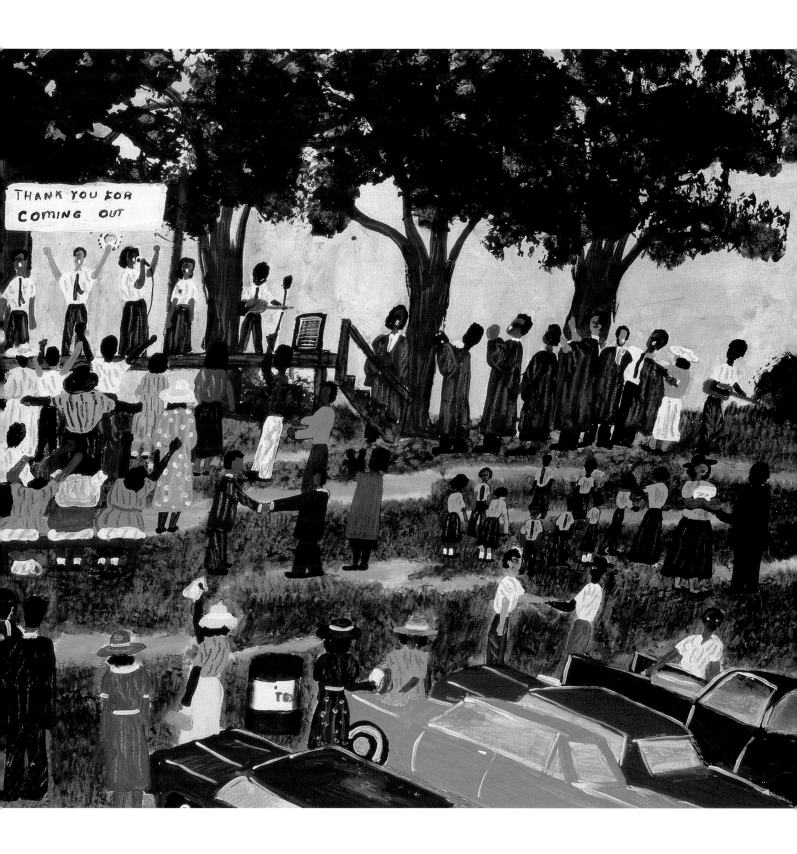

Christenberry's *Wall Construction V* (cat. 29; pages 50–51), an assemblage of metal signs and construction materials, offers a kaleidoscope of memory triggers. Rusted soft-drink signs vie with discarded metal panels and long-outdated product advertisements, resuscitating recollections of simpler times, when commercial messages existed primarily as part of the roadside landscape. After this piece was installed at Norrell's Virginia farm, her caretaker, a man in his sixties, was so affected by the nostalgia it evoked that he offered to attach one more piece to the metal collage: an old-fashioned bottle opener commonly used in the 1930s and 1940s.

David Bates's *Spearfishing* (cat. 11; page 152) gives a picturesque glimpse of country life, when fishing was not so much a hobby as an activity essential for non-urban self-sufficiency. The sturdy figures and regionalist evocations recall the august company of past artists who help guide his present work, among them Vincent van Gogh, Marsden Hartley, and Bill Traylor. "Once you start," Bates commented recently, "the memories get richer and all of a sudden different artists start showing up that you hadn't anticipated."[2]

Renée Stout's recent piece, *Sachets, Powders, House Sprays, and Herbs* (cat. 151; page 75), consists of a table sculpture with old-fashioned advertisements for Fatima Mayfield's cures and remedies. The handwritten menu of exotic root medicines, bath salts, and soaps along with homegrown testimonials give the work an antiques-store or flea-market quality. It harks back to a time when private practitioners resolved the most pressing human problems using their own nostrums—success, health, and love were all achievable with the appropriate advice or herbal concoction. According to Stout, the figure of Fatima Mayfield is based on a real person whose shop, inherited from her great-aunts, has walls still covered in yellowed and stained advertisements. In the artist's words, it was "a kind of funky, walk-in collage … a space that time and spirits had created."[3]

Norrell's trove of images in several media showing agricultural workers harvesting cotton serves as a reminder of the days when cotton was central to southern life. William Tolliver's paintings (cat. 153; page 57) combine several different actions within the same scene, recalling the gentle Renaissance storytelling technique of painting multiple actions on predella (altarpiece) panels. By contrast, Mary Hearne's more direct treatment, *Cotton Picking* (cat. 76; page 56), finds easy companionship with Clementine Hunter's magical, two-tiered rendering of the same subject (cat. 81; page 54). These evocations of the South's agrarian culture, along with Rita Huddleston's cotton-stuffed doll (cat. 80) representing a male cotton worker, enhance one another and find sympathetic resonance with several of the vintage photographs, especially Ben Shahn's unforgettable image of the Great Depression, *Day Laborers Picking Cotton near Lehi, Arkansas* (cat. 136; page 136).

Works devoted to cemeteries form a sub-theme in the Norrell Collection, one that reminds us of both our collective past and our ultimate destiny. Mose Tolliver's painted cruciform figure (cat. 152) would not likely last as a tomb marker. However, its elegiac quality, similar to Clyde Connell's stark vertical relief (cat. 36; page 168), suggests that it would not be out of place with the angels and crosses in photographs such as Richard Misrach's *Crucifix, Holy Rosary Cemetery* (cat. 115; page 129) or Shomei Tomatsu's forlorn commemoration of an abandoned churchyard in Nagasaki, Japan, about 650 yards (600 meters) from the site of the atomic bomb blast (cat. 154; page 159). Marked by scattered angel heads and broken columns, Tomatsu's photograph conveys a profound sense of loss and regret. These works, whether images or objects, provide rich stimuli for contemplating lost lives and our continuing relationship with them.

Place

For Norrell, meaning is closely tied to place. Her childhood in Arkansas, her political life in Washington, and her tree farm in Virginia constitute important touchstones that help define her life. Much of her collection consists of works that are emblematic of a particular culture, yet which also suggest a web of broader human connections. Here, as in other groupings, folk art, contemporary art, and photography inhabit the same world.

Portrayals of informal structures and crude cabins that might be described as shacks have come into the collection in several media. Willie Little's *Little's Grocery (Juke Joint)* (cat. 95), an assemblage of plywood and sandpaper, tells its story in an inscription on one of the gravelly sidewalls: "At night, it became a Piccolo Joint. Daddy would pack 'em in like sardines." Beverly Buchanan's pieces, which include photographs as well as three-dimensional works, depict domestic, hard-knock shelters that reveal the human hand in every aspect of their execution. Buchanan often photographs shacks—existing dwellings in the southern landscape—as well. Her *Mary Lou Furcron House* (cat. 20) shows us a place possessing a spirit as vivid as that found in her three-dimensional creations, such as *Small Red Shack* (cat. 21; page 63).

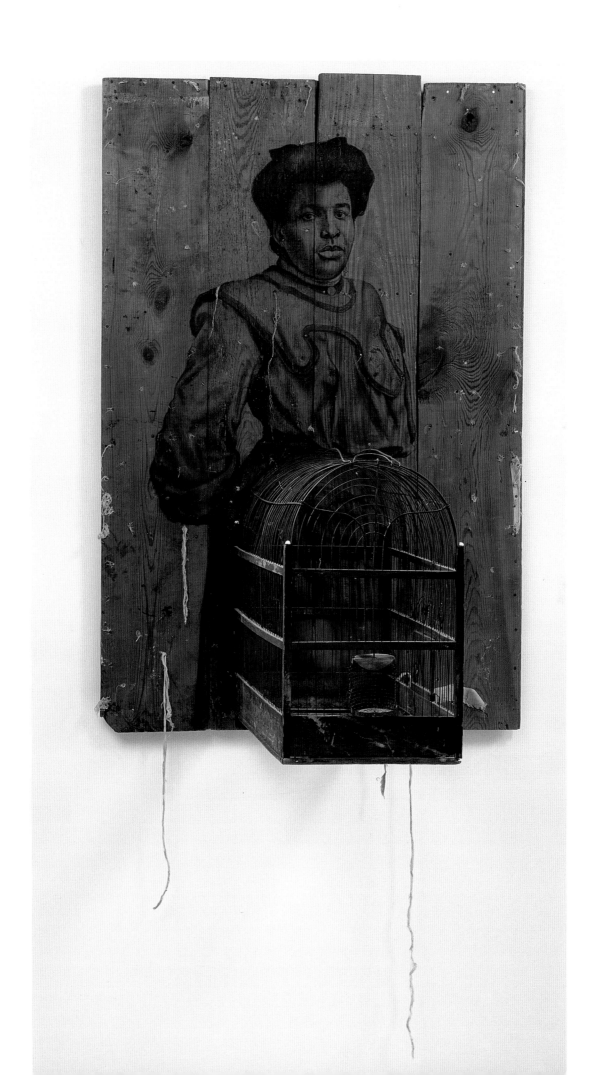

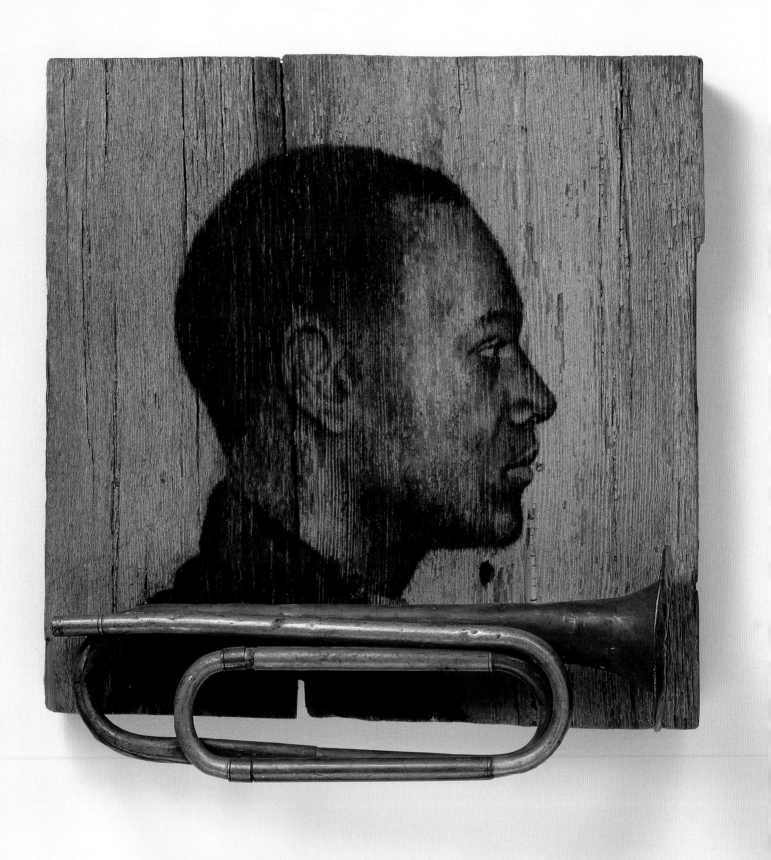

Whitfield Lovell, *Juba II*, 2003

William Christenberry has also devoted himself to documenting the essence and life cycle of simple buildings, particularly those in Hale County, Alabama, where his family has deep roots. Christenberry readily admits his visceral connection to the area: "I guess somebody would say that I am literally obsessed with that landscape where I am from. It is so ingrained in me. It is who I am. The place makes you who you are."[4] Christenberry's obsession plays out in both photographs and three-dimensional objects. Norrell has acquired the full series *The Bar-B-Q Inn, Greensboro, Alabama* (cat. 28; pages 30–31), sixteen photographs of a homey outpost that were taken periodically over the course of almost three decades. The documentation begins with a structure that houses a juke joint. Gradually, the building slides into disrepair, and finally it disappears altogether. The course of its demise offers a poignant parallel to the human life cycle. Christenberry's *Tingle House, near Akron, Alabama* (cat. 27), a two-part piece, shows a similar sequence: the first photograph presents an existing dwelling that, like Atlantis, slips from sight in the second photograph.

Among the collection's photographs, Walker Evans's *Star Pressing Club, Vicksburg, Mississippi* (cat. 52; page 48), Emmet Gowin's *Church, Mississippi* (cat. 66; page 82), and Arnold Newman's *Man in Church Doorway* (cat. 123; page 59) emphasize the ephemeral quality of the built environment that Christenberry dramatizes so effectively. A recent acquisition, *Times for Call to Prayer, Jami-ul-Alfar Mosque, Petlah, Colombo, Sri Lanka* (cat. 13; page 30), a large color photograph by Virginia Beahan and Laura McPhee showing the interior of a mosque in Colombo, Sri Lanka, creates a profound experience of a specific moment and locale. A pair of shoes placed near a clock stand makes us feel as if a worshipper has just stepped out of this intriguing antespace and into the sanctuary. The signs of creeping deterioration recorded in these photographs signal humankind's tenuous hold on its shelters and surroundings. These sites seem to thrive and decline according to their own life cycles, independent of the people associated with them. The scenes act as *memento mori*, symbols as well as documents of a particular place and moment.

Dreams

Dreams and imaginary scenes add to the poetic character of Norrell's holdings. Theora Hamblett's *Two Trees with Blowing Leaves* (cat. 75; pages 146–47) is a paean to fantasies of childhood fun and the carefree embrace of familiar outdoor surroundings.[5] Jonathan Green's *Daughters of the South* (cat. 70), in its perfect balance of color and pattern, fulfills dreams and aspirations for the New South in which beautiful African American girls are its pride and joy, rather than its prey.

The works of Whitfield Lovell provide a different order of dream and imagination, one in which found images of unidentified individuals are cast into open-ended narratives of his own creation. Lovell's reputation is based on his room-size installations as well as his detailed charcoal drawings on wood panels that are inspired by old black-and-white photographs. In *Cage* (cat. 97; page 71), Lovell depicts an elegant matron who looks apprehensively toward us. However, she need not fear our coming too close: a large birdcage attached to her torso separates her from our reach, if not our gaze. We have no way of knowing what Lovell saw in her posture or demeanor that suggested her pairing with the cage. As the artist has noted, "*Cage* is a piece whose enigmatic qualities are its strengths."[6] Is the woman protected by the cage or trapped by it? Rather like a dream, Lovell gives us fragments of the story, but not the script.

A smaller Lovell piece, *Juba II* (cat. 99; opposite), shows a man's handsome profile carefully rendered in charcoal on a greenish surface made up of recycled wood boards; Lovell has embellished the surface by attaching a battered brass bugle to the bottom edge. According to the artist, it is one of a "series of tableaux that join musical instruments with human faces."[7] In the title Lovell provides more of a clue to the imaginary identity he has assigned to the sitter. Juba was the nickname of a celebrated nineteenth-century African American dancer who entertained audiences in his native New York and in London; the name can also refer to a dance performed by slaves and later to music that could have accompanied such a dance.

African American playwright August Wilson includes a Juba dance scene in his drama *Joe Turner Has Come and Gone* (published in 1988). The play employs music as a metaphor for identity. To achieve a fulfilled existence, a character must find his "song" within himself and then be able to sing it. Perhaps we can interpret the bugle as a symbol of Juba's triumphant discovery of his inner song. Certainly this dignified ensemble suggests confidence and well-being, achieving what Lovell calls "a bold and powerful feel."[8]

At first glance, Jacob Lawrence's *Two Rebels* (cat. 90; page 102) appears to be a straightforward representation of a black protester being hauled off by police. But what are the circles up above? And why can we make out only one rebel, but two policemen? A comparison of this lithograph, Lawrence's first, with

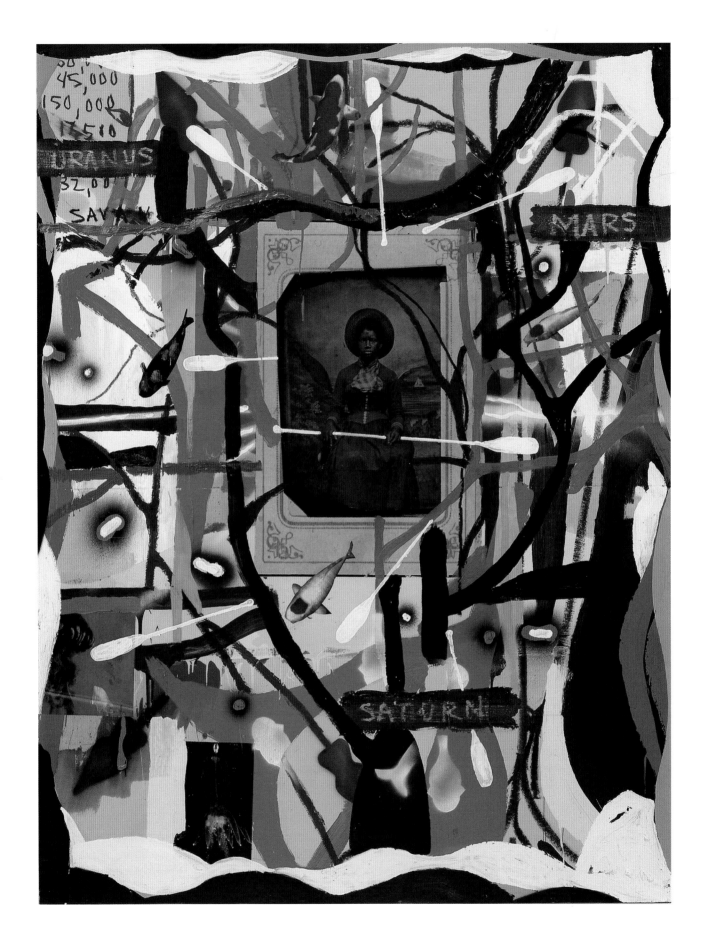

Radcliffe Bailey, *Untitled*, 2001 (above)
Renée Stout, *Sachets, Powders, House Sprays, and Herbs*, 2003 (opposite)

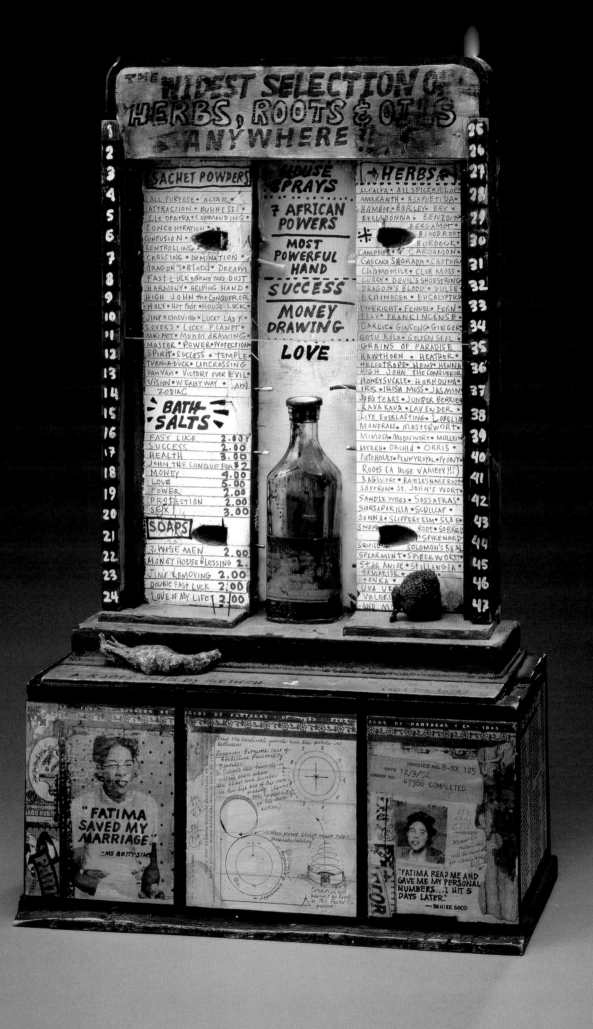

the painting from which it derives (from the collection of the Harmon and Harriet Kelley Foundation for the Arts) sheds some light on his approach. The two rebels and four policemen in the original painting have been reduced to one rebel and two law-enforcement officers in the print, and the faces of people in the crowd have morphed into circles that represent disembodied masks. As a result, Lawrence presents an image seen through the lens of a dream or nightmare. The unreality of the scene adds to its visual power, encouraging us to make broader associations with tragedy and martyrdom. The rebel's prone posture as he is being carried away in the arms of the police officers provides an uncanny resemblance to the many Deposition of Christ scenes found in Old Master paintings.

The Israeli photographer Adi Nes achieves a similarly surreal effect with his staged scenes of ordinary people involved in troubling, although somewhat enigmatic, events. In one untitled piece (cat. 121; page 10), a nighttime fire in a playground illuminates the faces of several teenagers who are the bystanders, or perhaps the perpetrators, of a violent episode. The eerie scene gives no confirmation either way. Are we witnessing a crime or caught up in a nonspecific nightmare? Nes likes to keep us guessing.

Radcliffe Bailey's untitled composition (cat. 9; page 74) offers an unusual mix of media by combining a striking nineteenth-century photograph of a well-dressed African American girl together with abstract painting. An oar has been painted on to the photograph so that it appears that the girl is holding it, and the names of the planets, printed like street signs, are strewn across the painted surface. Positioned at the center of a web of interplanetary associations and brightly colored arabesques is the black-and-white photograph of the unidentified girl. The relationship of photograph to painting remains unclear. Bailey's work often deals with African American identity and the Black Diaspora, so perhaps the network of symbolic intersections refers not to the subject's specific identity, but rather to her central place in the universe. It may also allude to the hopeful destiny of nameless others like her who will find a way, despite the obstacles, to navigate the world successfully. As such, the young woman becomes a major player in a cosmic dreamscape more powerful than reality.

Visions

Visions take many forms in the works in the Norrell Collection. Among the religiously inspired visions is Howard Finster's *1000 and 184* (cat. 53; page 117), which, with its apocalyptic image of a man's head surrounded by massive flames, makes a frightening

impression. Finster was a preacher who produced what he called "sermon art." Convinced that the world was nearing the Final Judgment, he executed works that reinforced his message of salvation. As Finster put it, "I'm in the plan of God, and whatever my art does is from God Almighty, from the world beyond." [9]

Another artist-preacher, "Prophet" William J. Blackmon, joins Finster in an attempt to communicate a redemptive message in words and pictures. In his Milwaukee church, which also houses his shoe-repair business, Blackmon produces works that link everyday life with an awe-inspiring vision of Christian deliverance. His *Vote for President* (cat. 14; page 116), showing a two-story, ark-like apartment building, combines a political message with the ever-present religious one: "Vote," it commands, in words painted around the perimeter, "but only for the one who says he loves Jesus."

Nicario Jimenez, a Peruvian artist, intertwines the mythical figures of his *Two-Tiered Retablo* (cat. 85). The *retablo* is traditionally a wooden box with carved religious scenes inside that is used by priests as a kind of portable altar. When the first "altar boxes" arrived in Peru with the Spanish in the sixteenth century, the local Indian tribes displayed them in their homes while secretly continuing to practice the traditional religion. Jimenez transforms these once-alien objects into contemporary shrines by weaving the mythical figures of his *retablo* into spiritual metaphors for the plight of his ethnic group, an indigenous people native to the mountains of Peru. Driven to create these devotional ensembles despite the lack of conventional materials, Jimenez modeled his figures using an unlikely mixture of cooked potatoes and gypsum.

Religious visions are not limited to these relatively unschooled artists, however. Another arresting photograph by Virginia Beahan and Laura McPhee, *Sleeping Buddha, Subodrahma Maua Viharaya Temple, Dehiwala, Sri Lanka* (cat. 12) presents a hypnotic image of a strangely feminine Buddha encountered in a temple in Dehiwala, Sri Lanka. The Buddha, lying with its head resting on a decorative pillow, appears both worldly and divine.

Other photographs in the Norrell Collection also challenge our sense of reality. In his *Writing on the Wall* series, Shimon Attie used photographs taken of Berlin's Jewish quarter before World War II to make slides that he then projected on to the façades of contemporary buildings in the same neighborhood. His photographs of these projections (cat. 4, 5; page 29), which make up the series, possess an apparitional quality, creating a mirage of the past that exists in the present.

Fred Wilson, another artist whose work Norrell has acquired recently, is known for staging provocative museum installations that reveal the unconscious racial and class biases implicit in conventional museum presentations of the history of art. Rather than confronting these issues in a straightforward way, Wilson uses his imagination—in what may at first look like a stream-of-consciousness approach—to arrive at a more intuitive presentation of his argument. As he puts it, "I began to view my work as a kind of *trompe l'œil* of curating."[10]

Wilson's 1994 exhibition *Old Salem: A Family of Strangers*, held at the Southeastern Center for Contemporary Art in Winston-Salem, North Carolina, featured a group of dolls from the museum's storage. The dolls, crafted by nineteenth- and early twentieth-century African Americans, had long ago dropped below the curatorial radar. Resurrected for this exhibition, they raised many questions about their origins, their identities (whom did the dolls represent?), and their historical significance. African American slaves and free blacks had once been active participants in this originally Moravian enclave, but they eventually became marginalized and deprived even of their burial grounds and grave markers. The phrase "family of strangers" in the exhibition's title refers to this rupture between blacks and whites who, more than a century later, would be inspired by Wilson's installation to renew a dialogue about their shared past.

Wilson subsequently made individual, large-format photographs of each doll for a New York gallery show. Norrell owns two of the photographs in the *Old Salem* series (cat. 179, 180; pages 78, 79), each startling in its vivid anthropomorphic presence. Lifted from the context of Wilson's exhibition, they have found new relationships in the welcome company of kindred works in Norrell's collection. Symbols no longer of racist exclusion but rather of cultural survival, they vie and converse with other photographic portraits in media as diverse as ambrotypes, tintypes, and daguerreotypes. They bask in the earthiness of Renée Stout's homage to Fatima Mayfield, the expressive grittiness of Beverly Buchanan's southern shacks and William Christenberry's *Wall Construction V*, and the mystery of Whitfield Lovell's eloquent tableaux. They contemplate the funerals and cemeteries, and they ache for the other country folks who came as close as they did to oblivion. They are once again part of a close-knit family in which they contribute to the visionary spirit that connects the art of the present with the lives and stories of the past. In Norrell's world, the ties that bind are strong indeed.

Notes

1. Lucy R. Lippard, "Crossing into Uncommon Grounds," in *Common Ground/Uncommon Vision: The Michael and Julie Hall Collection of American Folk Art,* exhib. cat. by Lucy R. Lippard *et al.,* Milwaukee Art Museum and others, 1993, p. 64.

2. *David Bates*, exhib. cat. by Carl Little and David Bates, New York, DC Moore Gallery, 2004, unpaginated.

3. Renée Stout, correspondence with author, January 16, 2004.

4. *William Christenberry: Art and Family*, exhib. cat. by J. Richard Gruber, New Orleans, Ogden Museum of Southern Art, University of New Orleans, 2000, p. 56.

5. Hamblett, a self-taught artist, privately published a book entitled *Dreams Can Work for You*. See Herbert W. Hemphill Jr., *Twentieth-Century American Folk Art and Artists*, New York (E.P. Dutton) 1974, p. 151.

6. Whitfield Lovell, correspondence with author, February 4, 2004.

7. *Idem*, correspondence with author, August 21, 2003.

8. *Ibid*.

9. Robert Peacock, with Annabel Jenkins, *Paradise Garden*, San Francisco (Chronicle Books) 1996, p. 64.

10. Fred Wilson, "Maurice Berger and Fred Wilson," in *Fred Wilson: Objects and Installations, 1979–2000: Issues in Cultural Theory*, exhib. cat. by Maurice Berger, Baltimore, Center for Art and Visual Culture, University of Maryland, 2001, p. 33.

Fred Wilson, *Old Salem: A Family of Strangers*, 1995 (overleaf)

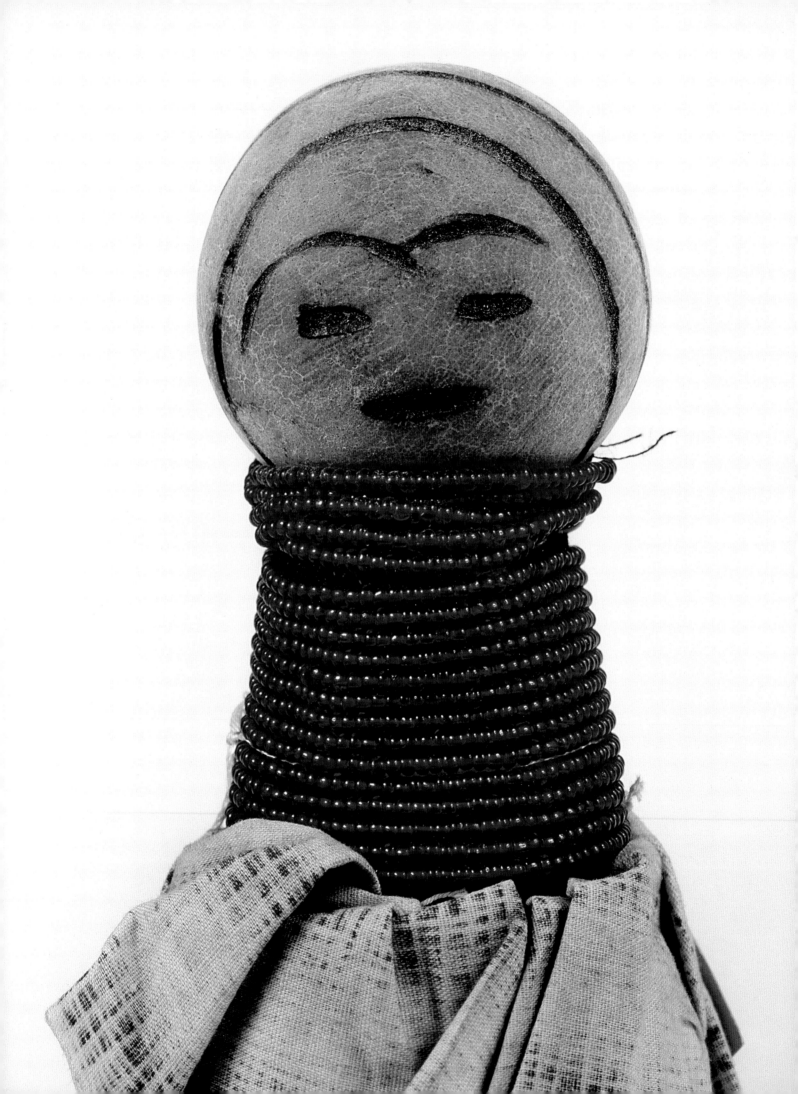

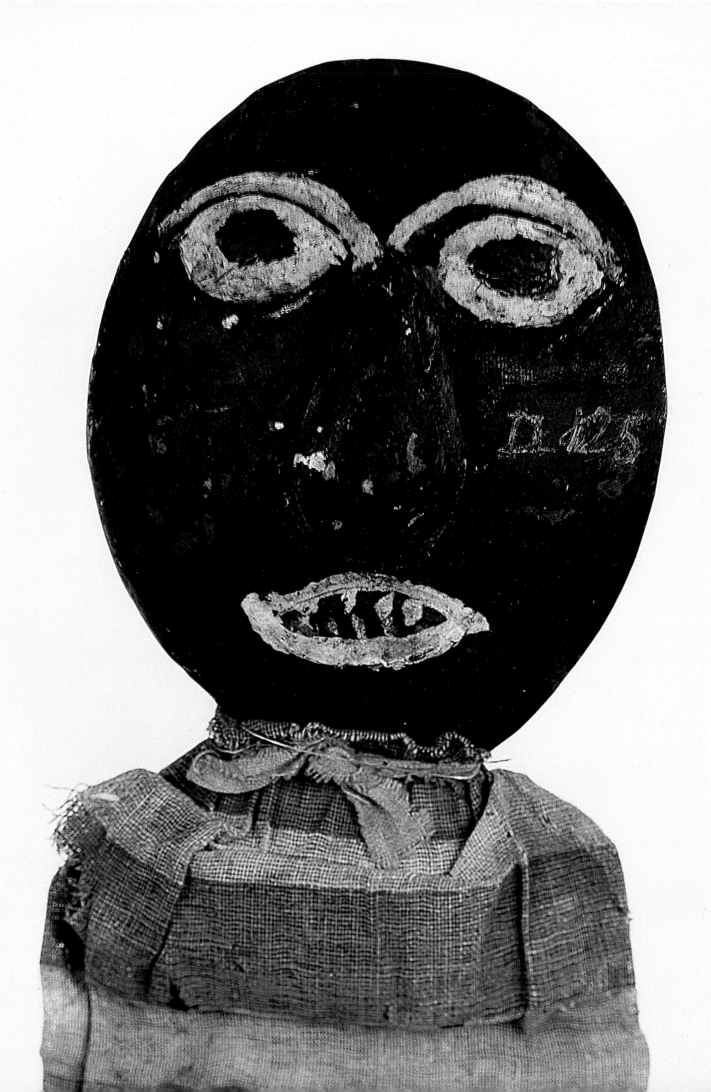

Mike Smith, *Piney Flats, Tennessee*, 1999

Community

Just as we can never outgrow our connectedness to the family, so all art, no matter how abstract, will have its roots in the story of the unfolding of life. I also realize now that my feelings and my concerns will always hold these same people in the heart of my unconscious mind. However, as one who backs away to see the world in a greater wholeness, the visage of that dear and familiar face, the loved one, diminishes to the infinite smallness of a speck. My task, and perhaps our task collectively, laying aside appearances, is to love that indiscernible point of life as the very being of our heart's desire, as imaginatively and vividly as if it were ourselves.

Emmet Gowin

Emmet Gowin, *Church, Mississippi*, 1969 (opposite)
Edward Weston, *William Edmondson, Sculptor, Nashville, Tennessee*, 1940 (above)

Lewis Hine, *Another "Dependent Father." Lyell, Columbus & Swift Mills, Columbus, Georgia*, 1913

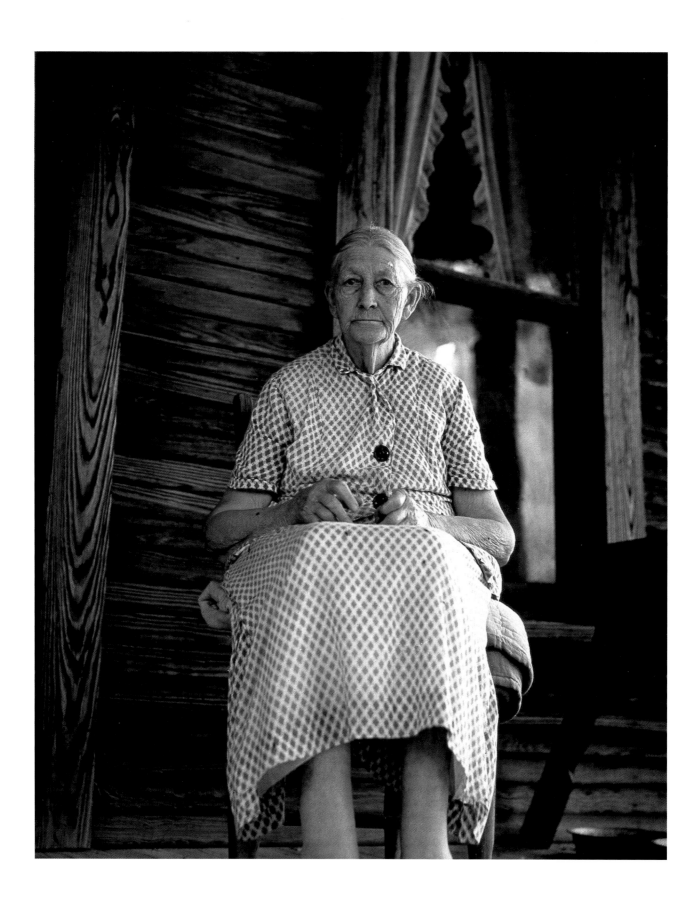

Dorothea Lange, *Ma Burnham, Conway, Arkansas*, 1938

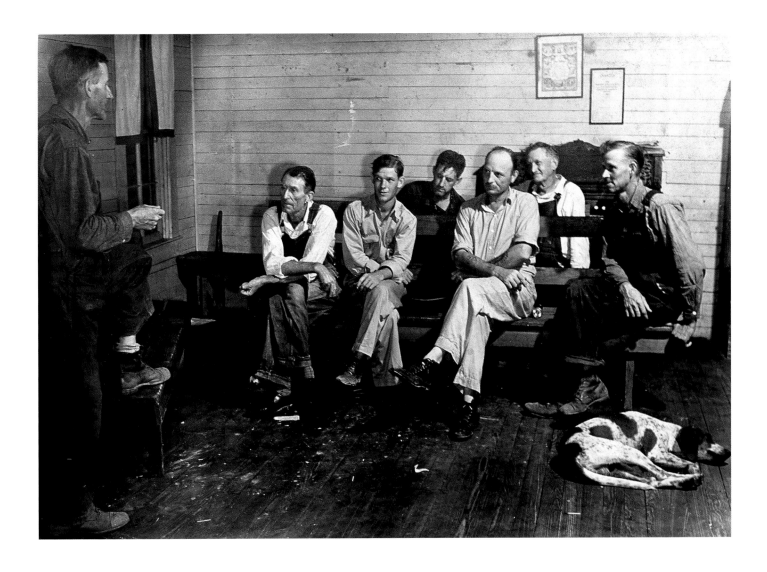

Sid Grossman, *Union Meeting, Arkansas*, 1940 (above)
Margaret Bourke-White, *Hood's Chapel, Georgia*, 1936 (opposite)

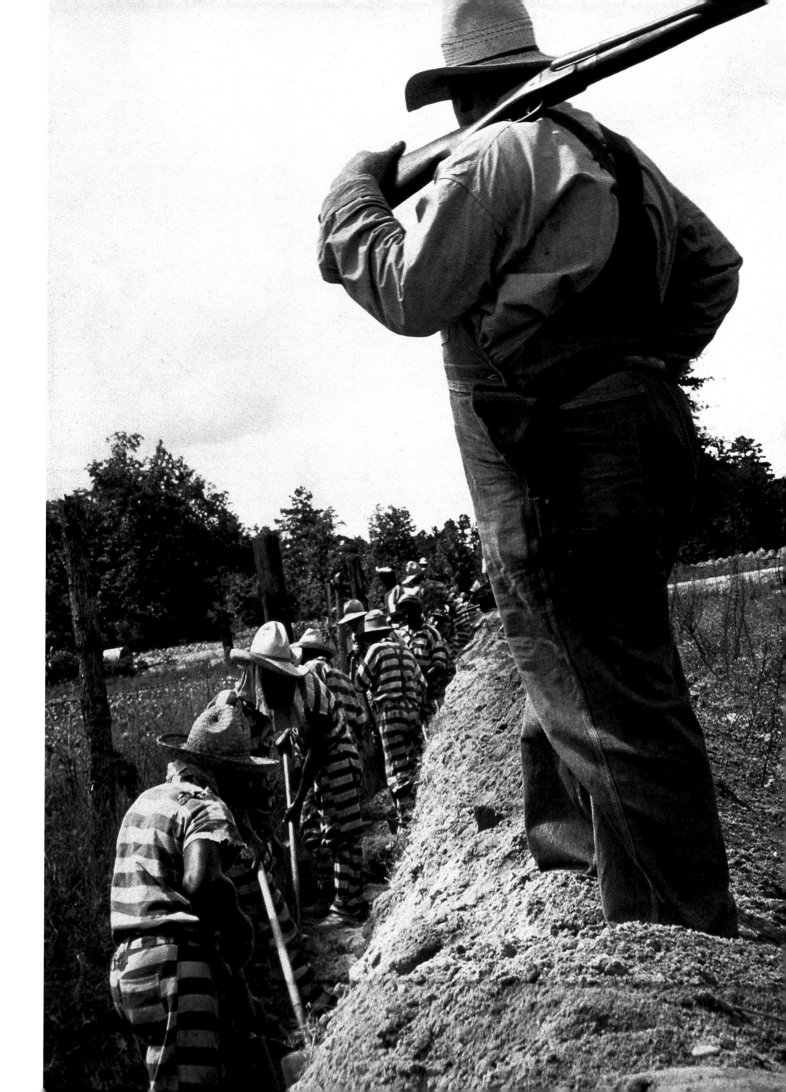

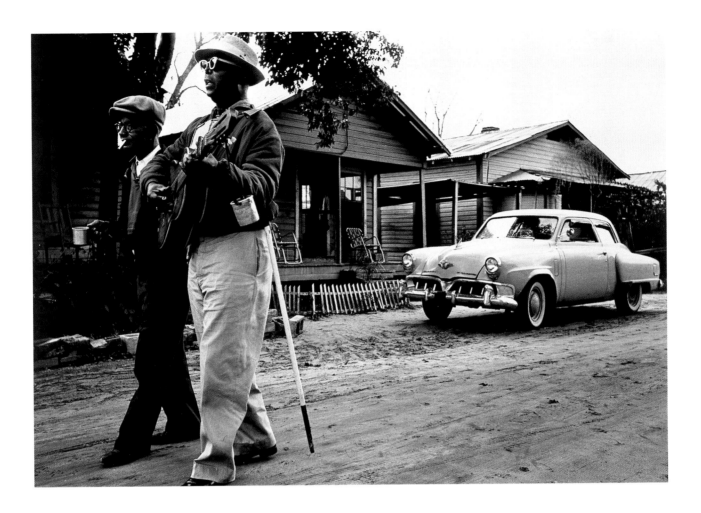

Jerry Uelsmann, *Untitled*, 1961

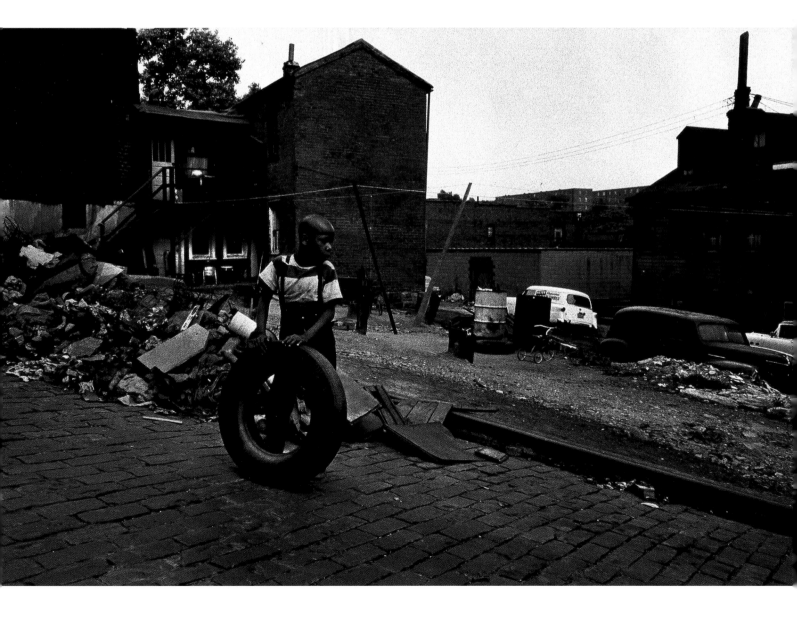

W. Eugene Smith, *Boy Rolling Tire, Pittsburgh*, c. 1956

Peter Sekaer, *Stable, Canton, Mississippi*, 1936

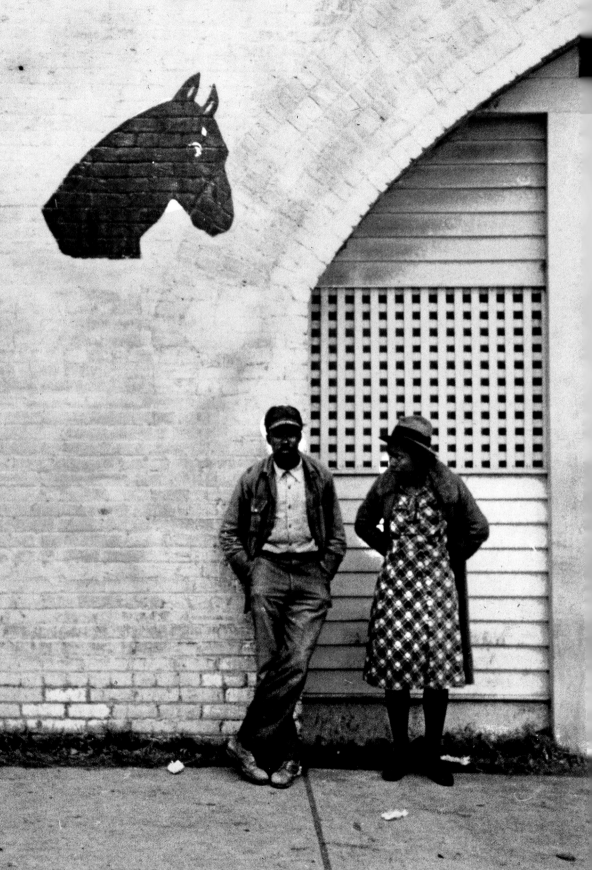

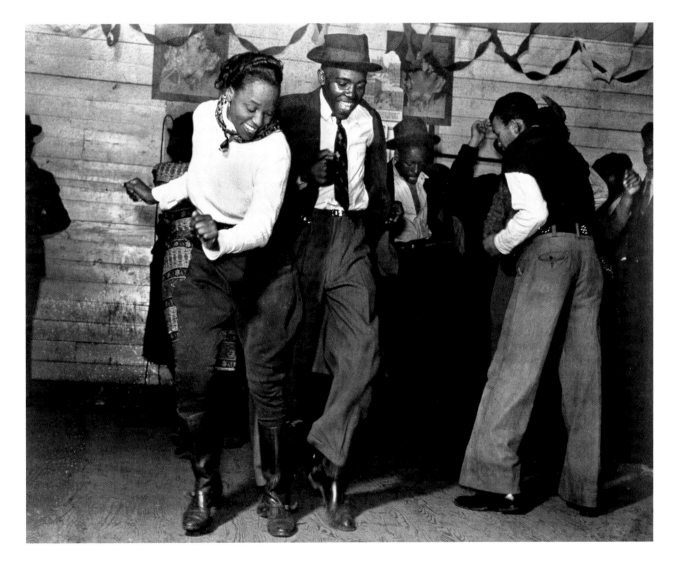

Marion Post Wolcott, *Jitterbugging on Saturday Night in a Juke Joint near Clarksdale, Mississippi*, 1939

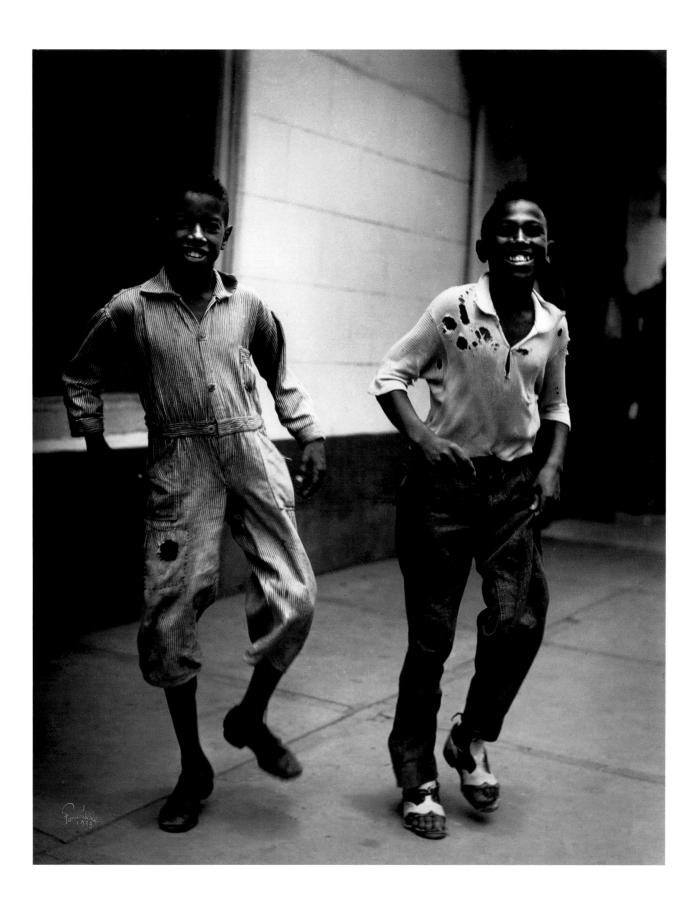

Fonville Winans, *Jig Dancers, New Orleans*, 1938

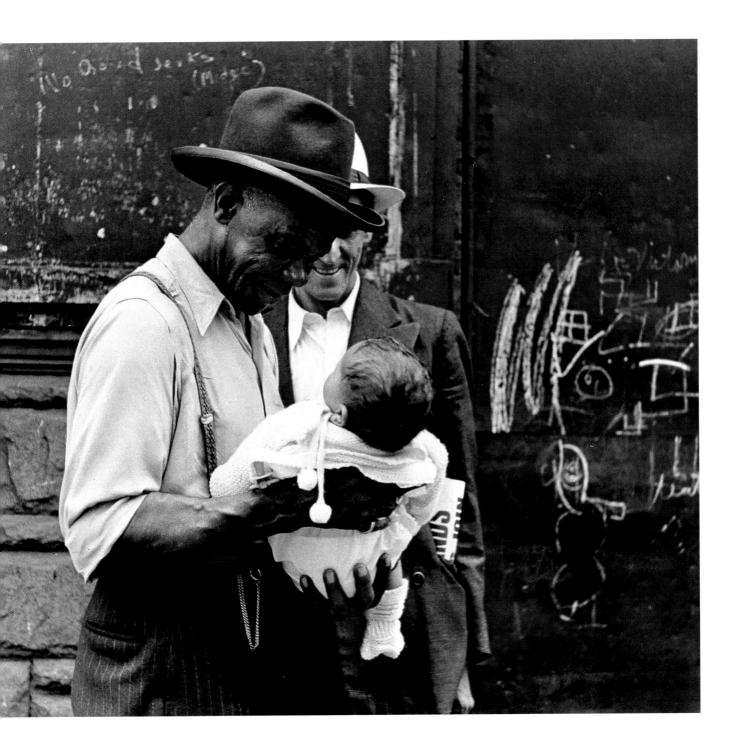

Helen Levitt, *New York, c.* 1940

Helen Levitt, *New York, c.* 1940

Chester Higgins Jr., *Lunchtime at Adele's*, 1975

Debbie Fleming Caffery, *KKK, Louisiana*, 2001 (above)
Jim Goldberg, *103 Degrees—Troy, Alabama*, 2002 (overleaf)

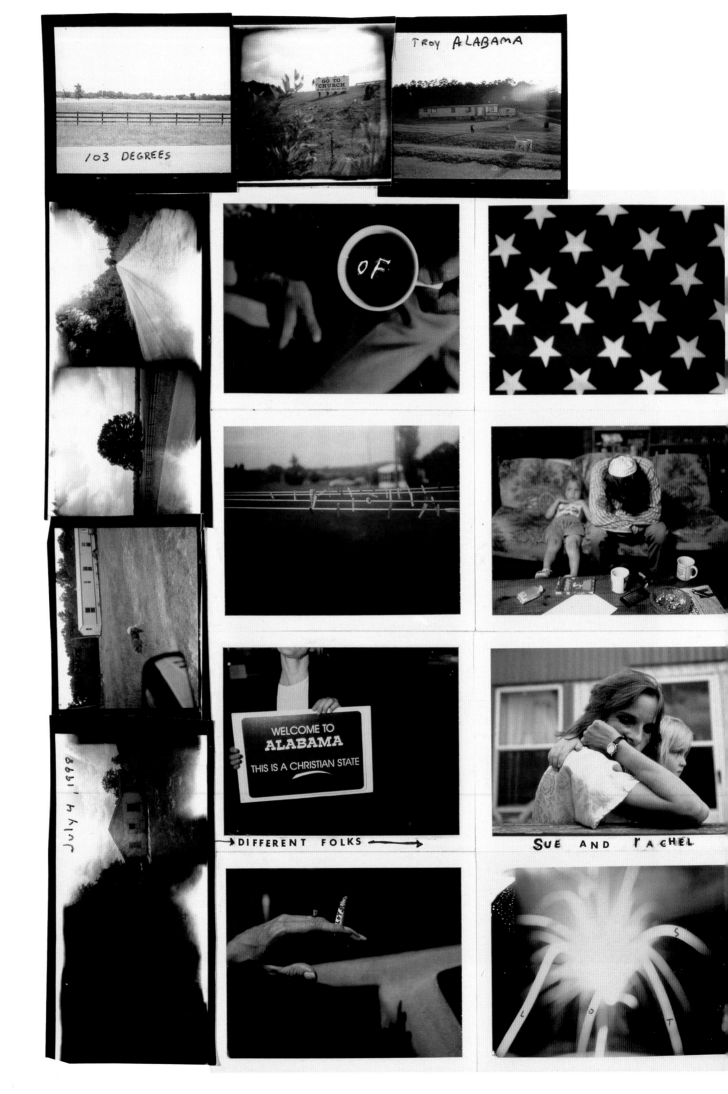

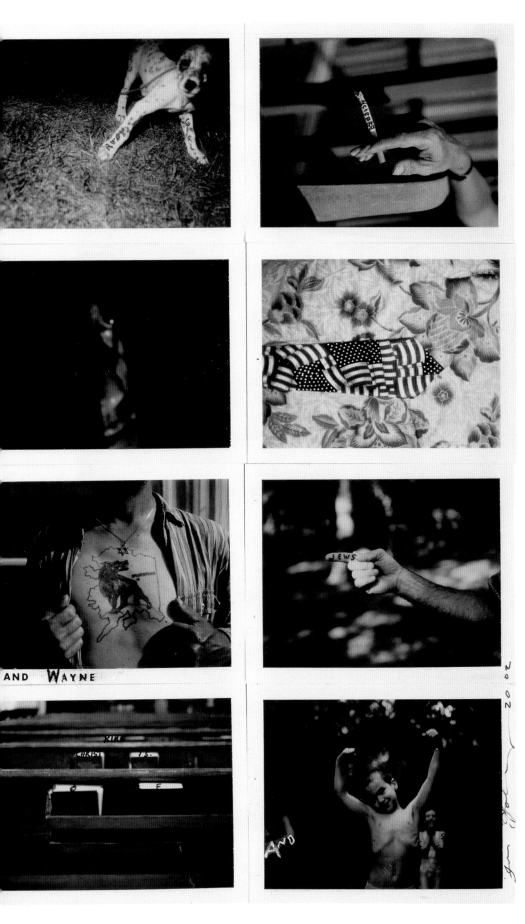

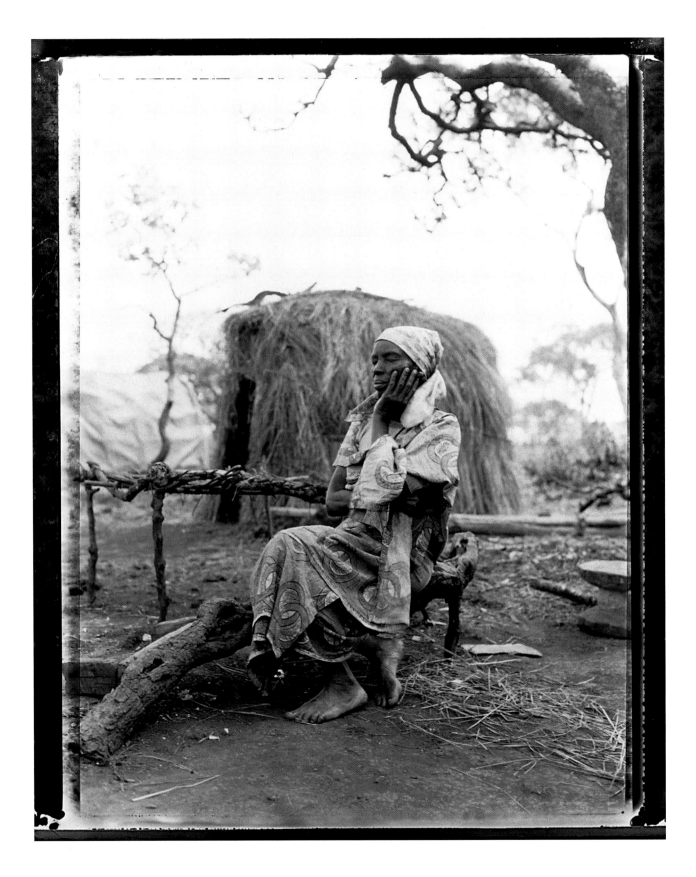

Fazal Sheikh, *Mama Nyiramugna, Rwandan Refugee Camp, Lumasi, Tanzania*, 1994

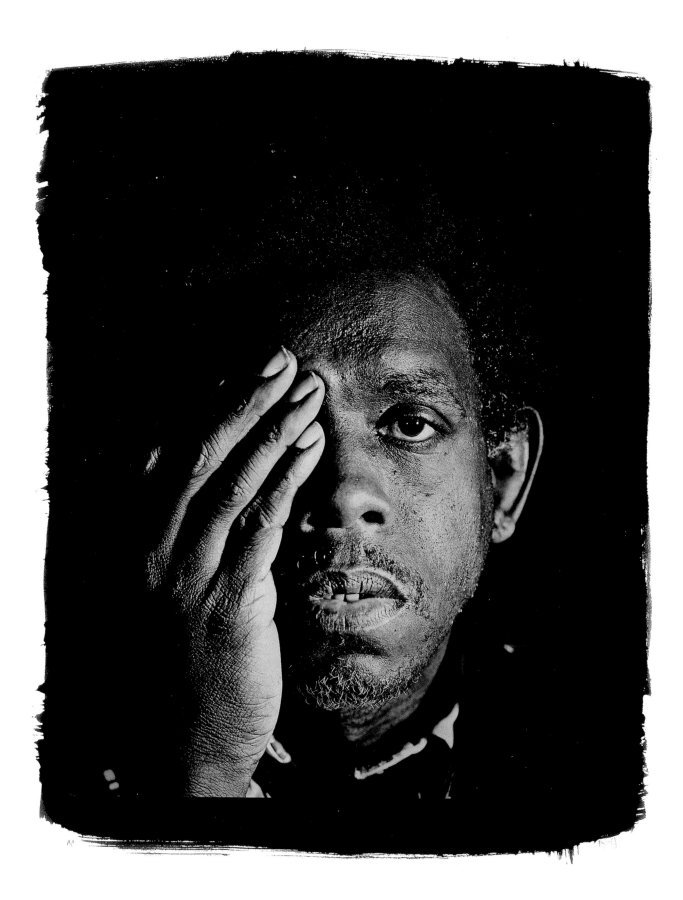

Rashid Johnson, *George*, 1999

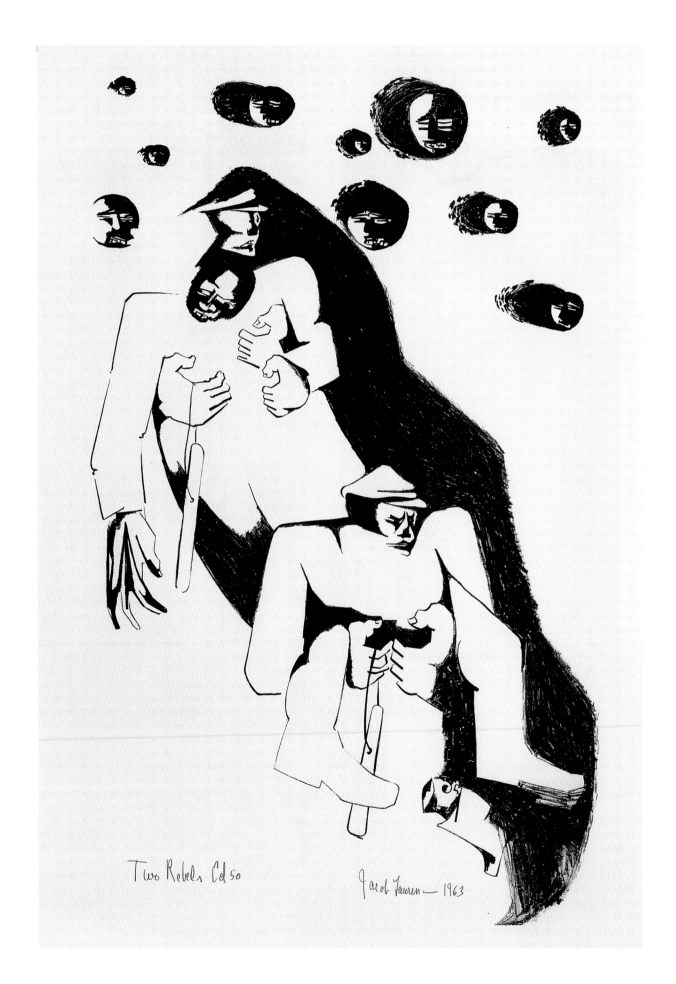

Jacob Lawrence, *Two Rebels*, 1963

Fred Wilson, *Untitled*, 2001

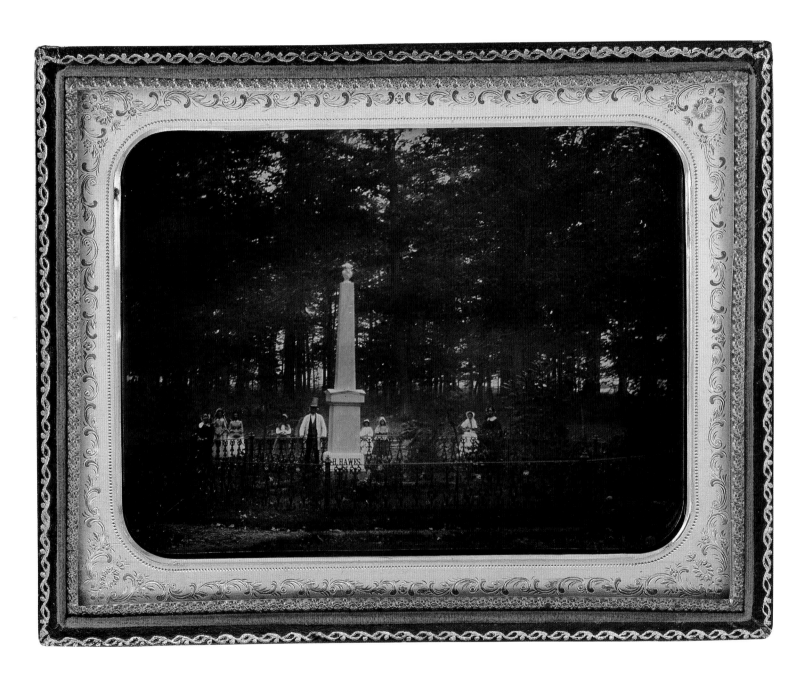

Unidentified photographer, *Untitled*, c. 1850

Selective Memory
Merry A. Foresta

In the fifteen years since photography's 150th anniversary, art historians have revitalized our way of looking at photographic images by reconsidering the medium's earliest moments.[1] Why, in the early twenty-first century, should we become so attracted to images from the nineteenth century?

Perhaps it is a matter of historical connoisseurship, as we rediscover the intrinsic beauty of daguerreotypes, tintypes, salt prints, and albumen prints, to name only a few of the processes of photography's childhood. Perhaps it is the discovery that these beautiful photographs were originally intended to be useful. Or perhaps our interest in an earlier photographic moment is an imaginative counter to the speed of our own rapidly advancing visual technology. (We need only consider the recent arrival of telephones with built-in cameras to confirm that photography's original contract between nature and its facsimile has been renegotiated.) The vast archives of the photographic past, which are now being made available to a wide audience through digital and electronic technologies, encourage us to re-experience the elemental sense of amazement and surprise that photographic seeing provoked in its inventors and early audiences. Few inventions have done as much to propel us into a new universe of visual perception.

The appeal of early photographic images is perhaps also due to the fact that they seem to defy time and death, showing us a past that we thought was forever entombed, accessible only through the veils of memory and imagination. At the same time, whether owing to the individual point of view of the photographer, gaps of information in the image itself, or the assumptions we bring as modern viewers, these early photographs often present ambiguities—between fact and interpretation, and between usefulness and beauty. This inherent ambiguity can also explain modern-day viewers' fascination with these images: the photographs present an opportunity to add our own narrative, or at the very least they encourage us to think more deeply about the stories and issues presented. This ambiguity also appeals to some contemporary photographers, who have chosen to re-enact the processes and appearance of nineteenth-century photography. Their pictures, considered side by side with their photographic points of origin, show that the very act of photographic representation is being freshly discovered.

Julia J. Norrell's continually evolving collection of modern and contemporary art is a case study in the interchange between photographic present and past. As a collector whose life regularly bridges the worlds of politics, business, and art, she has always treated aesthetic considerations and historical interpretations as having equal importance. Although the original focus of her collecting ambition was the South of her birth, some of her most recent acquisitions are photographs made within decades of the medium's mid-nineteenth-century invention. What could be called the common ground of her collection—the themes of civil rights, the redemptive spirit of creativity and imagination, and family and home—has in the past five years expanded to include history itself.

In her collection, Norrell gives particular emphasis to images such as those made by Walker Evans (cat. 48–52), Dorothea Lange (cat. 88), Russell Lee (cat. 91, 92), and others who worked for the Farm Security Administration in the South during the 1930s and 1940s. These images encourage viewers to look closely for motive rather than mere representation, thus yielding meanings that extend beyond illustration.[2] When many of these photographs were made in the 1930s, as the anxiety over the Depression deepened and the very meaning and identity of the country was questioned, there was a revival of interest in early American photography.[3] Art galleries showed daguerreotypes and critics wrote about their importance. In 1939 museums and scholars, celebrating the centennial anniversary of photography's invention, organized exhibitions of the history of photography and published catalogs. These studies offered modern photographers such as Evans a lesson in the power of simple and direct images. In this way, the social-documentary photographs that form the core of Norrell's collection are parallel to countless anonymous nineteenth-century pictures of everyday

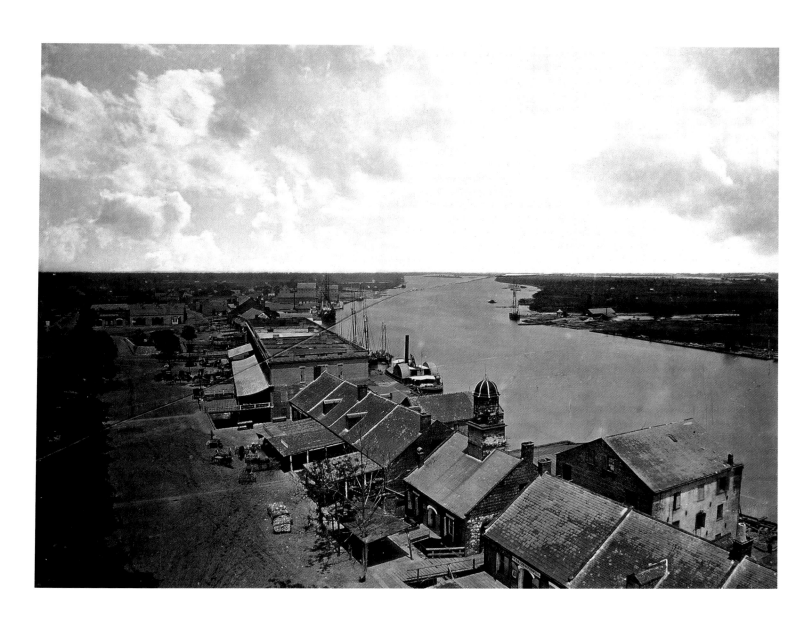

George Barnard, *Savannah, Georgia, No. 1*, 1866

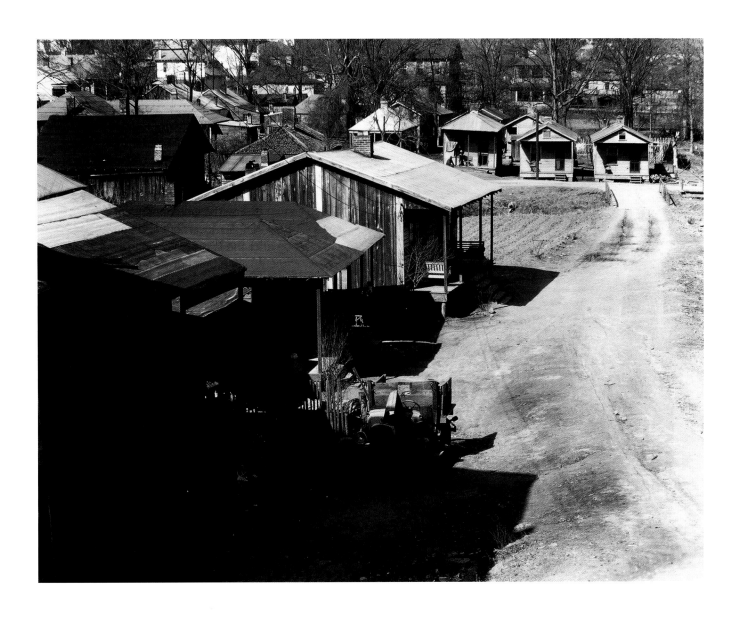

Walker Evans, *Scene from Negro Quarter, Atlanta, Georgia*, 1936

people and things. That is to say, both eras of photographs are filled with facts, but they also communicate the more abstract qualities of pride (of place and person), honesty, and truth.

The earliest image in the Norrell Collection is a daguerreotype as remarkable for its specificity as for its ambiguity (cat. 164; page 104). Because most photographers had abandoned the daguerreotype process by 1860, this is most likely a pre-Civil War image. We can suppose a great deal about its unusual subject, but we know very little for certain, except that the place, a rural family cemetery, was important enough to warrant a half-plate size photograph (a pre-1860 luxury item). The obelisk, by virtue of being most sharply in focus, would appear to be the primary object of attention. We can only guess at the relationship between "Hawes," whose name is carved on the obelisk, and the tall black man who stands by the sculpture or the clusters of women who gather outside the cemetery fence. Are they family or friends, servants or slaves? Perhaps this picture would later serve the Hawes descendents as a reminder of their origins or even as a meditation on death and rebirth. Or, depending on who commissioned the photographer, the image could have served the descendents of the undertaker or memorial maker.

As this image shows, the retrieval of memory through photographs is no easy task. Photographs are more slippery and less literal than we might imagine. They are not simply containers of history, but also vessels of historical imagination. As cultural historians such as Alan Trachtenberg have discussed, these nineteenth-century images have become "tokens of a relation between then and now."[4] Photographs, and especially those that are irresistible as aesthetic objects, change over time in ways that make them at once unreliable as evidence and rich with complex meanings. They gain value for other or additional reasons than those that occasioned their making.

It is difficult to grasp the ways in which Civil War photographs were viewed and appreciated in their own time. When George Barnard photographed Savannah, Georgia, in the spring of 1866 (cat. 10; page 106), the Civil War had been over for nearly a year. His expansive view from Savannah's central cupola describes both the town's geographic location at a wide, deep bend in the river and—as the ships, warehouses, and wagons full of cotton attest—the strategic importance of the city as a port. The clouds, picturesquely added from a second negative, are a clue to Barnard's desire to make a photograph of both aesthetic and historical consequence. The photographer included it, along with sixty other

images, in the album *Photographic Views of Sherman's Campaign* (1866).[5] The album contains an unusual variety of subjects, including scarred battlefields, ruined buildings, scenic landscapes, and a variety of bridges, trenches, and forts. Unlike many of his images that depict the war's damage to the natural landscape, Barnard's view of Savannah all but banishes the war from sight.

Barnard's view also eliminates any human activity. There are no people on the streets, no hands loading cotton on to the docks, no sailors on the ships. This apparent lack of activity can be explained by the fact that Barnard made the photograph to illustrate an event that had taken place two years earlier. The photographer, minus his camera, had been with General William T. Sherman on the morning in 1864 when the Union army had marched into the city. To the surprise of both general and army, Savannah had been abandoned by its defenders and inhabitants the night before. The later picture was a measured calculation of that day, and it was dependent on an exposure so slow that all movement and activity vanished. Made after the fact of Savannah's vacancy, it is a re-enactment with a point of view calculated to inspire a sense of dislocation: not only of the population of Savannah, but also of the viewer, then and now. Over and above his rendering of historic sites, in this picture Barnard presents a complex meditation on history, memory, and aesthetics founded upon a melancholy sense of time and cataclysmic destruction.

Barnard's subtle and immensely sophisticated album drew particular strength from its synthesis of typically American themes: the freedom and sacred beauty of the natural landscape, the ennobling subject of human enterprise, and the troubling moral ambiguity revealed in a layering of historical incident. These themes were revisited when Barnard and other war photographers like him journeyed west after the Civil War to work on the various geological surveys sponsored by the government. Besides laying claim to the view, in many cases they produced photographs that emphasized the act of looking itself. Timothy O'Sullivan's *Bluff Opposite Big Horn Camp, Black Cañon, Colorado River* (cat. 124; page 4) includes the small, flat-bottomed boat (aptly christened *The Picture*) that served the photographer as both transportation and darkroom. Beyond indicating human scale and presence, the boat reminds us of the distance between the picture and the motivation to make the picture—the distance between real experience and the picture that represents it.

John K. Hillers's photograph of an archaeological site near Fort Wingate, New Mexico (cat. 78; page 22),

Seneca Ray Stoddard, *Music Hath Charms*, c. 1890

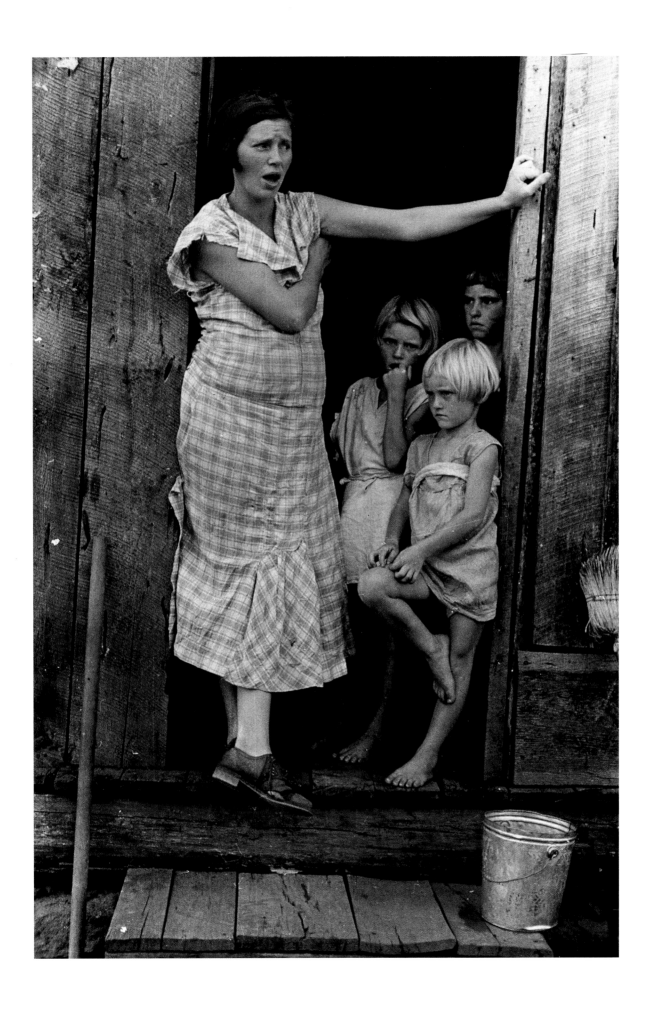

Arthur Rothstein, *Sharecropper's Wife and Children, Arkansas*, 1935 (opposite)
Russell Lee, *Child of Negro Sharecropper Looking out Window of Cabin Home. There is a Great Deal of Malaria in this Section, Bad and No Screening Being a Contributing Cause. Near Marshall, Texas*, 1939 (above)

taken in about 1880, contrasts the details of place with the more abstract idea of history. As the staff photographer for the newly formed United States Bureau of Ethnography, his task was to picture domestic structures that predate the arrival of European explorers. The image is about architecture and human occupation. By contrast, Laura Gilpin's early twentieth-century photographs surveyed the altered terrain of a western landscape that faced modern-day intrusions. Her artfully composed landscapes of places such as the cliff dwellings of Mesa Verde (cat. 61; page 23) or the temples of Chichén Itzá (cat. 62) show the remains of cultures that cleared land, built mysterious structures and monuments, and then, for reasons that are only partly understood, disappeared. Her softly focused images, compared with Hillers's closer, more detailed view, are less about architecture and more about emotional presence. Similarly, her portraits of native people (cat. 63; page 24) bear uneasy witness to more modern-day cultural loss. Hillers (and O'Sullivan) and Gilpin are flip sides of the same coin. Hillers made a useful picture and we now find it beautiful. Gilpin's beautiful images are also useful, even if the information they reveal is framed as an emotional, rather than indexical, response.

Such an exchange between beauty and purpose is seen even more clearly in the contemporary landscapes of Sally Mann. Better known for portraits of her family and particularly of her three children in the rural Virginia countryside, where she lives, her work has turned recently from innocence to experience. Her subject is now landscapes of the South, particularly those places, such as Civil War battlefields or sites of racial terrorism, where great violence occurred. One such place is the bank of the Tallahatchie River, where the beaten body of Emmett Till was found (cat. 105; page 113). Like Barnard's Savannah, Mann's landscape serves a particular purpose: a re-enactment of an event for which no photograph was taken.

To give her pictures resonance, and to distance us from their disturbing content, Mann has used hand-coated glass plates as her negatives, in the manner of nineteenth-century photographers. The results are often penumbral and dappled, like the liminal experiences sought after by the Transcendentalists. Twilight, dreams, daydreaming, melancholy, premonitions—her re-enactments are not fuzzings, but rather intensifications of knowledge. They operate at the margins of optical attention and exist in a charged world midway between subjective human consciousness and nature's reality. Unlike Barnard's photograph, Mann's image is not a replica of an historical past, but rather an evocation of it.

A contemporary view of the past is alternatively burdened and enlightened by a retrospective knowledge of the history between then and now. For example, Deborah Luster's spare portraits of prison inmates in Louisiana (cat. 100; page 44), printed on palm-size metal plates, recall the immensely popular tintypes from the Civil War. Soldiers taking leave of their loved ones made certain they left behind tintypes as keepsakes, and their loved ones reciprocated by mailing images of themselves to the frontlines. Made in the hundreds of thousands, these low-cost portraits of the common man and woman created a democracy of images that transcended the limits of time and space. Luster, setting up a plain studio in the prison, photographed inmates in various costumes or holding simple props of their choosing. These portraits of long-term prisoners are equally immediate and timeless, historic and contemporary. They are keepsakes for the sitters. Cataloged and presented to us in a dark cabinet, they are a record of unfinished lives.

In these images, Luster allows viewers to experience rare moments beyond the documentary fact of a maximum-security prison. In so doing, she addresses the nature and language of imaging as an appropriate and authentic experience. Her images illustrate how pictures work and keep us engaged. They also raise questions: Why do images have such power? Why are we seduced by images? How do images work as information? How is that information communicated? Like the study of history, Luster seems to say, the camera is a tool for making the past meaningful for the present and useful for the future.

Notes

1. Beginning with sesquicentennial exhibitions in 1989 that concentrated on photographs from the nineteenth century and the early decades of the twentieth century, the importance of photography's earliest moments has grown to include a sizeable bibliography. Among recent histories, see: *Photography in Nineteenth-Century America*, exhib. cat. by Alan Trachtenberg *et al.*, ed. Martha A. Sandweiss, Fort Worth TX, Amon Carter Museum, 1991; *The Waking Dream: Photography's First Century*, exhib. cat. by Maria Morris Hambourg *et al.*, New York, Metropolitan Museum of Art, 1993; *Secrets of the Dark Chamber: The Art of the American Daguerreotype*, exhib. cat. by Merry A. Foresta and John Wood, Washington D.C., Smithsonian American Art Museum, 1995; and *An American Century of Photography: From Dry-Plate to Digital*, exhib. cat. by Keith F. Davis, New York, Hallmark Photographic Collection, 1995.

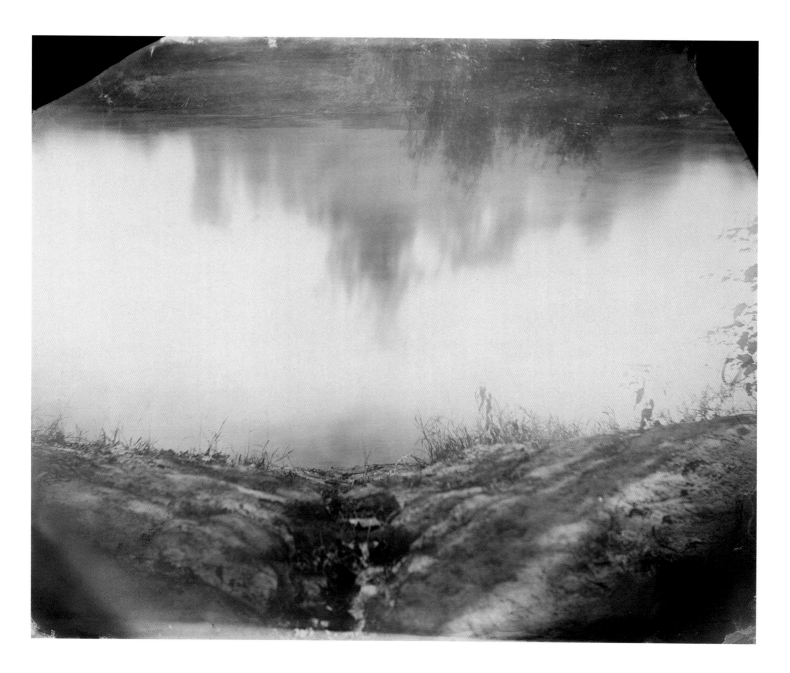

2. See *Myth, Memory and Imagination: Universal Themes in the Life and Culture of the South, Selections from the Collection of Julia J. Norwell*, exhib. cat. by Jay Williams *et al.*, Columbia SC, McKissick Museum, University of South Carolina, 1999. This catalog accompanied an exhibition of 273 works in all media organized by the McKissick Museum.

3. In 1933 a series of eleven Civil War photographs appeared in the October–December issue of Lincoln Kirsten's influential avant-garde journal, *Hound & Horn*, accompanied by an essay by Charles Flato entitled "Mathew B. Brady, 1823–1896." Two years later, the important dealer Julian Levy opened his New York gallery with an exhibition of daguerreotypes and Surrealist photography. In 1938 the Museum of Modern Art organized the first exhibition in the United States devoted to the art of photography.

4. Alan Trachtenberg, *Reading American Photographs: Images as History: Mathew Brady to Walker Evans*, New York (Hill and Wang) 1989, p. 6.

5. *Photographic Views of Sherman's Campaign Embracing Scenes of the Occupation of Nashville* was first published in 1866 in an edition of one hundred copies. It included sixty-one photographs, a small volume of historical text (printed by letterpress), and several official campaign maps. The luxury item weighed an impressive twenty pounds (nine kilograms) and sold for $100.

Sally Mann, *Untitled*, 1998

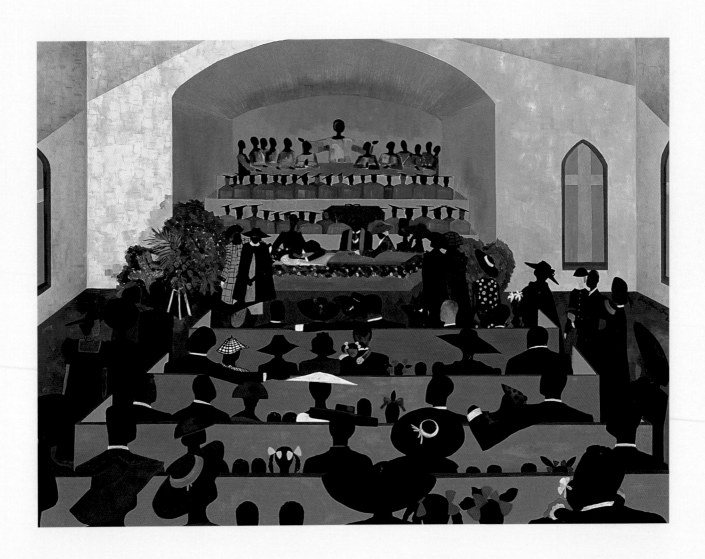

Jonathan Green, *The Passing of Eloise*, 1988

Hope and Belief

My father once said to me, "I go to church and I hear the preacher on Sunday speak about brotherly love, love thy neighbor as thy self, and the rest of the week all hell is breaking loose." The only way I could attempt to say anything, to do anything, was through my work…. I still feel to this day that it's the substance derived from that landscape, the feel of that landscape that I grew up in, that I want my work to be about. It's the feel of the place and the things in the landscape, the actual earth that nourishes our roots.

William Christenberry

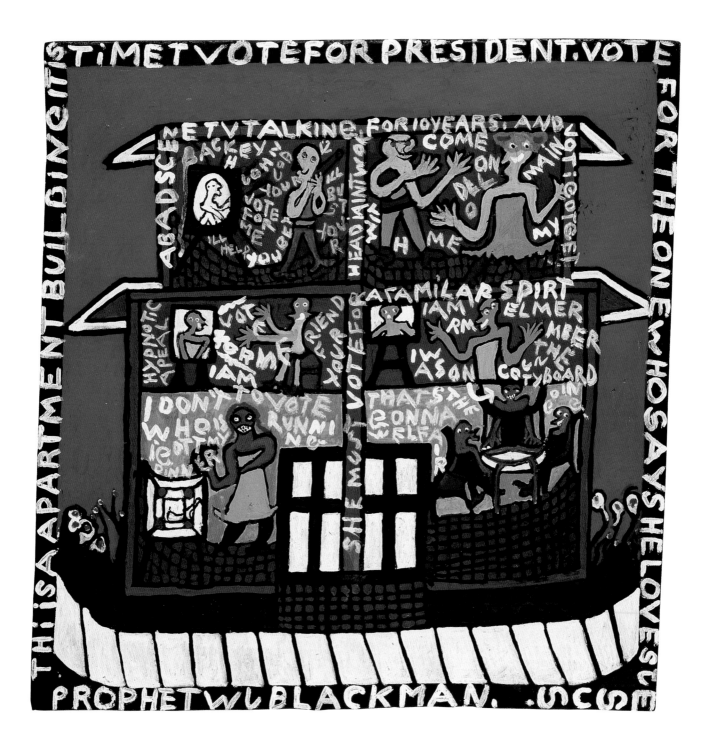

"Prophet" William J. Blackmon, *Vote for President*, n.d.

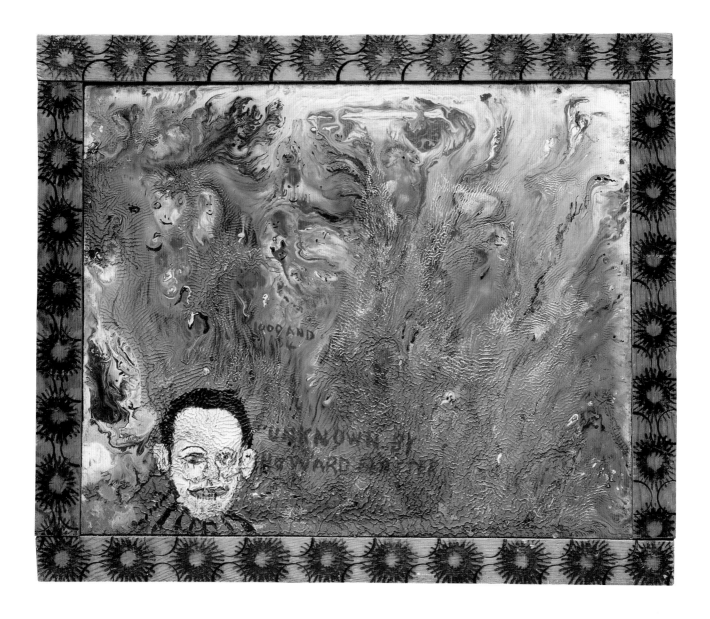

Howard Finster, *1000 and 184*, 1978

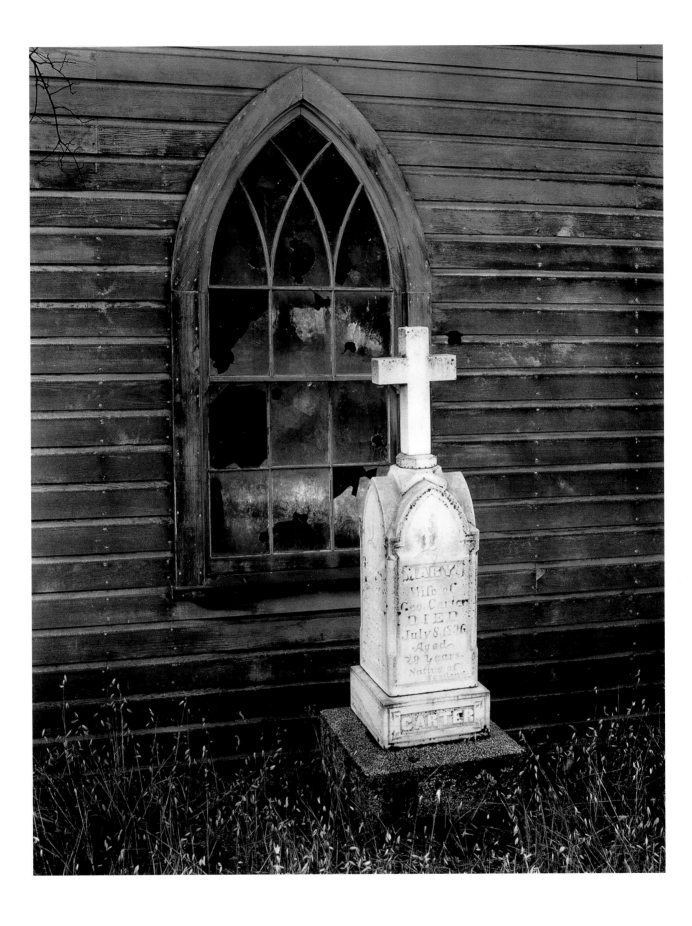

Willard Van Dyke, *Angels Camp*, 1933

William Clift, *Prayer Place, Hoboken, New Jersey,* 1964

John Gutmann, *Convent, New Orleans*, 1936 (opposite)
Brassaï (Gyula Halász), *Messe de minuit aux Baux-de-Provence*, 1950 (above)

Ralph Eugene Meatyard, *Untitled*, n.d. (opposite)
Linda Connor, *Religious Effigies, Banaras, India*, 1979 (above)

Addison Scurlock, *Baptism, Washington D.C.*, 1932

Scurlock Photo Sept. 18 1932

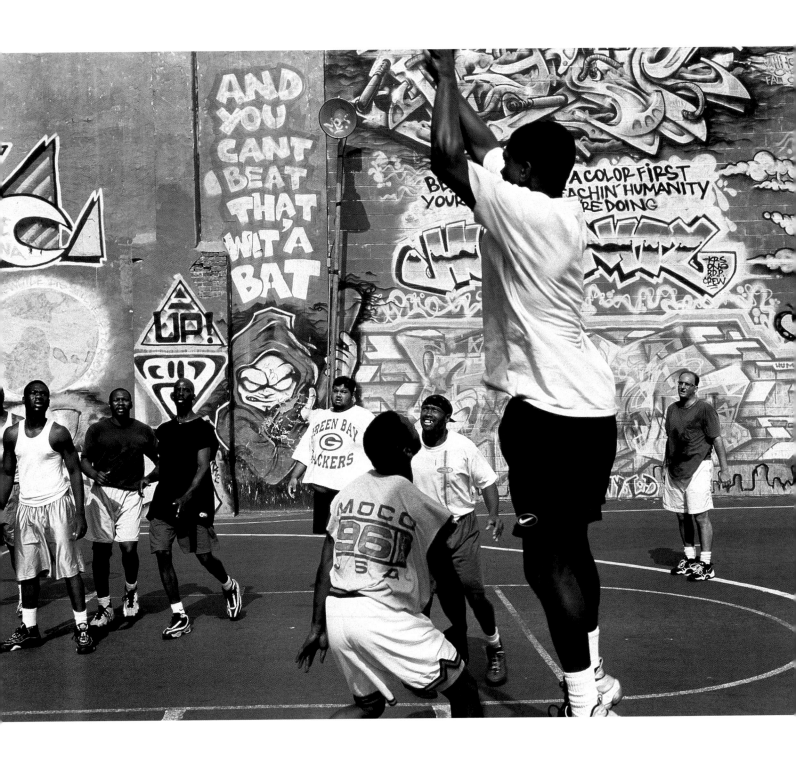

Brad Richman, *Washington D.C.*, 1999

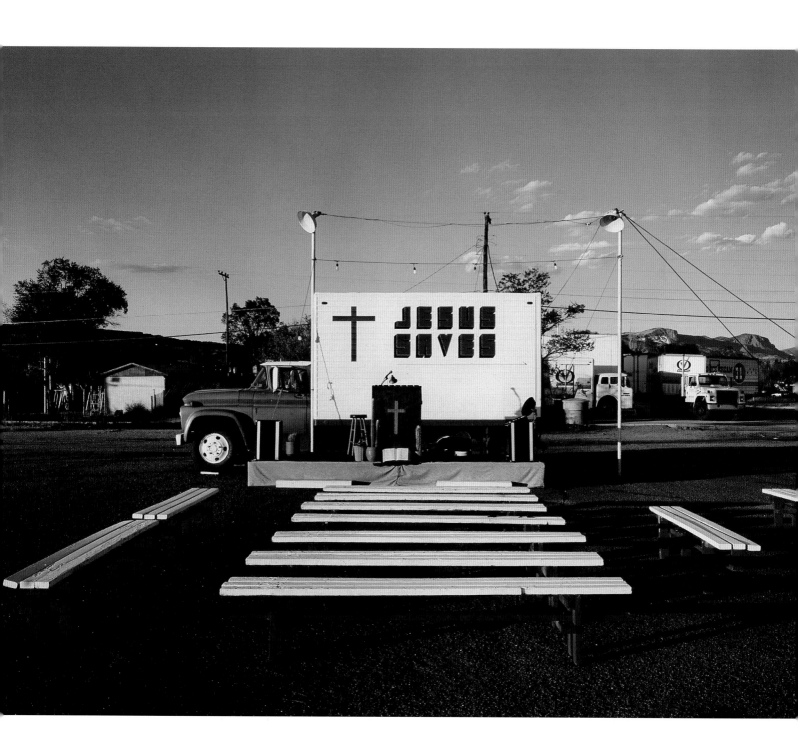

David Graham, *Jesus Saves, Grants, New Mexico*, 1989

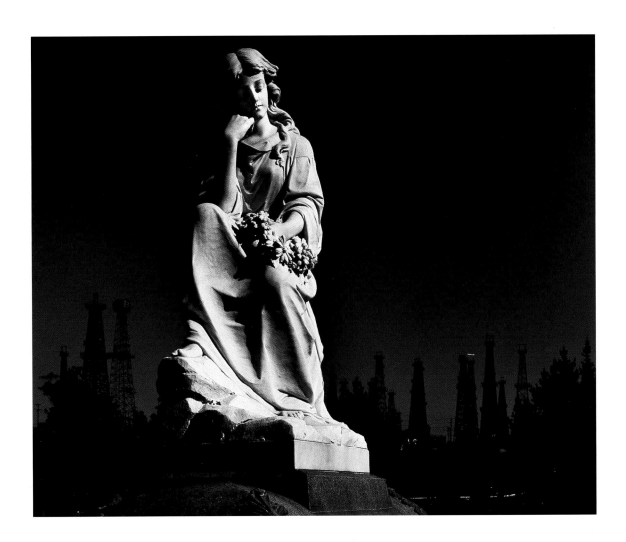

Ansel Adams, *Cemetery Statue and Derricks, Long Beach, California*, 1939

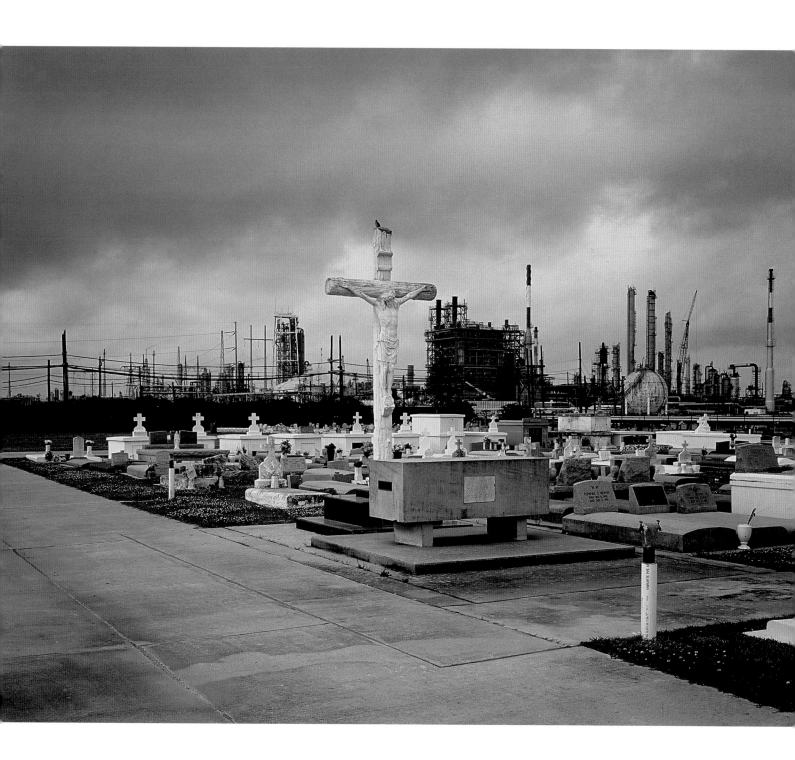

Richard Misrach, *Crucifix, Holy Rosary Cemetery, Taft, Louisiana*, 1998

Dana Salvo, *Altar with Cats*, 1987 (previous pages)
Donald Woodman, *Eyeglass Case at Auschwitz*, 1987 (above)

Jeffrey Wolin, *Moses Wloski, Born 1921, Wolkowisk, White Russia*, 1992–94

William Christenberry, *K House*, 1996

William H. Clarke, *Midnight*, 2000

Edward Grazda, *Mazar i Sharif, Afghanistan*, 1997

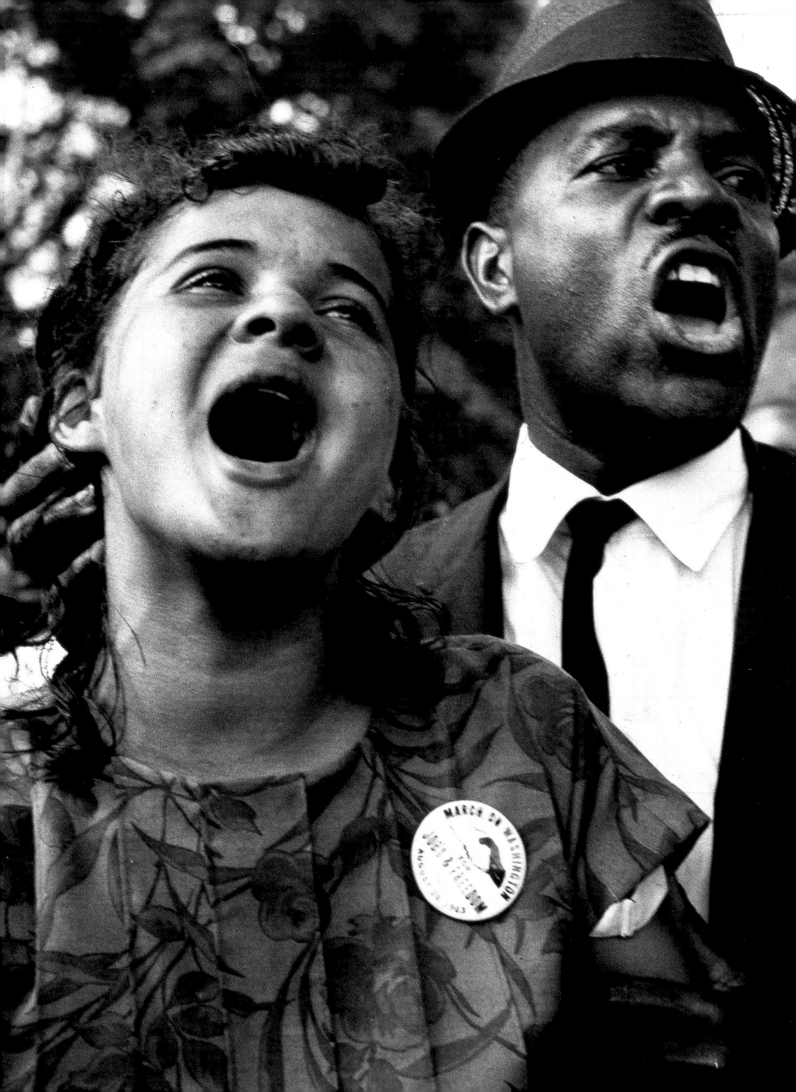

Keeper of Dreams
Paul Roth

Art collectors are the keepers of other people's dreams. As such they possess things rare and precious, objects that are physical manifestations of society's visions, wonderings, goals, and fears. While many in the wider world are unaware that such an activity as art collecting takes place, in the ecosystem of the art world, serious collectors are perhaps the most crucial species other than the artist-dreamers themselves. Without their passionate attention, art might go unfound, unnoted, unsung, and unwanted. Without their fervent belief in the necessity and utility of art, our visual artifacts might have no value whatsoever as a commodity. For the most serious among them, the need for art is like a constant thirst. To those who share this thirst (such as curators, historians, other artists, and fellow art lovers) but lack the means, vision, or energy to acquire art, the collector often leads the way, like a guide in search of fresh water in a remote and hidden oasis.

Art collectors are as varied and independent as one can imagine. Collecting is an avocation rather than a profession; but, for the most serious practitioners, the process of acquiring art is nevertheless a primary enterprise. It is an expression of his or her very identity, a matter nearly as serious as breathing. It is an intensive and ongoing activity, each acquisition the result of countless hours of seeking, looking, learning, judging, and the purposeful exercise of myriad personal and professional relationships; and each new find sparks the next cycle of those same elements, leading in a loop, like a Möbius strip, on to another prize, and the next one, and so on.

For Julia J. Norrell ("Judy" to those who know her), the unfolding hours spent collecting art, and her many interactions with artists, dealers, curators, and audiences, are key elements of her life. She regards these connections as a great privilege. Building a collection, she has said, is both a social and a creative act, an extension out into the world and a movement inward to one's own thoughts. And though she often speaks of it in personal terms, as the sum result of her interests, education, and relationships, Judy Norrell's collection is as notable for its humane and spiritual

dimensions as it is for the quality of its aesthetics. Both specific in its interests and sweeping in its scope, Norrell's collection originates in the American South of her childhood and follows what she terms "the dilemmas of my southern-ness" out to the wider world.

The daughter of two dedicated public servants (her mother and father were both Members of Congress), Norrell was reared in the post-Depression era, shuttling in her parents' wake between southeastern Arkansas and Washington D.C. She first became a collector as a child, gathering an extensive array of matchbooks. Using a Bolsey 35 mm camera, she also collected memories by photographing scenes from the saddle of her horse as she explored back roads during her father's frequent visits to his constituency in the Sixth Congressional District. She now recalls how viewing those pictures kept her rooted during her more lengthy stays in Washington. At the age of fourteen she acquired two woodcuts during a trip to the Ozarks. Meanwhile, she haunted the National Gallery of Art, The Phillips Collection, and the Corcoran Gallery of Art, honing an appreciation for art in her adopted home city. Norrell dates her first purposeful art acquisition later, to her early twenties, when she fell in love with a Cuban abstract painting and asked her father to buy it for her. He refused, saying that he would subsidize her education but never anything as frivolous as art. Surprised and defiant, Norrell went out and found her first job so that she could pay for the painting—which she still owns.

Eager to declare independence from her parents' political world in Washington and from the social discontents of what she calls "the traditional South," Norrell attended college at Ohio Wesleyan University in Delaware, Ohio, summered in Europe to learn art history, and studied philosophy at the University of Madras in India on a Fulbright Fellowship. Upon her return to Washington, she enrolled in law school at George Washington University, attended to her father's ill health, and began her first serious collection: fine first editions of books. Norrell was especially interested in southern fiction, and beginning in 1961 she sought scarce editions by William Faulkner,

Flannery O'Conner, Walker Percy, Eudora Welty, Tennessee Williams, and Thomas Wolfe. The work of these writers often reflected her experience of growing up in the South as they questioned hypocrisy and evoked both the beauty and the discontents of a changing culture.

As Norrell became more focused on her collecting, she often arranged her travels around the pursuit of particular titles. One journey led her to Oxford, Mississippi, where she searched for the rare and coveted first edition of Faulkner's first book, *The Marble Faun* (1924). Norrell fondly recalls each detail of the search, the discovery, and the negotiation for a purchase that had appreciated well beyond the original cover price of one nickel.

Norrell's travels around the Deep South in search of books reawakened her interest in her Arkansas roots, and she renewed her childhood habit of photographing scenes of her home state. She also began acquiring folk art that carried the spirit of the region, and later she began to collect photographs that depicted rural Arkansas and other southern states as she remembered them from her childhood. These paintings, objects, and photographs, combined with her first acquisition of pictures by Walker Evans and other photographers working under the aegis of the Roosevelt-era Farm Security Administration, marked a pathway home for her. Filled with ideas and recognitions, this burgeoning collection of art gave Norrell access to her past, allowing her to reconnect with many of the important issues that have defined the region and, by extension, her own life. In transit again between Washington and the South—but older now—she was able to revisit the quandaries that had occasioned her earlier flight for independence, this time through art.

A 1997 exhibition at The Phillips Collection in Washington called *Spirits of the South* marked a watershed for Norrell. Curator Elizabeth Hutton Turner selected and arranged twenty-eight of Norrell's photographs, using a museum exhibition to animate many of the themes common to her collection. Racial conflict and the civil rights movement, poverty, religious ritual and practice, and ideas of home, love of land, family, and community were all addressed as concomitants of southern life. Though she had previously lent artworks to museum exhibitions, Norrell says that before then she did not think of herself as a collector *per se*. Watching visitors during her several trips to The Phillips Collection galleries and seeing their reactions to significant juxtapositions, she felt for the first time that a collection of images organized around themes of the American South could constitute a major

intellectual and emotional inquiry. Never one to think of herself as a "tastemaker," one who only seeks out an artist's best-known work, or one who is a crusader for a certain style or movement, Norrell redoubled her efforts to define her collection by its themes and to pursue aggressively examples that would strengthen the whole. She began to consider how these themes resonate outside the region of her childhood, following the ideas beyond the geographical boundaries of the South. She also began to think of the collection as a legacy, demonstrating how artists consider human values such as justice, mercy, and love.

Including nearly 1500 objects at the time of this writing, and growing all the time, Norrell's art collection is the product less of an acquisitive drive than of her omnivorous curiosity. She searches with fervor for new ideas, driving down back roads, attending art fairs, and visiting galleries, private dealers, and artists' studios. She maintains working relationships with many curators, keeping up several ongoing dialogues about artists, artworks, and history. Much of her collection is contemporary, and she is particularly excited by the lasting friendships that have evolved with some of the artists whose work she owns. For Norrell, collecting art is the sum of all these activities; and though she often calls the process a respite from her daily life, increasingly collecting is what matters to her most.

Norrell's row house in Washington and farm in Virginia are filled with pictures and sculptures, the walls and staircases hung floor to ceiling with images of faces, homes, townscapes, churches, cemeteries, horses, landscapes, labor, dancing, and worship. Her holdings include art from different periods and disparate media, and Norrell does not discriminate between traditional categories of folk art, so-called "high art," and artifacts of social life such as nineteenth century commercial photographic portraiture. Her collection oscillates between art that is socially conscious and art that is primarily aesthetic. Yet each theme, medium, and artist is as important to her vision as the others and many works straddle the categorical divisions. Everywhere one can find food for the imagination, and her homes have become aesthetic laboratories where ideas are constantly in the air. She often shows visitors her latest finds, and watches with satisfaction as they consider and discuss one piece and then another.

Norrell knows well each piece in her collection and can discuss in detail the era and subject depicted, even the period of its acquisition. Each work has come to seem like a part of her, and though she often lends to exhibitions, she feels a sense of acute loss

Roy DeCarava, *This Site, New York*, 1963

when the pieces are removed from her home. When the McKissick Museum at the University of South Carolina toured an exhibition of more than 275 works beginning in 2000, she experienced what she calls only half-jokingly "major depression." In the first few days, looking at her bare walls, she imagined the future final dispersion of the collection, tasting her mortality through the fate of her artworks. But of course, she coped. First she refilled the walls of her townhouse from the core of her holdings. Then, she went right on collecting, using the perceived vacuum as a prompting to acquire more art. And something more happened: emboldened that such a substantial exhibition could be drawn from her collection, excited to see familiar objects on unfamiliar walls, and pleased to have her choices ratified in the context of a southern museum, she again expanded her boundaries. Increasingly she investigated new tangents, and followed ideas and aesthetics beyond the territory she had earlier marked out.

Serious art collectors, when asked to explain the origins of their passion, often say that their compulsion to acquire art is not easily described in words. But it is worth examining the whole of a collection to seek a portrait of the person who assembles it. By connecting the dots represented by the different artworks, by following their relationships and their interwoven meanings in search of a synchronous whole, one might discern something of the sensibility and inspirations of the collector. For Norrell, who spent her childhood in transit on a two-way highway between the American South and the nation's capital, her collection is in many ways a reconstruction of the idea of home. She sees herself straddling a divide; uprooted from one place, growing up in another on the edge of her home territory, she is both an outsider looking in and an insider looking out.

A philosopher and lawyer by education, and a lobbyist by trade, Norrell works as a standard-bearer for ideas, representing the views of her clients in the debates that determine public policy. It is hard to escape the parallels when assessing her collecting. Standing in the charged space between artist and audience, between the moment of an artwork's creation and the perpetuity of its evaluation, Norrell has become a catalyst. Looking homeward, she seeks access not just to her past, but also to the discords and wonderments that animate her identity as a southerner and Arkansan. In so doing, she hopes to stimulate vital debates about beauty and ugliness, harmony and contention, present-day dreams and the nightmares of history. Norrell's collection is created from her impulse to understand the way people feel and think, the way they overcome obstacles and celebrate life. It explores both what is unique about people and what binds them together. Regional in its focus, universal in its concerns, Norrell's collection enacts a perpetual journey between two places—one inside, one outside—where we all find common ground.

Osamu James Nakagawa, *Morning Light, Bloomington, Indiana*, from the series *Kai*, 1999

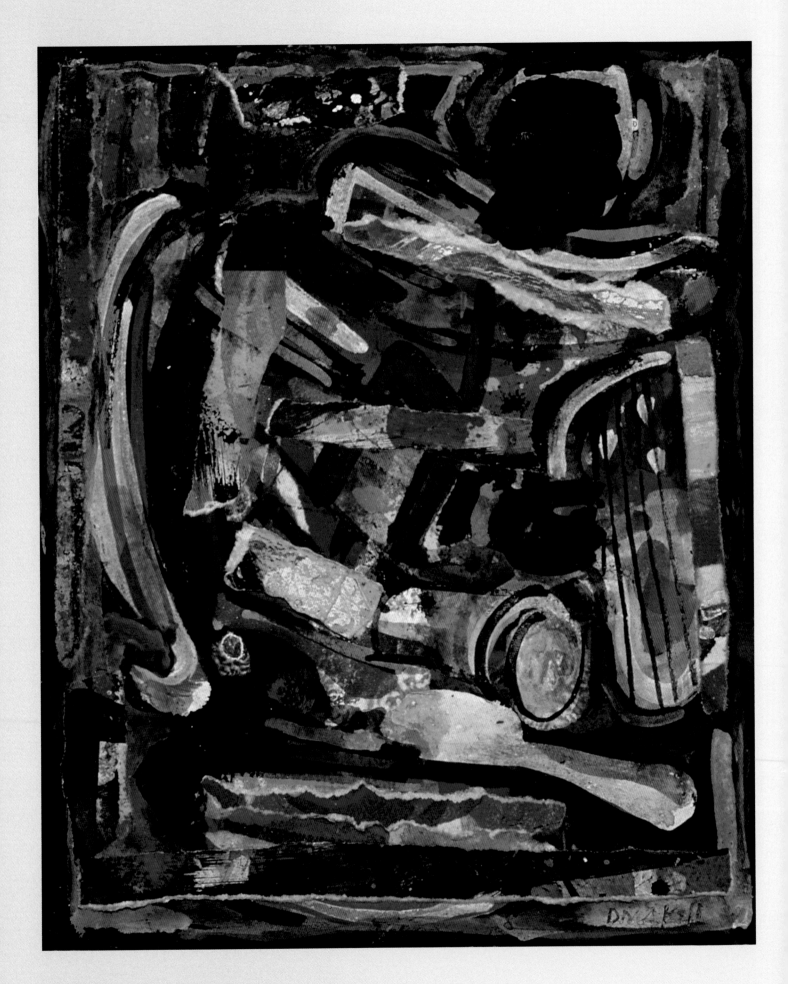

David Driskell, *African Musician*, 1994

Memory and Tribute

The human face and the human body are eloquent in themselves, and stubborn and wayward, and a snapshot is a moment's glimpse (as a story may be a long look, a growing contemplation) into what never stops moving, never ceases to express for itself something of our common feeling. Every feeling waits upon its gesture. Then when it does come, how unpredictable it turns out to be, after all.

Eudora Welty

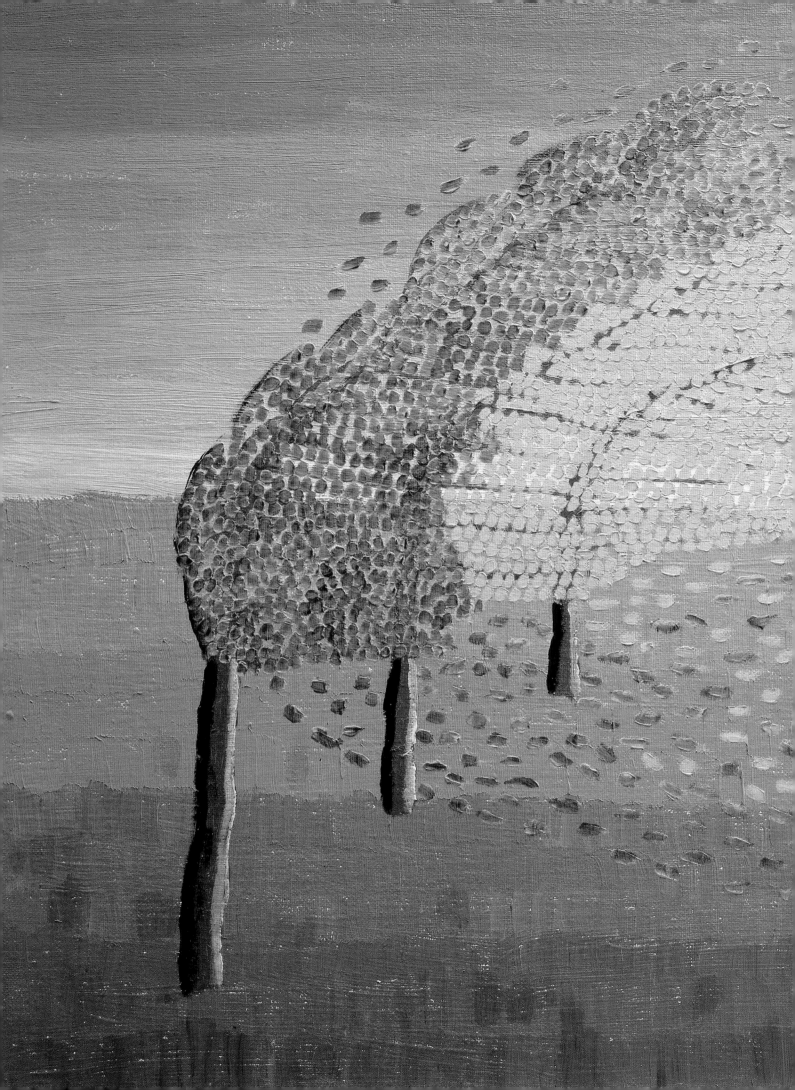

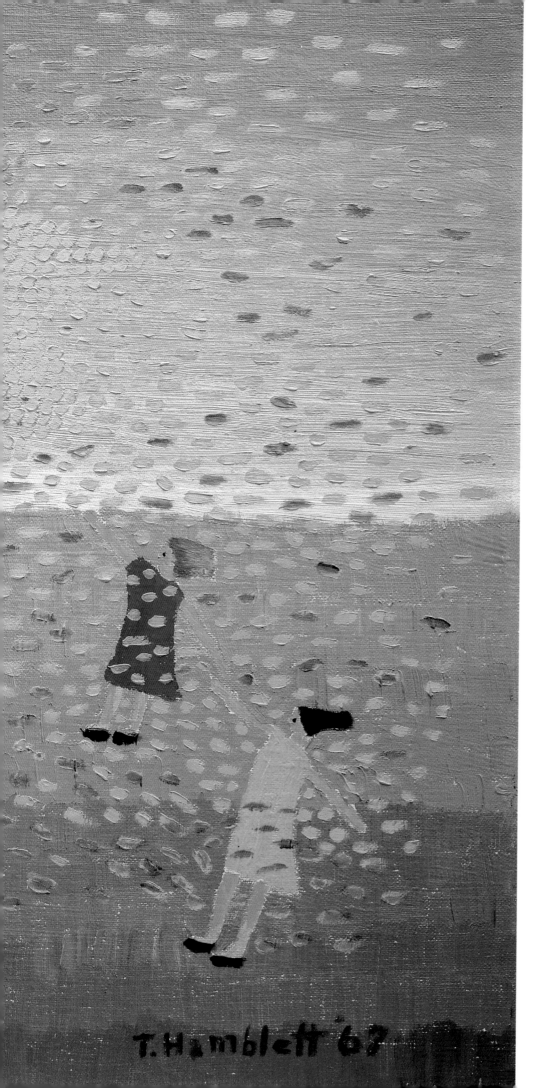

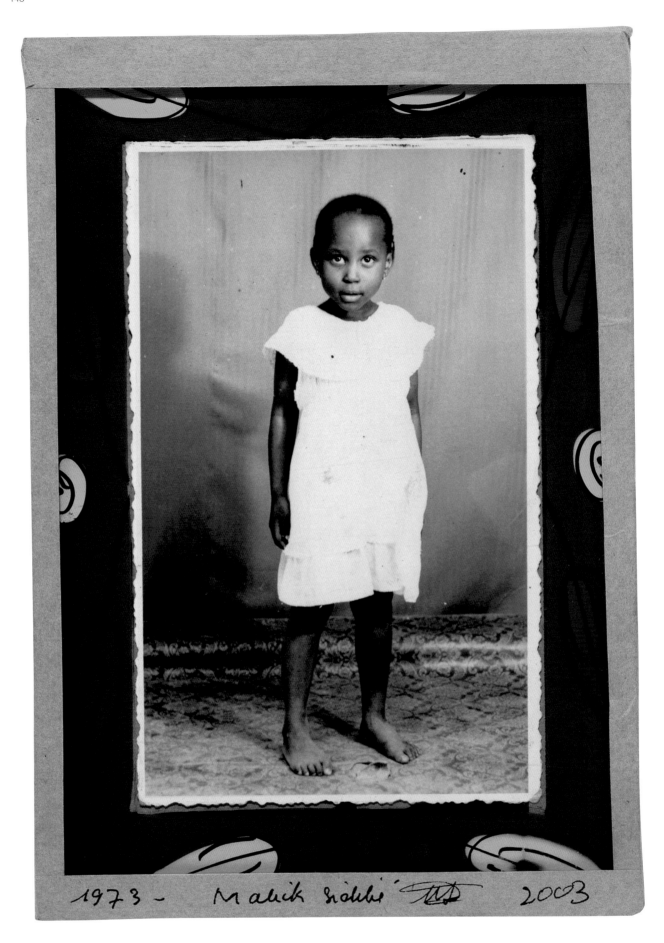

1973 - Malick Sidibé 2003

Theora Hamblett, *Two Trees with Blowing Leaves*, 1967 (previous pages)
Malick Sidibé, *Untitled*, 1973 (above)

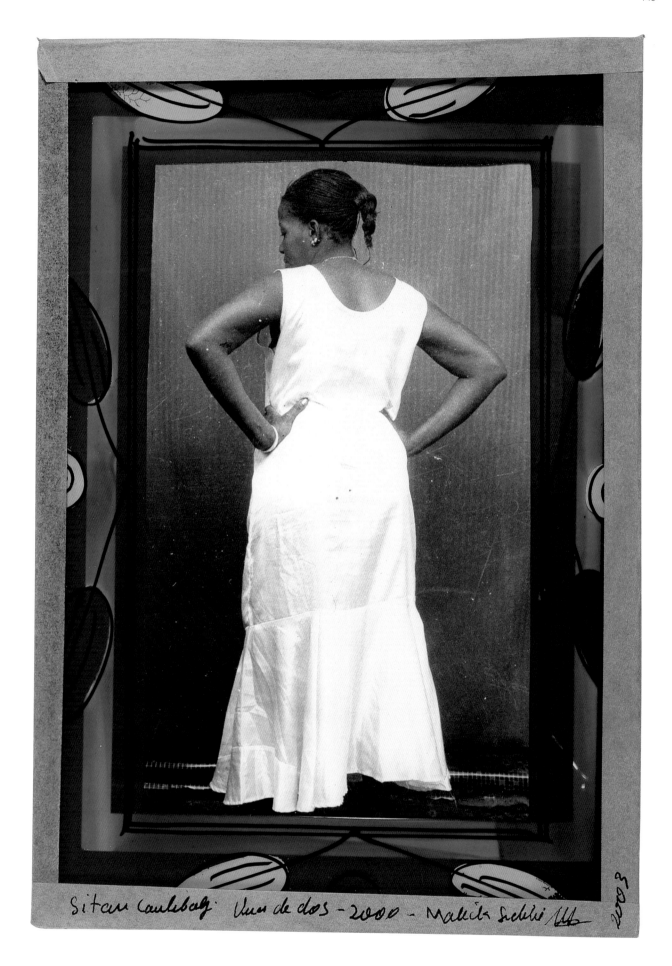

Malick Sidibé, *Sitau Caulibaly—Vues de Dos*, 2000

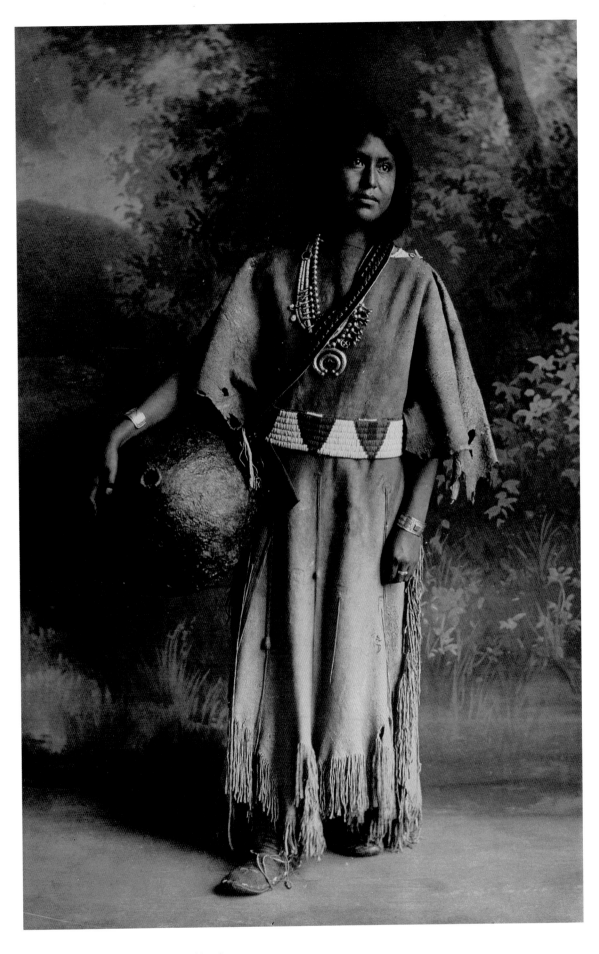

Karl E. Moon, *Isleta Indian Woman*, c. 1905 (above)
Delilah Montoya, *God's Gift*, 1993 (opposite)

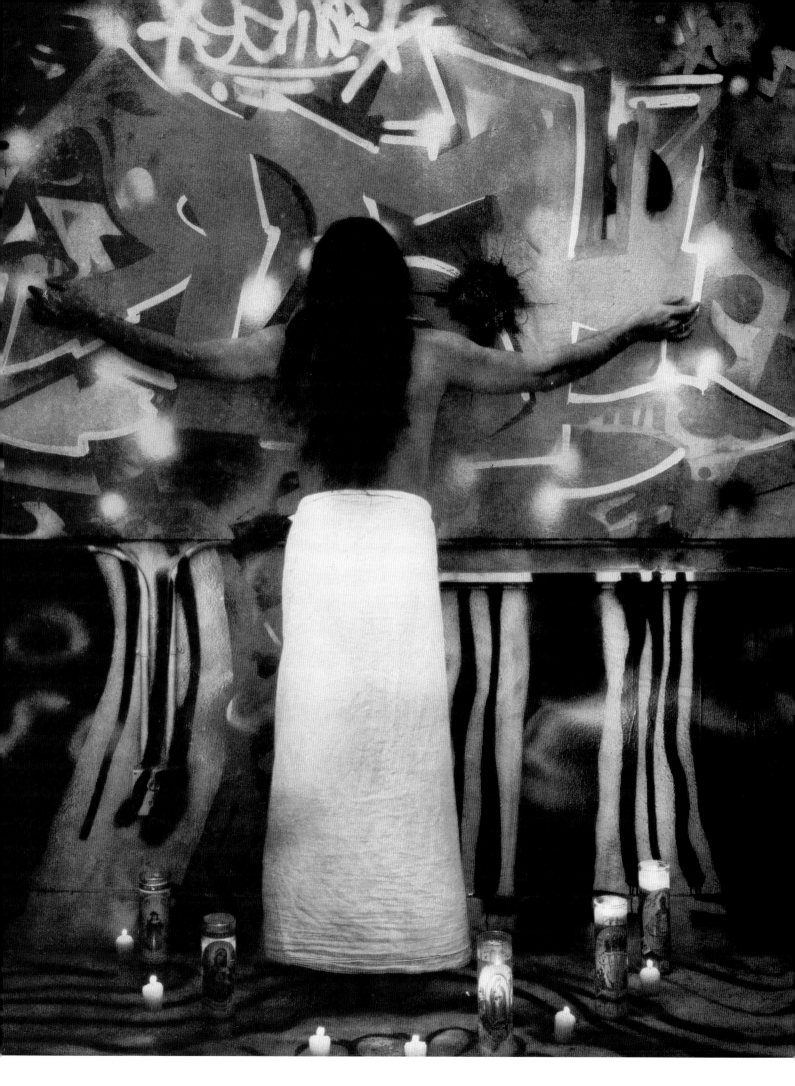

David Bates, *Spearfishing*, 1989

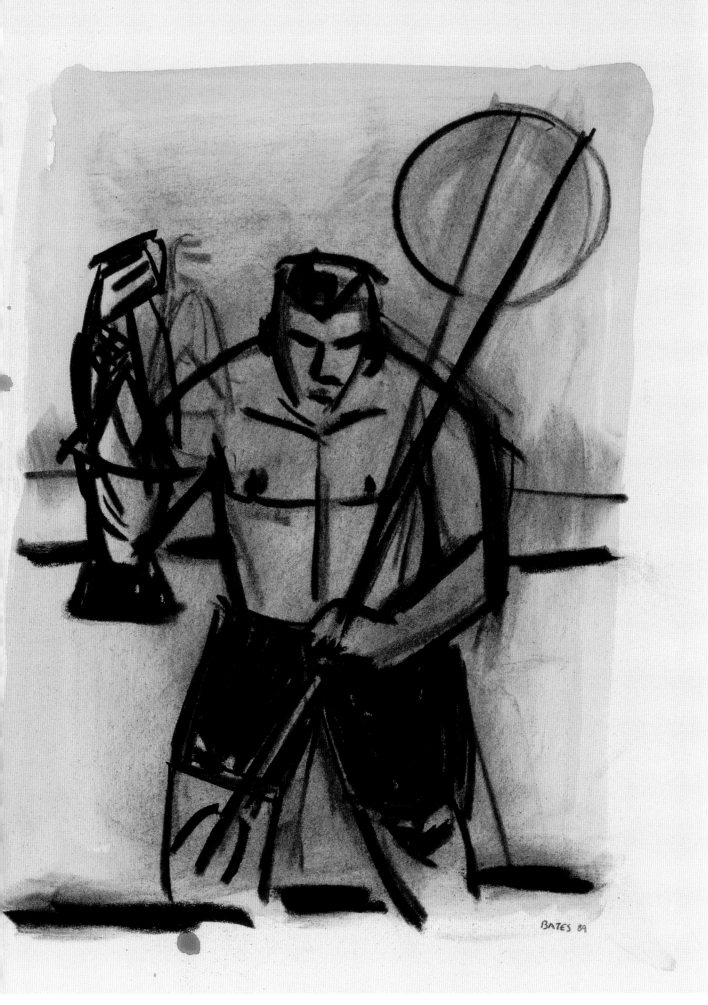

BATES 89

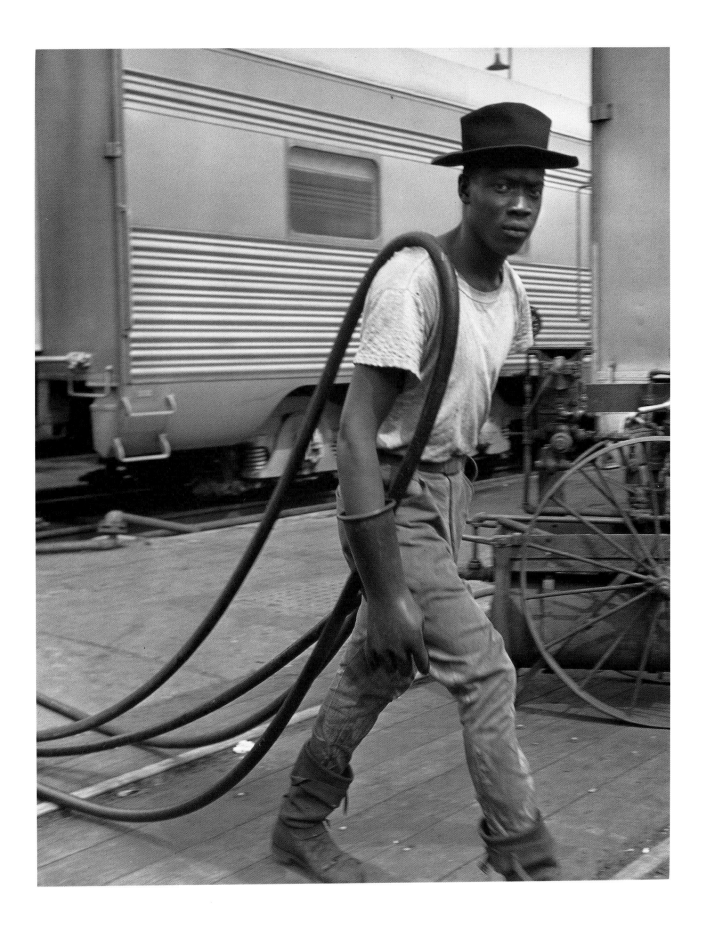

Wayne Miller, *Railroad Passenger Car Maintenance Man. Air Hoses Were Used to Clean the Cars*, 1947

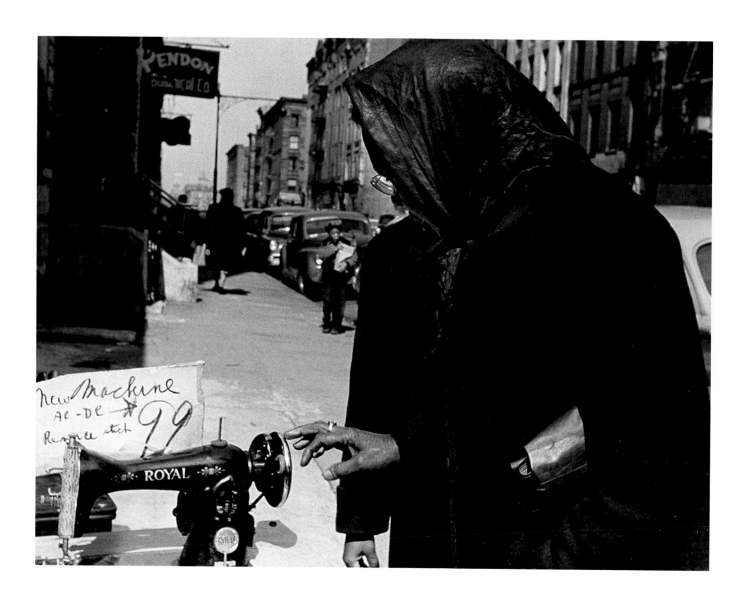

Roy DeCarava, *Woman Touching Sewing Machine*, 1955

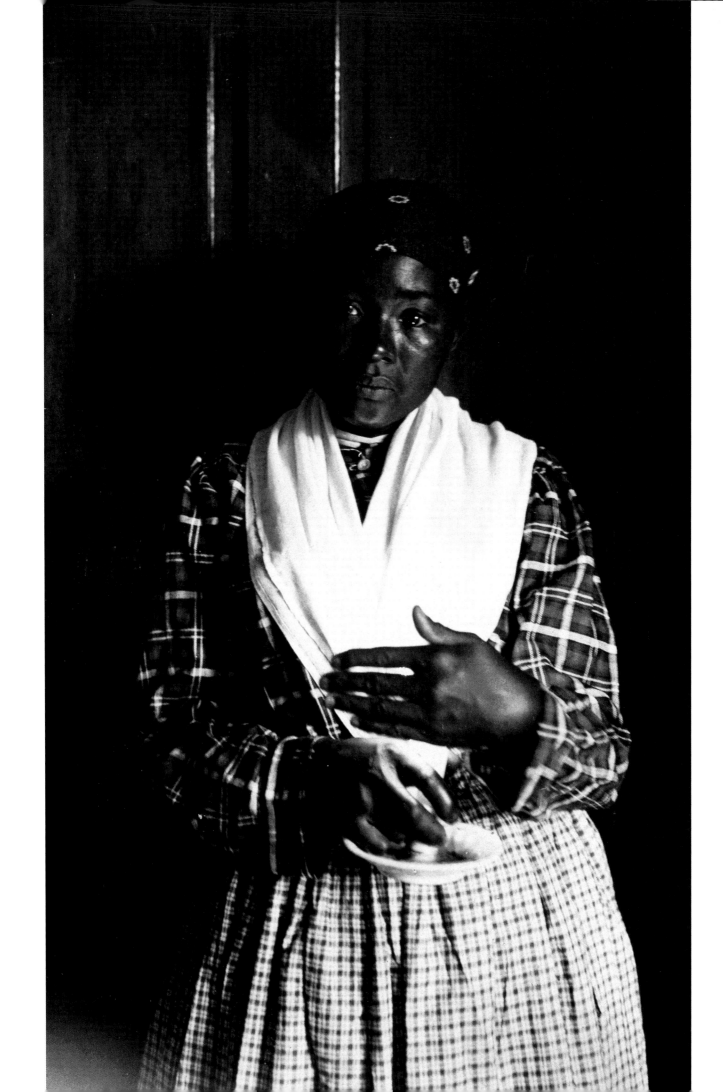

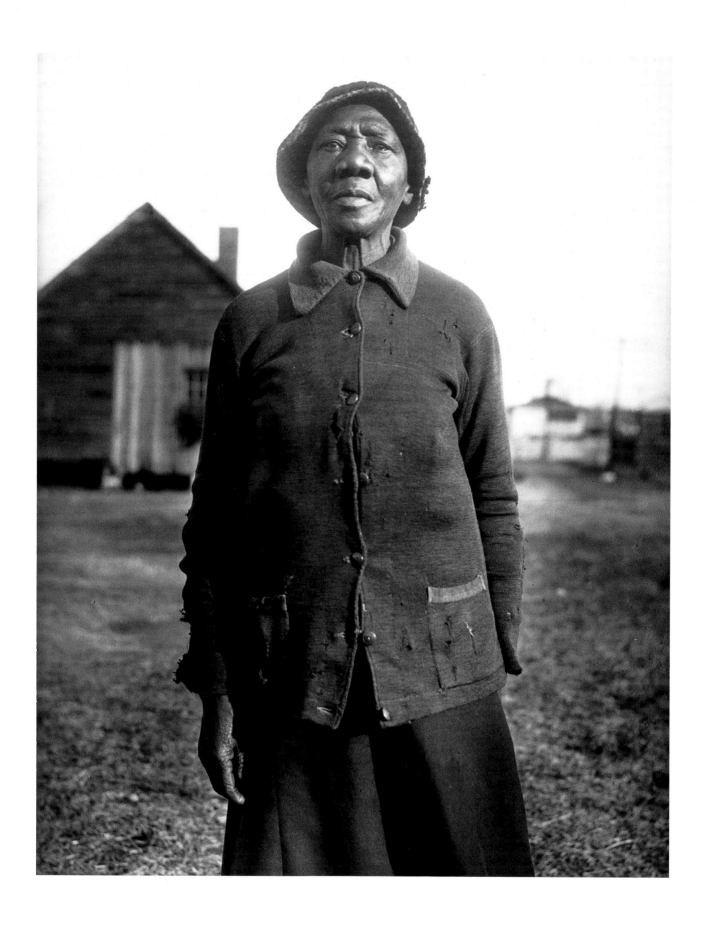

Leigh Richmond Miner, *Untitled*, *c*. 1900 (opposite)
Eudora Welty, *A Woman of the Thirties*, *c*. 1935 (above)

158

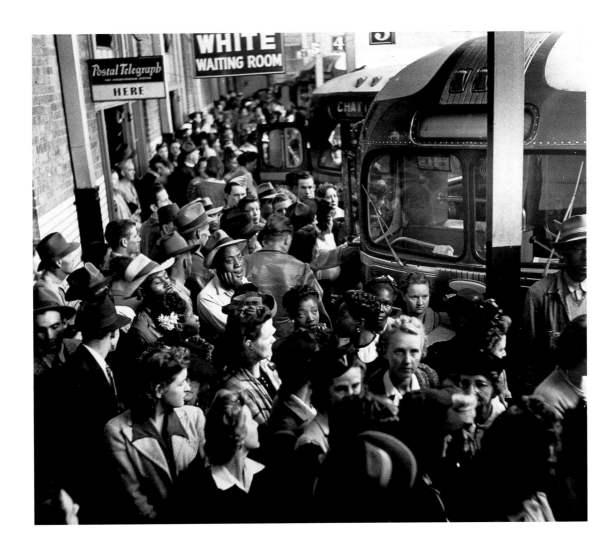

Esther Bubley, *White Waiting Room, Memphis, Greyhound Terminal*, 1943

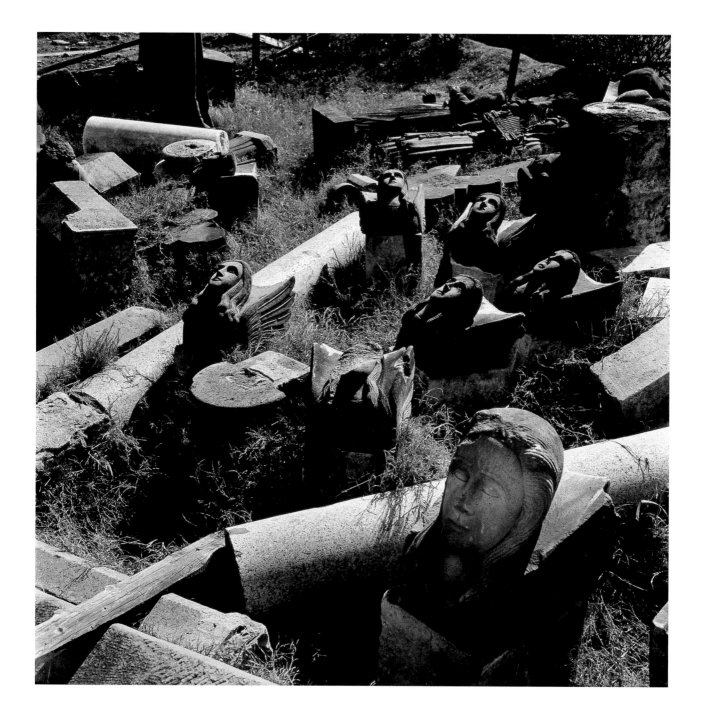

Shomei Tomatsu, *Uragami Church, 600 Meters from Blast, Nagasaki*, 1961

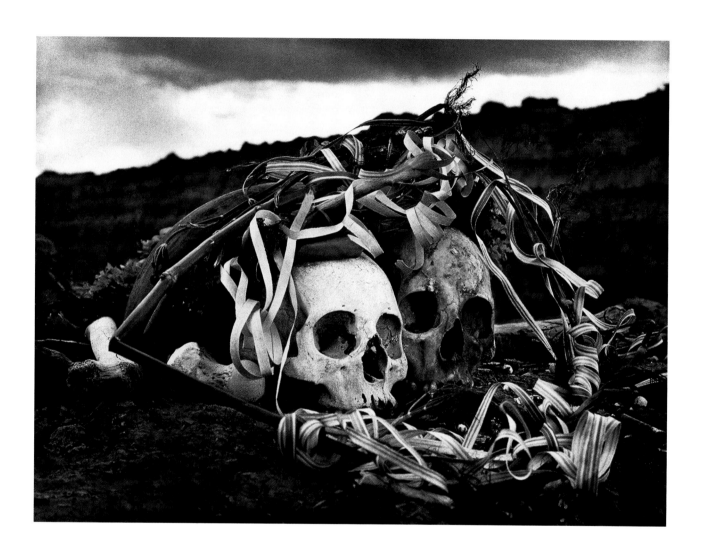

Kenro Izu, *Ladakh #61, Leh, India*, 1999 (opposite)
Flor Garduño, *Dust They Become, But Dust in Love, Toledo, Bolivia*, 1990 (above)

Carrie Mae Weems, *Sea Island Series #3269*, 1992

Birney Imes, *Lowndes County, Mississippi*, 1998

Ken Ashton, *The Howard Theater*, 1993

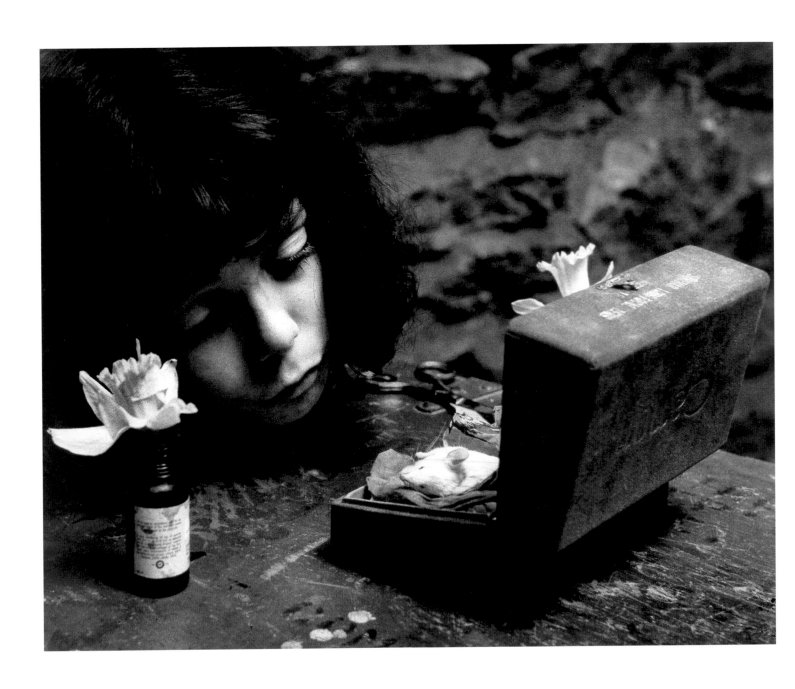

Let the Mystery Be
Julia J. Norrell

Everybody is wonderin' what and where they all came from
Everybody is worryin' bout where they're gonna go
When the whole thing's done
But no one knows for certain
And so it's all the same to me
I think I'll just let the mystery be

Iris DeMent, "Let the Mystery Be"

Several summers ago, as I traveled from Memphis to New Orleans with photographer Deborah Luster, we zigzagged back and forth across the Mississippi and Arkansas deltas. We listened to the night noises of the delta, ate the tamales of Doe's Eat Place in Greenville, Mississippi, and danced in the Oakland Cemetery in Monticello, Arkansas. Both my parents lie there now, as do so many others from my childhood, and this is where my own tombstone already rests. There I rediscovered a sense and love of home and the past, and of the mystery behind each tombstone. As we two admired this stone or that, and I recognized the names that peopled them, I remembered that we were two women from Arkansas, sharing what was in many ways our essence, and ultimately my alpha and omega.

In 1953, as a freshman in college, I was taught that part of the grace of life is to learn to live with unanswered questions. Then I burned with questions of being and not being, of God or not God, of goodness and evil, of man's inhumanity to man. I asked, "Can good come from evil? Can beauty survive ugliness? Is there meaning in this universe?" These basic existential questions can, if taken to the extreme, drive us insane, or they can help us to seek and find meaning in our lives. To this day, I have no definitive answers, but I have come to believe in our ability to seek and find meaning in the universe, to find beauty in ugliness, compassion for one's self and others, hope in despair, laughter in adversity, joy in sharing, and love that transcends hate. Artists, photographers, poets, and writers are all part of this whole that allows us to prevail in what may seem an indifferent world.

I have been fortunate to have sought and found much solace in art, beauty, and love. I am humbled by this joy, which has made me into that which I never sought to become: a collector. I owe a large debt to my parents, who once sent me to Europe on an art tour before they had ever left the country; to the educators who both taught and challenged me at Holton-Arms School, Ohio Wesleyan University, the University of Madras in India, and the George Washington University Law Center; and to the many museums that nurtured my growing interest in art.

What was different about that recent visit home to the cemetery in Monticello, Arkansas? It followed several museum exhibitions drawn from my collection, which had each given me the opportunity to share my love of art. The first was a small show of photographs at The Phillips Collection in Washington D.C., on view with a major exhibition of William Christenberry's paintings. Both had something in common: a bonding of souls of the South, a love of place, of memory, of beauty found in unsuspecting places. That exhibition, curated by Dr. Elizabeth Hutton Turner, was an event too great for me to grasp at first. Beth told me that it would change my life and at the time I thought not. But she was ever so right. It gave me joy and challenged me; it made me want my reach to exceed my grasp. It also gave me a very special and valued friendship with Beth and "the art people."

Following this I might have hung up my spurs, but Jay Willliams, a gentle, pensive, and patient man who had seen that exhibition, asked if I would allow the McKissick Museum at the University of South Carolina, Columbia, to mount a larger exhibition from my collection and publish a catalog. *Myth, Memory, and Imagination: Universal Themes in the Life and Culture of the South*, a wonderful project

W. Eugene Smith, *Death of Gus-Gus*, 1953

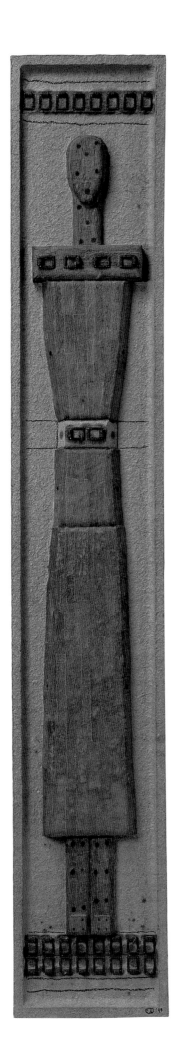

accomplished with feeling, joy, and hope, opened there in fall, 1999. It traveled to other museums, and the reactions of visitors across the country gave me new insights into collecting art.

The seeds of *Common Ground: Discovering Community in 150 Years of Art* germinated then, as the Corcoran Gallery of Art soon asked to organize a new exhibition selected from my colllection. I am indeed grateful to David Levy, Jacquelyn Days Serwer, and Philip Brookman, for making this new project a reality. Our many trips together, our shared perception and discovery of new art, and the sharing of knowledge, friends, and humor, made it all possible. I thank all the many participants at the Corcoran for their kindnesses.

To me, there are three main elements that have made my collection what it is, and I liken them to a three-legged stool. Without one leg the stool would topple. First, there would be no collection without the artists. I respect their struggle, their insight, their compassion, and their caring. I suspect that the creation of art is the loneliest undertaking there is, and each act of creation is an exercise in exploring one's soul. I much admire, if not revere, that courage to expose the inner-self. Second, many museums, art galleries, and dealers in Washington and beyond have nurtured me. The Phillips Collection, the National Gallery of Art, the Smithsonian Institution, and the Corcoran Gallery of Art have all helped define my home and I am fortunate to have worked with them to explore, and in some cases share, my collection. I have also been fortunate to know and appreciate regional museums around the country, both big and small. They all play an important role even though they often must overcome huge odds to bring the art and educational programs to their constituencies. I think with admiration and affection of the McKissick Museum, the Morris Museum of Art in Augusta, Georgia, the Arkansas Art Center in Little Rock, the Naples Museum of Art, Naples, Florida, the North Dakota Museum of Art, Grand Forks, the Columbus Museum of Art, Columbus, Georgia, and the Hampton University Museum, Hampton, Virginia. Many art dealers have played an important role in establishing my collection. Over the years they opened new doors to me, shared knowledge and passion for the art and artists they represent, extended credit, and moved heaven and earth to be sure my deadlines or that of a museum were met. Finally, my friends are the constant here, and my wealth is indeed in my friends, who include so many known and unknown people who have wished me well. To those friends who have nurtured and supported me throughout my life I extend my thanks for the memories traveled together.

Clyde Connell, *Untitled*, 1994 (opposite)
William Eggleston, *Porch*, *c.* 1981 (above)

David Scheinbaum, *Dindigul, India*, 2000

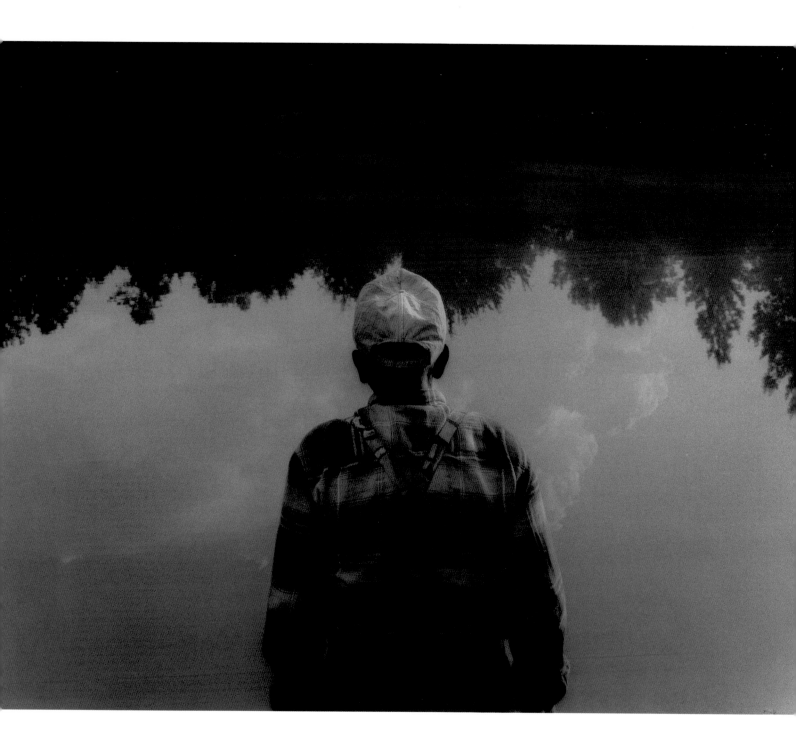

Jack Spencer, *Cooter at the Abyss, Coila, Mississippi*, 1996

Acknowledgments

This book and exhibition, *Common Ground: Discovering Community in 150 Years of Art*, grew from the Corcoran Gallery of Art's long and varied relationship with a collector and a unique collection of art. Julia "Judy" J. Norrell has been around the Washington D.C. arts community for years. Photographs pulled from the walls of her home have been shown in The Phillips Collection and in several exhibitions at the Corcoran. She has haunted the city's galleries, antique shops, and museum exhibitions since her youth, building her reputation as a lawyer, lobbyist, astute collector, and patron. She is as much at home in the midst of a reception for a contemporary art exhibition as she is at a political fund-raiser. She never completely separates these two seemingly disparate worlds.

After many conversations, the Corcoran approached Norrell in 2001 with the idea of organizing a new exhibition selected from her growing collection. Our biggest challenge was to distill the essence of the whole group. From folk art, baskets, William Faulkner first editions, and Australian aboriginal paintings to photography and contemporary painting, sculpture, and assemblage works, Norrell's collection represents many diverse ideas with certain common themes. Yet it was only when looking at all this work in the context of Norrell's own life and passions that its common ground became clear.

We would first like to thank Judy Norrell for her generosity and good humor in sharing her collection with the public. She has given us her time and made her entire collection available for study, introducing us to new ideas and artists. It has been a great privilege to collaborate with her on this project. Her excitement about and interest in art is infectious, as is her outrage at injustice. It is this enthusiasm for art and life that we hope to convey in this exhibition.

A project of this scope, requiring specialized research, publishing, and curatorial skills, could never be realized without the generous assistance and talent of many different people. We are especially grateful to Paul Roth, Associate Curator of Photography and Media Arts; Alana Quinn, Photography and Media Arts Curatorial Assistant; Merry A. Foresta, Senior Curator

of Photographic Collections for the Smithsonian Institution; Hilary Allard and Lauren Harry, assistants to the Chief Curator; and Emilie Johnson, Education Department Manager at the Corcoran. Each was equally adept at coordinating many of the complex details of this project, assisting the curators as well as Judy Norrell with the exhibition, conducting research, writing, and helping us to grasp and interpret the work. We also want to thank Jobyl Boone, who assiduously created for us a detailed catalog of Norrell's entire collection.

Special thanks must go to President Bill Clinton for his perceptive words and generous spirit in crafting the foreword to this book. The concept of common ground is one that he has seriously considered throughout his career, and it is enlightening to connect his enthusiasm for humanity to that of the artists in this exhibition. We would also like to thank Maggie Williams and Eugenie Bisulco for their help in coordinating his writing.

The insights required to make a book such as *Common Ground* come from an inspired understanding of art and publishing, and of how to integrate the two. Joan Louise Brookbank, US Director, and Hugh Merrell, Publisher, of Merrell Publishers Limited in London have been instrumental in the creation of this book. Their thoughtfulness and attention to every detail of content, editing, production, and distribution have insured the quality of *Common Ground*. Also at Merrell, we wish to thank Nicola Bailey, Michelle Draycott, and Sam Wythe. The book was designed by Robert Villaflor, Design Director at the Corcoran, who was assisted by Daniel Klein, Sharae Curtis, and Seza Bali. Mark Gulezian of Quicksilver Photographers, Takoma Park, Maryland, made the high-quality transparencies used to reproduce most works of art. Tim Buchman photographed Deborah Luster's work on page 44.

At the Corcoran Gallery of Art, many talented people have nurtured this project from the start. David C. Levy, President and Director, Otto Ruesch, Chairman of the Board of Trustees, and Anne Hazel, Chair of the Museum Board of Overseers, have supported our work throughout. Also instrumental

were Margaret Turner, Vice President for Development; Michael Roark, Chief Financial and Administrative Officer; Jan Rothschild, Chief Communications Officer; Susan Badder, Senior Curator of Education; Nancy Swallow, Registrar; Elizabeth Parr, Exhibitions Director; Dare Hartwell, Conservator; Ken Ashton, Museum Technician; and Kate Gibney, Director of Corporate and Foundation Relations. Others at the museum whose assistance contributed greatly to the production of the exhibition and book include Kelly Baker, Chris Brooks, Steve Brown, Kim Davis, Sara Durr, Abby Frankson, Rebecca Gentry, David Jung, Susan Kenney, Mike McCullough, Joan Oshinsky, Clyde Paton, Rebekah Sobel, Janet Solinger, Ellen Tozer, Becky Ventorini, and Sarah Wagner.

As a collector, Judy Norrell has also worked closely with many individuals from museums and galleries to help realize her vision. She would like to join us in extending special thanks to the following people from museums: Townsend Wolfe and Brian Young of the Arkansas Art Center, Little Rock; Ramona Austin and Mary Lou Hultgren of the Hampton University Museum; Jeff Rosenheim of The Metropolitan Museum of Art; Lynn Robertson and Jay Williams of the McKissick Museum, University of South Carolina, Columbia; Anne Tucker of The Museum of Fine Arts, Houston; Sarah Greenough of the National Gallery of Art, Washington D.C.; Laurel Reuter of the North Dakota Museum of Art, Grand Forks; Dr. Elizabeth Hutton Turner, Eliza Rathbone, Stephen Phillips, and Shelly Wischhusen of The Phillips Collection, Washington D.C.; and Sandra Phillips of the San Francisco Museum of Modern Art. Judy would also like to join us in thanking the following people and galleries: Kathleen Ewing of Kathleen Ewing Gallery, from whom she bought her first photograph and who has always been a friend and supporter; Margaret Veerhoff and her family, from whom she bought many paintings and with whom she spent countless Saturdays; Helen Levinson of White Canvas Gallery, with whom she discovered many artists; Attic Gallery; Vicki Bassetti of Bassetti Fine Arts; Deborah Bell; Bonni Benrubi of Bonni Benrubi Gallery; Sandra Berler of Sandra Berler Gallery; Zelda

Cheatle Gallery; John Cleary Gallery; Catherine Edelman of Catherine Edelman Gallery; Gary Edwards Gallery; Fraenkel Gallery; Joshua Pailet of A Gallery for Fine Photography; Tom Gitterman of Gitterman Gallery; Howard Greenberg, Parker Stevenson, Karen Marks, and Margit Erb of Howard Greenberg Gallery; Halsted Gallery; Thelma Harris; Garbo Hearne; George Hemphill of Hemphill Fine Arts; Paul M. Hertzmann, Inc.; Hodges Taylor Gallery; Edwynn Houk Gallery; Jackson Fine Art; Ken and Jenny Jacobson; Klotz/Sirmon Gallery; Mack Lee of Lee Gallery; Lewis Lehr; the late Arlene LewAllen of LewAllen Contemporary; Lee M. Marks of Lee Marks Fine Art; McMurtrey Gallery; William Meek of Harmon Meek Gallery; Tom Heman of Metro Pictures; Larry Miller and Vicki Harris of Laurence Miller Gallery; Bridget Moore, Suzanne Julig, Edward De Luca, Heidi Lange, Brian Kenny, and Sandra Taci of DC Moore Gallery; Scott Nichols of Scott Nichols Gallery; Peter MacGill of Pace/MacGill Gallery; Arthur Roger of Arthur Roger Gallery; William Schaeffer of William L. Schaeffer Photography; Janet Russek and David Scheinbaum of Scheinbaum & Russek Ltd; Charles Schwartz of Charles Schwartz Ltd; Jack Shainman, Claude Simard, and Judy Sagal of Jack Shainman Gallery; Andrew Smith of Andrew Smith Gallery; John Stevenson Gallery; and Neil Folberg of Vision Gallery.

Norrell and the Corcoran also would like to extend sincere thanks to Kate and Craig Norrell, who have lived with the art, lived with the collector, and loved the "art people"; to friends Andy Grundberg and Mike Luster; to Lottie Shackelford; and to Philip Chen, friend and transportation coordinator in New York in all elements.

Finally, this exhibition and book would not have been possible without the very generous financial support of The President's Exhibition Fund of the Corcoran Gallery of Art.

Philip Brookman
Senior Curator of Photography and Media Arts

Jacquelyn Days Serwer
Chief Curator

Checklist

The checklist numbers below are referenced as catalog numbers throughout the text and in the artist biography and bibliography section.

1 Ansel Adams (page 128)
Cemetery Statue and Oil Derricks, Long Beach, California, 1939
Gelatin silver print

2 Ansel Adams
Gravestone Carving Detail, Susanville, California, 1960
Gelatin silver transfer (Polaroid) print

3 Ken Ashton (pages 164–65)
The Howard Theater, 1993
Color coupler (chromogenic) print

4 Shimon Attie (page 29)
Mulackstrasse 32: Slide Projections of Former Jewish Residents and Hebrew Reading Room, Berlin (1930), 1993
Color coupler (chromogenic) print

5 Shimon Attie
Mulackstrasse 37: Slide Projection of Kosher Butcher Shop and Laundry, Berlin (1930), 1993
Color coupler (chromogenic) print

6 Eldridge Bagley
On Grassy Key, 1996
Oil on linen

7 Eldridge Bagley (page 55)
Reunion Table, 1998
Oil on linen

8 Eldridge Bagley
In the Early Morning Rain, 1999
Oil on canvas

9 Radcliffe Bailey (page 74)
Untitled, 2001
Mixed media on paper

10 George Barnard (page 106)
Savannah, Georgia, No. 1, 1866
Albumen print

11 David Bates (page 152)
Spearfishing, 1989
Charcoal and wash on paper

12 Virginia Beahan and Laura McPhee
Sleeping Buddha, Subodrahma Maua Viharaya Temple, Dehiwala, Sri Lanka, 1993
Color coupler (chromogenic) print

13 Virginia Beahan and Laura McPhee (page 20)
Times for Call to Prayer, Jami-ul-Alfar Mosque, Petlah, Colombo, Sri Lanka, 1993
Color coupler (chromogenic) print

14 "Prophet" William J. Blackmon (page 116)
Vote for President, n.d.
Oil on wood

15 A. Aubrey Bodine
Maryland Log Cabin, 1945
Gelatin silver print

16 Margaret Bourke-White (page 87)
Hood's Chapel, Georgia, 1936
Gelatin silver print

17 Brassaï (Gyula Halász) (page 121)
Messe de minuit aux Baux-de-Provence, 1950
Gelatin silver print

18 Esther Bubley (page 158)
White Waiting Room, Memphis, Greyhound Terminal, 1943
Gelatin silver print

19 Beverly Buchanan (page 62)
Chair, 1988
Painted wood

20 Beverly Buchanan
Mary Lou Furcron House, 1994
Color coupler (chromogenic) print

21 Beverly Buchanan (page 63)
 Small Red Shack, 1997
 Painted foam core board

22 Beverly Buchanan
 Untitled, 1997
 Painted foam core board

23 Debbie Fleming Caffery
 Way of the Cross, 1994
 Gelatin silver print

24 Debbie Fleming Caffery (page 97)
 KKK, Louisiana, 2001
 Gelatin silver print

25 John Candelario
 *Indians Among Themselves May Be Worlds
 Apart But Always There Is Water that Brings
 Them Together. Water Hole at the Gallup
 Ceremonial Grounds. From Left to Right:
 Navajo, San Felipe, Shoshone, Apache, and
 Navajo*, c. 1930
 Gelatin silver print

26 Manuel Carrillo (page 65)
 Perro viendo a su amo Zihuatanejo, Guerrero,
 n.d.
 Gelatin silver print

27 William Christenberry
 Tingle House, near Akron, Alabama, 1961
 Two gelatin silver prints

28 William Christenberry (pages 30–31)
 The Bar-B-Q Inn, Greensboro, Alabama,
 1964–91
 Fifteen color coupler (chromogenic) prints and
 one gelatin silver print

29 William Christenberry (pages 50–51)
 Wall Construction V, 1985
 Mixed media, tin, and acrylic on wood

30 William Christenberry (page 134)
 K House, 1996
 White ink on black archival paper

31 William H. Clarke (page 135)
 Midnight, 2000
 Oil on board

32 William H. Clarke (pages 68–69)
 Church of Francisco, 2000
 Oil on board

33 William H. Clarke
 No One Live Here Anymore, 2000
 Acrylic and oil on paper

34 William Clift (page 119)
 Prayer Place, Hoboken, New Jersey, 1964
 Gelatin silver print

35 William Clift
 Thomas Chapel Methodist Church, Tennessee,
 1965
 Gelatin silver print

36 Clyde Connell (page 168)
 Untitled, 1994
 Papier-mâché on wood

37 Linda Connor (page 123)
 Religious Effigies, Banaras, India, 1979
 Gold-toned gelatin silver print on printing-out
 paper

38 Linda Connor (page 18)
 My Hand with My Mother's, 1987
 Gold-toned gelatin silver print on printing-out
 paper

39 Roy DeCarava (page 155)
 Woman Touching Sewing Machine, 1955
 Gelatin silver print

40 Roy DeCarava (page 141)
 This Site, New York, 1963
 Gelatin silver print

41 Adolf Dehn
 India Night, 1961
 Lithograph

42 David Driskell
 Ancient Dance, 1993
 Collage and mixed media on paper

43 David Driskell (page 144)
 African Musician, 1994
 Encaustic and collage on paper

44 William Dunlap (page 64)
Dog Trot, 1984
Oil paint, dry pigment, and watercolor on rag paper

45 Clifford Earl
What Happens to Snakes, 1999
Mixed media

46 William Eggleston (page 169)
Porch, c. 1981
Color coupler (chromogenic) print

47 Elliott Erwitt
South Carolina, 1950
Gelatin silver print

48 Walker Evans (attributed)
Man with Eye Patch, 1935
Gelatin silver print

49 Walker Evans (page 58)
Room in Louisiana Plantation House, 1935
Gelatin silver print

50 Walker Evans (page 26)
Child's Grave, Hale County, Alabama, 1936
Gelatin silver print

51 Walker Evans (page 107)
Scene from Negro Quarter, Atlanta, Georgia, 1936
Gelatin silver print

52 Walker Evans (page 48)
Star Pressing Club, Vicksburg, Mississippi, 1936
Gelatin silver print on postcard paper

53 Howard Finster (page 117)
1000 and 184, 1978
Oil on wood with hand-painted frame

54 Robert Frank (page 27)
South Carolina, 1955
Gelatin silver print

55 David Freed
Study for Virginia/A Monument (Female Figure), 1990–91
Watercolor and pastel on paper

56 Leonard Freed (page 138)
March on Washington, August 28, 1963
Gelatin silver print

57 Lee Friedlander (page 3)
Hillcrest, 1970
Gelatin silver print

58 Flor Garduño (page 161)
Dust they Become, But Dust in Love, Toledo, Bolivia, 1990
Platinum print

59 William Gedney (page 9)
Kentucky, 1964
Gelatin silver print

60 William Gedney
Kentucky, 1972
Gelatin silver print

61 Laura Gilpin (page 23)
Untitled (Square Tower House, Mesa Verde National Park, Colorado), 1925
Gelatin silver print

62 Laura Gilpin
Untitled (The Well of Sacrifice, Chichén Itzá, Yucatán), 1932
Gelatin silver print

63 Laura Gilpin (page 24)
Navajo Family (Francis Nakai and Family, Red Rock), 1950
Gelatin silver print

64 Jim Goldberg (pages 98–99)
103 Degrees—Troy, Alabama, 2002
Six gelatin silver prints and sixteen dye diffusion transfer (Polaroid) prints

65 Elijah Gowin (page 16)
Bottle Tree at Night, 1995
Toned gelatin silver print

66 Emmet Gowin (page 82)
Church, Mississippi, 1969
Gelatin silver print

67 David Graham (page 127)
Jesus Saves, Grants, New Mexico, 1989
Color coupler (chromogenic) print

68 Edward Grazda (pages 136–37)
Mazar i Sharif, Afghanistan, 1997
Gelatin silver print

69 Jonathan Green (page 114)
The Passing of Eloise, 1988
Oil on Masonite

70 Jonathan Green
Daughters of the South, 1993
Oil on canvas

71 Sid Grossman (page 86)
Union Meeting, Arkansas, 1940
Gelatin silver print

72 John Gutmann (page 120)
Convent, New Orleans, 1936
Gelatin silver print

73 John Gutmann
Jitterbug, New Orleans, 1937
Gelatin silver print

74 John Gutmann
Before Pearl Harbor, ROTC at Mission High School, San Francisco, California, 1938
Gelatin silver print

75 Theora Hamblett (pages 146–47)
Two Trees with Blowing Leaves, 1967
Oil on canvas

76 Mary Hearne (page 56)
Cotton Picking, 1986
Oil on board

77 Chester Higgins Jr. (page 96)
Lunchtime at Adele's, 1975
Gelatin silver print

78 John K. Hillers (page 22)
Ruins near Fort Wingate, c. 1880
Albumen print

79 Lewis Hine (page 84)
Another "Dependent Father." Lyell, Columbus & Swift Mills, Columbus, Georgia, 1913
Gelatin silver print

80 Rita Huddleston
Jubal, c. 1980
Cloth and mixed media

81 Clementine Hunter (page 54)
Cotton Pickers, n.d.
Oil on canvas

82 Birney Imes (page 163)
Lowndes County, Mississippi, 1988
Gelatin silver print

83 Graciela Iturbide (page 61)
Mississippi at Memphis, Tennessee, n.d.
Platinum print

84 Kenro Izu (page 160)
Ladakh #61, Leh, India, 1999
Platinum palladium print

85 Nicario Jimenez
Two-Tiered Retablo, n.d.
Mixed-media construction

86 Rashid Johnson (page 101)
George, 1999
Van Dyke Brown print

87 Lewis Koch
Khajuraho, Madhya, Pradesh, India; and *"A Note on Death"*, 1996
Two gelatin silver prints

88 Dorothea Lange (page 85)
Ma Burnham, Conway, Arkansas, 1938
Gelatin silver print

89 Clarence John Laughlin (page 66)
In the Spell of the Shadow, 1953
Gelatin silver print

90 Jacob Lawrence (page 102)
Two Rebels, 1963
Lithograph

91 Russell Lee (page 111)
Child of Negro Sharecropper Looking out Window of Cabin Home. There is a Great Deal of Malaria in this Section, Bad and No Screening Being a Contributing Cause. Near Marshall, Texas, 1939
Gelatin silver print

92 Russell Lee
Corner of Room of Living Quarters Provided for Negro Strawberry Pickers, near Independence, Louisiana, 1939
Gelatin silver print

93 Helen Levitt (page 94)
New York, c. 1940
Gelatin silver print

94 Helen Levitt (page 95)
New York, c. 1940
Gelatin silver print

95 Willie Little
Little's Grocery (Juke Joint), 1998
Mixed media

96 Whitfield Lovell
Frame, 1993
Oil stick and charcoal on paper

97 Whitfield Lovell (page 71)
Cage, 2001
Charcoal and mixed media on wood with found
object

98 Whitfield Lovell
Nkisi, 2001
Charcoal on wood with found object

99 Whitfield Lovell (page 72)
Juba II, 2003
Charcoal on wood with found object

100 Deborah Luster (page 44)
One Big Self: Prisoners of Louisiana,
1998–2002
Mixed-media installation with gelatin silver prints
on aluminum

101 Danny Lyon (pages 34–35)
Knoxville, 1967
Gelatin silver print

102 Mark Mann
Deep End, 2000
Silver dye bleach (Ilfochrome) print mounted on
aluminum

103 Mark Mann (page 14)
Screen, 2001
Silver dye bleach (Ilfochrome) print mounted
on aluminum

104 Sally Mann (page 7)
Easter Dress, 1986
Gelatin silver print

105 Sally Mann (page 113)
Untitled, 1998
Toned gelatin silver print

106 Mary Ellen Mark (page 38)
Lilly, Seattle, 1983
Gelatin silver print

107 Mary Ellen Mark
Calcutta, 1988
Toned gelatin silver print

108 Victor Masayesva Jr. (page 25)
Night and Day, 1993
Gelatin silver print with acrylic and collage

109 Ralph Eugene Meatyard (page 122)
Untitled, n.d.
Gelatin silver print

110 Ray K. Metzker (page 6)
Untitled, from the series *My Camera
and I in the Loop*, 1958
Gelatin silver print

111 Ray K. Metzker
Untitled (Dewey's Famous), 1965
Gelatin silver print

112 Wayne Miller
Blues at the Maxwell Street Flea Market, 1947
Gelatin silver print

113 Wayne Miller (page 154)
*Railroad Passenger Car Maintenance Man.
Air Hoses Were Used to Clean the Cars*, 1947
Gelatin silver print

114 Leigh Richmond Miner (page 156)
Untitled, c. 1900
Platinum print

115 Richard Misrach (page 129)
Crucifix, Holy Rosary Cemetery, Taft, Louisiana,
1998
Color coupler (chromogenic) print

116 Delilah Montoya (page 151)
God's Gift, 1993
Collotype

117 Karl E. Moon (page 150)
Isleta Indian Woman, c. 1905
Gelatin silver print

118 Abelardo Morell (page 5)
Camera Obscura Image of the Grand Tetons in Resort Room, 1997
Gelatin silver print

119 Zwelethu Mthethwa (pages 12–13)
Untitled, 2002
Color coupler (chromogenic) print

120 Osamu James Nakagawa (page 143)
Morning Light, Bloomington, Indiana, from the series *Kai*, 1999
Gelatin silver print

121 Adi Nes (page 10)
Untitled, 2000
Color coupler (chromogenic) print

122 Adi Nes (page 11)
Untitled, 2000
Color coupler (chromogenic) print

123 Arnold Newman (page 59)
Man in Church Doorway, 1940
Gelatin silver print

124 Timothy O'Sullivan (page 4)
Bluff Opposite Big Horn Camp, Black Cañon, Colorado River, 1871
Albumen print

125 Gordon Parks (page 60)
Dirt Road near Paoli, Lancaster County, Pennsylvania, 1946
Gelatin silver print

126 Mark Power
Untitled, Family Bible Series #2, 1994
Gelatin silver print

127 Brad Richman (page 126)
Washington D.C., 1999
Gelatin silver print

128 Arthur Rothstein (page 110)
Sharecropper's Wife and Children, Arkansas, 1935
Gelatin silver print

129 Dana Salvo (pages 130–31)
Altar with Cats, 1987
Color coupler (chromogenic) print

130 David Scheinbaum (page 170)
Dindigul, India, 2000
Toned gelatin silver print with applied wax

131 David Scheinbaum
Lost Children I, Kyoto, Japan, 2000
Toned gelatin silver print with applied wax

132 Addison Scurlock (pages 124–25)
Baptism, Washington D.C., 1932
Gelatin silver print

133 Peter Sekaer (page 91)
Stable, Canton, Mississippi, 1936
Gelatin silver print

134 Peter Sekaer
New Orleans, Mardi Gras, c. 1939
Gelatin silver print

135 Ben Shahn (page 53)
Cotton Picker, Arkansas, 1935
Gelatin silver print

136 Ben Shahn (page 52)
Day Laborers Picking Cotton near Lehi, Arkansas, 1935
Gelatin silver print

137 Fazal Sheikh (page 100)
Mama Nyiramugna, Rwandan Refugee Camp, Lumasi, Tanzania, 1994
Toned gelatin silver print

138 Malick Sidibé (page 148)
Untitled, 1973
Gelatin silver print, painted tape, and glass

139 Malick Sidibé
Untitled, c. 1975
Gelatin silver print and glass

140 Malick Sidibé
Untitled, 1977
Gelatin silver print and glass

141 Malick Sidibé
Untitled, 1987
Gelatin silver print and glass

168 James VanDerZee (page 36)
Untitled, c. 1920
Gelatin silver print

169 James VanDerZee
Untitled, 1926
Hand-painted gelatin silver print

170 Willard Van Dyke (page 118)
Angels Camp, 1933
Gelatin silver print

171 Roman Vishniac (page 28)
Side Entrance to the Jewish Quarter, Bratislava,
1939
Gelatin silver print

172 George Kendall Warren
African American Man, Harvard University, 1861
Salted paper print

173 Weegee (Arthur Fellig) (page 39)
NAACP, c. 1943
Gelatin silver print

174 Carrie Mae Weems (page 162)
Sea Island Series #3269, 1992
Gelatin silver print

175 Eudora Welty (page 157)
A Woman of the Thirties, c. 1935
Gelatin silver print

176 Edward Weston (page 83)
William Edmondson, Sculptor, Nashville,
Tennessee, 1940
Gelatin silver print

177 Edward Weston
Willie, St. Roch Cemetery, New Orleans,
Louisiana, 1941
Gelatin silver print

178 Willie White
Untitled, n.d.
Ink marker on paper

179 Fred Wilson (page 78)
Old Salem: A Family of Strangers, 1995
Color coupler (chromogenic) print

180 Fred Wilson (page 79)
Old Salem: A Family of Strangers, 1995
Color coupler (chromogenic) print

181 Fred Wilson (page 103)
Untitled, 2001
Pen and ink on paper

182 Fonville Winans (page 93)
Jig Dancers, New Orleans, 1938
Gelatin silver print

183 Marion Post Wolcott (page 92)
Jitterbugging on Saturday Night in a Juke Joint
near Clarksdale, Mississippi, 1939
Gelatin silver print

184 Marion Post Wolcott
Negro Going in a Colored Entrance to Movie
House on Saturday Afternoon, Belzoni,
Mississippi, 1939
Gelatin silver print

185 Jeffrey Wolin (page 133)
Moses Wloski, Born 1921, Wolkowisk, White
Russia, 1992–94
Toned gelatin silver print with silver ink

186 Donald Woodman (page 132)
Eyeglass Case at Auschwitz, 1987
Gelatin silver print

187 Reid Yalom
Blessing, Part I, San Francisco, California, 1998
Gelatin silver print

Artist Biographies and Selected Bibliographies

Following are selected biographies and bibliographies for the artists featured in *Common Ground: Discovering Community in 150 Years of Art*. Alana Quinn (AQ) supervised the research and wrote many of these texts. Hilary Allard (HA), Philip Brookman (PB), Emilie Johnson (EJ), and Paul Roth (PR) each wrote additional entries. For general information about the Julia J. Norrell Collection and some of the artists it includes, see *Myth, Memory and Imagination: Universal Themes in the Life and Culture of the South, Selections from the Collection of Julia J. Norrell*, exhib. cat. by Jay Williams *et al.*, Columbia SC, McKissick Museum, University of South Carolina, 1999.

Ansel Adams (born 1902, California — died 1984, California) Landscape photographer and master printer, outdoorsman and conservationist, pioneering educator and crusader for the medium, Ansel Adams was photography's most public and revered figure. He was a founder of Group f.64 (which argued in 1932 for a precisionist photographic aesthetic) and a Sierra Club director from 1934 to 1971, and his majestic black-and-white photographs of the American wilderness were both homages to nature in the vein of American Romantic painting and visual evidence in support of environmentalist politics. Although his images of Yosemite National Park are widely known, Adams's greatest contribution may be his popularization of photography as an art form. His many books put technical mastery within reach of the amateur (via his "zone system" of photographic exposure), and he was instrumental in founding many important university programs, museum departments, and resource centers devoted to photography. In 1980 Adams was awarded the nation's highest civic honor, the Presidential Medal of Freedom. PR

Catalog numbers: 1, 2

Ansel Adams, *Examples: The Making of 40 Photographs*, Boston (Little, Brown & Co.) 1983

Ansel Adams, with Mary Street Alinder, *Ansel Adams, An Autobiography*, Boston (Bulfinch Press) 1985

Mary Street Alinder (ed.), *Ansel Adams: Letters and Images, 1916–1984*, Boston (Bulfinch Press) 1988

Ken Ashton (born 1963, Washington) Ken Ashton has spent many years photographing the Washington D.C. metropolitan area and other urban centers in the United States and abroad. His work explores the subtle transitions that take place in working-class neighborhoods and inner cities as economic realities harden, people move in and out, new buildings rise up, and old ones fall into disrepair. In one such project, Ashton photographed abandoned theaters that were once thriving centers of entertainment and culture. His work is included in the collections of the Corcoran Gallery of Art, the Museum of Contemporary Photography, Chicago, and the University of Maryland, College Park. AQ & PR

Catalog number: 3

Deborah Willis, *Reflections in Black: A History of Black Photographers, 1840 to the Present*, New York (W.W. Norton & Co.) 2000

Shimon Attie (born 1957, California) Shimon Attie supported himself as a psychologist while studying art, leaving his first career after he received a master's degree in fine arts from San Francisco State University in 1991. Attie soon moved to Berlin and launched the distinct body of work *The Writing on the Wall*. In this series, Attie projected historical photographs of pre-World War II Jewish street life on to the building façades and street corners that presently mark the original locations in the photographs. In doing so, Attie visually retraced lost memories of people and places victimized during the war. Attie's work is included in the collections of the Corcoran Gallery of Art, the High Museum of Art, Atlanta, and the Museum of Modern Art. AQ

Catalog numbers: 4, 5

Shimon Attie, *Sites Unseen: Shimon Attie European Projects: Installations and Photographs*, Burlington VT (Verve) 1998

Eldridge Bagley (born 1945, Virginia) Eldridge Bagley grew up assuming that he would someday run his family's tobacco farm. In 1973 he read an inspiring article about self-taught artist Grandma Moses. Curious to test his own abilities, Bagley set out to find art supplies. He bought a paint-by-number kit at a local store and used the paints to create his own image over the pre-drawn lines. His early artistic interests soon blossomed into a successful career. Bagley is well known for his depictions of daily life in the rural South, where he continues to live and work. He is represented by White Canvas Gallery in Richmond. AQ

Catalog numbers: 6–8

Eldridge Bagley and Susan Tyler Hitchcock, *Eldridge Bagley: Son of the Soil, Soul of an Artist*, Richmond (Rand McNally Book Services Group) 1997

Eldridge Bagley, *Hounds Creek Chronicles*, 2004

Radcliffe Bailey (born 1968, New Jersey) Both personal and political, Radcliffe Bailey's work investigates the cross of cultures spurred by the African Diaspora. He is sympathetic to the stylistic affinities of artists at the vanguard of contemporary art, yet he has developed a visual vocabulary distinctly his own. Based in Atlanta, Bailey designed a large-scale painting in Hartsfield International Airport during the city's 1996 Olympics festivities. He has

collaborated with the band Arrested Development and often draws upon musical imagery. His work is included in the collections of more than a dozen American institutions, including the Corcoran Gallery of Art, the Harvard University Art Collection, The Metropolitan Museum of Art, and the Smithsonian American Art Museum. HA

Catalog number: 9

Rebecca Dimling Cochran, "Radcliffe Bailey," *Journal of Contemporary African Art*, no. 15, fall–winter 2001, p. 84

Nicholas Drake, "Spiritual Migrations: Radcliffe Bailey's Hybrid Identities," *Art Papers*, XXIV, no. 6, November–December 2000, pp. 24–27

Mason Klein, "Radcliffe Bailey," *Artforum*, XXXVIII, no. 6, February 2000, p. 121

Sheryl G. Tucker, "Artists and the Shotgun: Houston's Project Row Houses," *Art Papers*, XIX, no. 5, September–October 1995, pp. 35–39

George Barnard (born 1819, Connecticut — died 1902, New York)
George Barnard is best known for his extensive documentation of the United States during the Civil War. Employed by Mathew Brady's photography studio, Barnard covered General William T. Sherman's campaign through Georgia and the Carolinas. His use of the labor-intensive wet collodion process prevented him from making images of battles, and so, like many of his contemporaries, he chose to document their devastating aftermath instead. A prolific photographer, Barnard operated his own studio before and after the war. His work is included in the collections of the George Eastman House International Museum of Photography and Film and the Library of Congress. AQ

Catalog number: 10

George Barnard, *Photographic Views of Sherman's Campaign* [1866], New York (Dover Publications) 1977

David Bates (born 1952, Texas)
A Dallas native, David Bates commands a new generation of American modernists. He paints in vivid color, yet has also experimented with darker palettes, specifically during a period coinciding with the loss of his parents in the late 1990s. His expressive portraits of friends and family and life-affirming still lifes with flowers in full bloom compose a significant portion of his œuvre. Bates's work has appeared in numerous solo and group exhibitions and is included in the collections of the Corcoran Gallery of Art, the Dallas Museum of Art, The Metropolitan Museum of Art, and the San Francisco Museum of Modern Art. HA

Catalog number: 11

David Bates, exhib. cat. by David Bates and Carl Little, New York, DC Moore Gallery, 2004

David Bates: Forty Paintings, exhib. cat. by Marla Price, Modern Art Museum of Fort Worth, 1988

David Bates: Poems, exhib. cat. by David Bates and Philip van Keuren, Dallas, Dunn and Brown Contemporary, 2003

Virginia Beahan (born 1946, Pennsylvania)
Laura McPhee (born 1958, New York)
Virginia Beahan and Laura McPhee met in 1977, while attending an introductory photography course taught by Emmet Gowin at Princeton University. Ten years later, they set out on a photography trip together, each equipped with a camera. They have since cultivated a unique partnership, wherein both artists collaborate on all aspects of the picture-making process. They have traveled across the globe, from Iceland to Costa Rica, and from Sri Lanka to New York, in search of landscapes that reveal the complexity of people's attitudes toward and relationships with their environments. Their work is included in the collections of the Los Angeles County Museum of Art, The Museum of Fine Arts, Houston, and the San Francisco Museum of Modern Art. AQ

Catalog numbers: 12, 13

Virginia Beahan *et al.*, *No Ordinary Land: Encounters in a Changing Environment*, New York (Aperture) 1998

"Prophet" William J. Blackmon (born 1921, Michigan)
William J. Blackmon's strong faith in the eternal love and absolute power of God has shaped his life. He first discovered his talents for prophecy and healing upon discharge from the US Army after World War II. In the decades that followed, Blackmon practiced street preaching, and in the 1970s he opened his Revival Center and Shoe Repair Shop, a combination storefront church and neighborhood self-help agency in Milwaukee WI. His hand-painted signs attracted attention from local collectors, which, in turn, inspired him to paint figuratively. Over the past twenty years, Blackmon has depicted a range of subjects, from his favorite biblical scenes to issues of contemporary urban life. AQ

Catalog number: 14

Signs of Inspiration: The Art of William J. Blackmon, exhib. cat. by Jeffrey Russell Hayes *et al.*, Milwaukee, Patrick and Beatrice Haggerty Museum of Art, Marquette University, 1999

A. Aubrey Bodine (born 1906, Maryland — died 1970, Maryland)
A. Aubrey Bodine began his fifty-year career with *The Baltimore Sun* as a messenger. By the age of twenty-one, he had secured a position as a photojournalist for the newspaper. He is best remembered for his depictions of life on Maryland's Chesapeake Bay. His work is included in the collections of The Metropolitan Museum of Art, the Smithsonian Institution, and the Baltimore Museum of Art. AQ

Catalog number: 15

Kathleen M.H. Ewing, *A. Aubrey Bodine: Baltimore Pictorialist, 1906–1970*, Baltimore (Johns Hopkins University Press) 1985

Margaret Bourke-White (born 1906, New York — died 1971, Connecticut)
Noted as an innovator of the photo-essay, Margaret Bourke-White began her professional career as an industrial and architectural photographer. Her dramatic and original imagery caught the attention of Henry Luce, the successful publisher of the picture magazines *Time*, *Fortune*, and *Life*. In the 1930s she created photo-essays on Germany, the Soviet Union, and the American Midwest for *Fortune* and *Life*. Bourke-White became the first woman photographer to travel with the US Army during World War II. She continued her magazine work after the war, and became particularly well known for her images of Mahatma Gandhi. Her photographs are included in the collections of the Brooklyn Museum of Art, the George Eastman House International Museum of Photography and Film, and the Library of Congress. AQ

Catalog number: 16

Vicki Goldberg, *Margaret Bourke-White: A Biography*, New York (Harper & Row) 1986

Susan Goldman Rubin, *Margaret Bourke-White: Her Pictures Were Her Life*, New York (Harry N. Abrams) 1999

Brassaï (born 1899, Hungary — died 1984, France)
Born Gyula Halász, the artist adopted a pseudonym derived from his native city of Brassó, Hungary. Brassaï studied at art academies in Budapest and Berlin before settling in France in 1924, where he worked as a sculptor, painter, and journalist. He originally had little interest in photography, but found that it was sometimes necessary in his journalistic work. Influenced by photographer and friend André Kertész, Brassaï began photographing Paris at night, creating the work for which he is now most famous. His work is included in the collections of the George Eastman House International Museum of Photography and Film and the Museum of Modern Art. AQ

Catalog number: 17

Brassaï, *Paris by Night* [1933], Boston (Bulfinch Press) 2001

Brassaï: The Eye of Paris, exhib. cat. by Anne Tucker *et al.*, Houston, The Museum of Fine Arts and others, 1998–2000

Esther Bubley (born 1921, Wisconsin — died 1998, New York)
Esther Bubley's interest in photography developed in high school and strengthened in college. Her career was launched in 1942, when Roy Stryker hired her to work for the Office of War Information's photography unit in Washington D.C. Bubley became one of the preeminent freelance photographers during the "golden age" of American photojournalism. At a time when most women focused on domestic life, she was traveling the world as a photojournalist for *Life* and the *Ladies' Home Journal*, among other publications. Her work is included in the collections of the Library of Congress, The Metropolitan Museum of Art, and the Museum of Modern Art. AQ

Catalog number: 18

Let Us Now Praise Famous Women: Women Photographers for the US Government, 1935 to 1944, exhib. cat. by Andrea Fisher, Bradford, England, National Museum of Photography, Film and Television, 1987

Beverly Buchanan (born 1940, North Carolina)
Beverly Buchanan first identified herself as a visual artist when she began studying at the Arts Students' League in New York in the late 1960s. At that time, she worked as a health educator with a master's degree from Columbia University. Buchanan's drawings and sculptures of domestic structures capture the essence of the lives lived within. She responds viscerally to the connection between memory and reality, valuing the physical, spiritual, and emotional elements that constitute the idea of home. In 1980 Buchanan won both Guggenheim and National Endowment for the Arts fellowships. HA

Catalog numbers: 19–22

Bearing Witness: Contemporary Works by African American Women Artists, exhib. cat. by Jontyle Theresa Robinson *et al.*, Fort Wayne Museum of Art, 1996

David C. Driskell (ed.), *African American Visual Aesthetics: A Postmodernist View*, Washington D.C. (Smithsonian Institution Press) 1995

House and Home: Spirits of the South/Max Belcher, Beverly Buchanan, William Christenberry, exhib. cat. by Jock Reynolds *et al.*, Andover MA, Addison Gallery of American Art and others, 1994

Debbie Fleming Caffery (born 1948, Louisiana)
In photographs of the American South and Mexico, Debbie Fleming Caffery evokes psychological moments by manipulating light and shadow. A native of Louisiana bayou country, she uses the moody, regional, and almost cinematic light of the area to create images that are at once real and surreal. Her ability to combine several photographic processes in a single work establishes relationships among people, the landscape, folk rituals, and visionary thinking. Employing the traditions of documentary and environmental portraiture, she emphasizes the visual symbolism of her subjects. Caffery's photographs are as much about personal feelings, movement, and the passage of time as they are about people and places. Her work is included in the collections of the George Eastman House International Museum of Photography and Film, The Metropolitan Museum of Art, and The Museum of Fine Arts, Houston. PB

Catalog numbers: 23, 24

Debbie Fleming Caffery, *Carry Me Home: Louisiana Sugar Country Photographs*, Washington D.C. (Smithsonian Institution Press) 1990

Debbie Fleming Caffery, *The Shadows*, Santa Fe NM (Twin Palms Publishers) 2002

John Candelario (born 1916, New Mexico — died 1993)
A seventh-generation New Mexican, John Candelario got his start sharpening knives for Georgia O'Keeffe. He photographed O'Keeffe, who then shared the images with her husband, the photographer Alfred Stieglitz. Stieglitz displayed some of the works in his own gallery, which led to Candelario's first major exhibition in 1944 at the Museum of Modern Art. He became known for his dramatic images of New Mexico's Native Americans, landscapes, and adobe architecture, which graced numerous magazine covers, including *Life*, *Look*, and the *Saturday Evening Post*. In the 1950s he turned to color photography, screenwriting, and film production. AQ

Catalog number: 25

Retratos Nuevos Mexicanos: A Collection of Hispanic New Mexico Photography, exhib. cat. by Steve Yates, Taos NM, Harwood Foundation Museum, University of New Mexico, 1993

Three Generations of Hispanic Photographers Working in New Mexico, exhib. cat. by Van Deren Coke, Taos NM, Harwood Foundation Museum, University of New Mexico, 1993

Manuel Carrillo (born 1906, Mexico — died 1989, Mexico)
Manuel Carrillo launched his photography career at the age of forty-nine when he joined the Club Fotográfico de Mexico and the Photographic Society of America. Up until that point, he had divided much of his time between the United States and Mexico, performing as a waltz and tango champion, and working for a Wall Street firm. He returned to Mexico in 1930, where he eventually sought employment with the Illinois Central Railroad's office in Mexico City. Carrillo is noted as a photographer of images that capture the spirit of daily life in rural Mexico during the country's post-revolutionary period. His first exhibition, entitled *Mi Pueblo* (My People), was held at the Chicago Public Library in 1960. An extensive archive of his work is located at the University of El Paso, Texas. AQ

Catalog number: 26

William Christenberry (born 1936, Alabama)
William Christenberry moved briefly from Alabama to New York in 1961, during the twilight of Abstract Expressionism and the explosion of Pop Art. With an affinity for everyday objects, Christenberry maps the political and social landscape of the American South. He practices in a range of media including painting, collage, and assemblage. His most poignant photographs document vernacular architecture within a fixed yet ageing landscape. He has been a professor of drawing and painting at the Corcoran College of Art and Design in Washington D.C. since 1968. HA

Catalog numbers: 27–30

William Christenberry, *Southern Photographs: William Christenberry*, Millerton NY (Aperture) 1983

Of Time and Place: Walker Evans and William Christenberry, exhib.

cat. by Thomas Southall, Fort Worth TX, Amon Carter Museum and others, 1990

William Christenberry: The Early Years 1954–1968, exhib. cat. by Richard J. Gruber, Augusta GA, Morris Museum of Art, 1996

William H. Clarke (born 1950, Virginia)
William H. Clarke grew up in the rural farming community of Blackstone, Virginia. He began painting and drawing at the age of six. As a teenager, he won prizes for his work and excelled in a college-level correspondence art course. His work depicts life in the rural counties of Virginia, where he lives. Clarke is a deeply religious man whose mission is to share and express his God-given artistic talent with others. He is represented by White Canvas Gallery in Richmond. AQ

Catalog numbers: 31–33

Kim Sicola, "Helen Singleton, William Clarke, and Lee Battaglia: Three Virginia Artists Look Back," *Folk Art Messenger*, XV, no. 2, 2002, pp. 24–27

William Clift (born 1944, Massachusetts)
William Clift is a photographer whose work focuses on architecture, landscape, and family portraits. Mainly self-taught, he built a darkroom at the age of ten and, as a teenager, participated in a workshop with renowned photographer Paul Caponigro. From 1962 to 1970, he also did commerical work specializing in architectural subjects. He then settled in Santa Fe NM, where he became captivated by the New Mexican landscape. In 1975, Clift photographed county court houses across the country. His quiet imagery imposes order on chaos and subtly references law and religion. Clift has been the recipient of many fellowships, including two Guggenheims, and his photographs are included in the collections of over ninety institutions AQ

Catalog numbers: 34, 35

William Clift, *Certain Places*, Santa Fe NM (William Clift Editions) 1987

William Clift, *A Hudson Landscape*, Santa Fe NM (William Clift Editions) 1994

Clyde Connell (born 1901, Louisiana — died 1998, Louisiana)
The eldest daughter of plantation owners, Clyde Connell showed artistic skill at an early age. She took several art courses at Georgia's Breneau College before marrying and raising a family. She continued to paint throughout the 1930s, 1940s, and 1950s, mainly working with figurative imagery. Her work reached a turning point in the mid-1950s, when she saw the Abstract Expressionist works of Jackson Pollock, Willem de Kooning, and Franz Kline in New York. Her paintings evolved into abstract collages, and she began experimenting with layers of thick paint, paper, and found objects. Her husband's retirement in 1959 prompted their move to rural Lake Bistineau, and it was there that her work reached its full creative potential. Drawing inspiration and

materials from the dense forest that surrounded their lakefront home, Connell created sculptures that relate closely to natural cycles of birth, life, and death. Her work is included in the collection of Louisiana State University. AQ

Catalog number: 36

Charlotte Moser, *Clyde Connell: The Art and Life of a Louisiana Woman*, Austin (University of Texas) 1988

Linda Connor (born 1944, New York)
Linda Connor studied under photographers Harry Callahan and Aaron Siskind. Her interest in spiritual subjects has led her to photograph sacred sites in India, Nepal, Thailand, Egypt, and North America. She is best known for the luminous and otherworldly character of her prints, which are made with a characteristically nineteenth-century process on gold-toned printing-out paper. Her work is included in the collections of the Corcoran Gallery of Art, the Museum of Modern Art, and the San Francisco Museum of Modern Art. AQ & PR

Catalog numbers: 37, 38

Linda Connor *et al.*, *Marks in Place: Contemporary Responses to Rock Art*, Albuquerque NM (University of New Mexico Press) 1988

Spiral Journey: Photographs 1967–1990, exhib. cat. by Linda Connor, Chicago, The Museum of Contemporary Photography, Columbia College, 1990

Roy DeCarava (born 1919, New York)
Trained as a painter and printmaker, Roy DeCarava originally used photography to explore ideas for his subject matter. He was influenced by his older contemporaries, including Jacob Lawrence, Romare Bearden, and Charles White, whose work focused on African American life and history. While supporting himself as a commercial illustrator, DeCarava's interests gradually shifted toward photography, documenting the jazz musicians and street life of his Harlem neighborhood. In the 1960s, he traveled to Washington D.C. to document civil-rights protests. He spent much of the 1960s and 1970s making pictures on assignment for *Sports Illustrated*. His work is included in the collections of The Metropolitan Museum of Art, the Museum of Modern Art, and the Corcoran Gallery of Art. AQ

Catalog numbers: 39, 40

Roy DeCarava, *The Sound I Saw*, London and New York (Phaidon Press) 2001

Roy DeCarava and Langston Hughes, *The Sweet Flypaper of Life*, New York (Simon & Schuster) 1955

Roy DeCarava: A Retrospective, exhib. cat. by Peter Galassi and Sherry Turner DeCarava, New York, Museum of Modern Art, 1996

Adolf Dehn (born 1895, Minnesota — died 1968, New York)
Known for his contributions to the art and technique of lithography, Adolf Dehn spent much of his adult life in Europe and North America, creating prints that satirized the upper classes and romanticized the landscape. The son of second-generation German-Americans, he spent his childhood sketching animals on their Minnesota farm. After attending the Minneapolis School of Art, Dehn set his sights on Europe, and spent much of the 1920s in Berlin, London, Paris, and Vienna where he thrived in the booming art scene. He maintained connections on both sides of the Atlantic, and had numerous shows in New York galleries in the 1920s and 1930s. Over the last thirty years of his life, he taught, traveled extensively, and continued to expand the boundaries of the print medium. He was the recipient of a Guggenheim Fellowship and his work is included in the collections of The Metropolitan Museum of Art, the Museum of Modern Art, and the Whitney Museum of American Art. AQ

Catalog number: 41

Joycelyn Pang Lumsdaine and Thomas O'Sullivan, *The Prints of Adolf Dehn: A Catalogue Raisonné*, St. Paul (Minnesota Historical Society) 1987

David Driskell (born 1931, Georgia)
A leading authority on African American art, David Driskell is also a renowned artist. His paintings, prints, and collages are inspired by a wide range of art-historical sources and his own African American heritage and southern upbringing. Seen as a whole, Driskell's work reveals the complex relationships between various cultures and art movements. He is Professor Emeritus of Art at the University of Maryland, and has lectured at many prestigious institutions, including Bowdoin College, Brunswick ME, the Corcoran Gallery of Art, and The Metropolitan Museum of Art. AQ

Catalog numbers: 42, 43

David Driskell: A Survey, exhib. cat. by Edith A. Tonelli, College Park MD, University of Maryland Art Gallery, 1980

Two Centuries of Black American Art, exhib. cat. by David C. Driskell, Los Angeles County Museum of Art and others, 1976

William Dunlap (born 1944, Mississippi)
Drawing influence from the rich narrative traditions of the South and from American art movements of the nineteenth and twentieth centuries, William Dunlap creates symbolic paintings and mixed-media constructions in a style he describes as "hypothetical realism." His images often feature imagined settings composed from sketches and photographs of multiple existing locations. After receiving his MFA from the University of Mississippi, Dunlap pursued a teaching career that he set aside in the late 1970s to focus on his art-making practice full-time. Since then, he has gained widespread recognition for his work, which, with its unique blend of symbolism and realism, cannot easily be classified. His work is included in the collections of the Corcoran Gallery of Art, the Mississippi Museum of Art, and The Metropolitan Museum of Art. AQ

Catalog number: 44

William Dunlap: Re-constructed Re-collections, exhib. cat. by William Dunlap and Ruth Stevens Appelhof, Roanoke VA, Art Museum of Western Virginia and others, 1992

Clifford Earl (born 1945, Washington D.C.)
As a child in Washington D.C., Clifford Earl frequented the Smithsonian Institution and National Zoo. He particularly enjoyed sketching in the zoo's serpentarium. Today, he still finds inspiration in animals, as well as in an array of found materials, including earrings, old engines, and twigs. Earl's desire to make works of art out of simple objects has led him to create playful sculptures, flying machines, wheeled mechanical toys, and carved wooden tables. His sculptures are included in the collections of Lawrence Rockefeller, Philip Morris & Co., and the Federal Reserve Bank. AQ

Catalog number: 45

William Eggleston (born 1939, Tennessee)
A pioneering artist who broke away from traditional black-and-white prints, in 1976 William Eggleston was the subject of the first exhibition of color photography at the Museum of Modern Art. He uses bright, contrasting colors and an ostensibly unstudied, spontaneous approach to celebrate the beauty of the commonplace object. Eggleston documents the places he knows intimately, and he takes the time to appreciate the unusualness of familiar subjects. His images of domestic exteriors are characterized by strict compositional organization and a distinctive point of view, in effect transforming the images from seemingly straightforward snapshots to extremely deliberate, highly crafted works of art. Examples of Eggleston's work can be found in the collections of the Cleveland Museum of Art, the High Museum of Art, Atlanta, the J. Paul Getty Museum, and the Museum of Modern Art. EJ

Catalog number: 46

William Eggleston, *The Democratic Forest*, New York (Doubleday) 1989

William Eggleston's Guide, exhib. cat. by William Eggleston and John Szarkowski, New York, Museum of Modern Art, 1976

Elliott Erwitt (born 1928, Paris)
Known for his skillful use of visual puns, Elliott Erwitt is both a photojournalist and a formalist. The son of Russian immigrants, he settled in New York in 1948, where he studied film at the New School for Social Research. He soon met photography luminaries Edward Steichen, Robert Capa, and Roy Stryker. In 1953 Capa invited Erwitt to join Magnum Photos. His work is included in the collections of The Art Institute of Chicago, the Museum of Modern Art, and the Smithsonian Institution. AQ

Catalog number: 47

Elliott Erwitt, *Personal Exposures*, New York (W.W. Norton & Co.) 1988

Elliott Erwitt, John Szarkowski, and Sam Holmes, *Photographs and Anti-Photographs*, London and New York (Thames & Hudson) 1972

Elliott Erwitt and Wilfred Sheed, *Recent Developments*, New York (Simon & Schuster) 1978

Walker Evans (born 1903, Missouri — died 1975, Connecticut)
Through his straightforward, impeccably composed images and his love of American vernacular culture, Walker Evans helped redefine documentary photography in the 1920s and 1930s. Reacting against pictorialist traditions in art and photography, Evans developed an expository style in an effort to capture the heart of his subjects in a more truthful way. From 1935 to 1937 he photographed for the Farm Security Administration, detailing in frontal compositions the look and symbolism of Depression-era America. During this time he also worked with writer James Agee to document sharecropper families and architecture in Alabama for their book, *Let Us Now Praise Famous Men* (1940). In 1938 a selection of his pictures was published as *American Photographs*, a groundbreaking, literary sequence that helped create a new language for photography. He later worked as an editor for *Time* and *Fortune* magazines and taught at Yale University. His photographs are included in the collections of The Metropolitan Museum of Art, the J. Paul Getty Museum, and the National Gallery of Art. PB

Catalog numbers: 48–52

Walker Evans and Lincoln Kirstein, *American Photographs* [1938], New York (Museum of Modern Art) 2004

Walker Evans, exhib. cat. by Jeff Rosenheim, Maria Morris Hambourg *et al.*, New York, San Francisco, and Houston, 2000–01

Howard Finster (born 1916, Alabama — died 2001, Georgia)
Howard Finster spent most of his life as a pastor at several small churches throughout Alabama. He was drawn to this vocation through visions that began when he was only three years old. In 1976 Finster reported that a humanoid face appeared in a paint smudge on his finger and told him to "paint sacred art." By this time, his Paradise Gardens Park and Museum — an outdoor display of makeshift monuments, found-object constructions, and hand-painted religious signs in Penville GA—had gained public attention. His visions reaffirmed his art making, and he spent the last twenty-five years of his life creating over forty-five thousand religious works of art. His work appears on the covers of recordings by REM and the Talking Heads, and he represented the United States at the Venice Biennale in 1984. AQ

Catalog number: 53

Howard Finster *et al.*, *Howard Finster: Stranger from Another World: Man of Visions Now on This Earth*, New York (Abbeville Press) 1989

Thelma Finster Bradshaw, *Howard Finster: The Early Years: A Private Portrait of America's Premier Folk Artist*, Birmingham AL (Crane Hill Publishers) 2001

Robert Frank (born 1924, Switzerland)
For more than fifty years, Robert Frank has repeatedly broken the rules of photography and filmmaking to expand their expressive potential. Best known for his seminal book *The Americans*, first published in 1958, he pioneered a revolutionary approach to art that combines autobiography, poetry, and emotion with the logic of gritty realism. Frank moved from Zurich to New York in 1947. In 1954 he received a Guggenheim Fellowship, and he spent the next two years photographing throughout the United States. *The Americans* presents an unflinching look at important cultural themes of the United States in the 1950s: race, politics, poverty, religion, cars, and music. Frank briefly gave up still photography for filmmaking, and in the late 1960s he moved from New York to Nova Scotia, Canada. He began to explore his own life in collages, montages, films, and videos about the landscape, people, and everyday things around him. His photographs are in the collections of the Corcoran Gallery of Art, the National Gallery of Art, the Museum of Modern Art, and The Museum of Fine Arts, Houston. PB

Catalog number: 54

Robert Frank, *The Americans* [1958], Zurich (Scalo) 1998

Sarah Greenough and Philip Brookman, *Robert Frank: Moving Out*, Zurich (Scalo) 1994

David Freed (born 1936, Ohio)
Involved in the arts throughout his adolescence, David Freed found true inspiration when he saw an intaglio print by Mauricio Lasansky while in college. Soon afterward, he pursued an opportunity to study printmaking with Lasansky at the University of Iowa. Today, Freed is known for his insightful portraits of friends and his abstract depictions of weather and landscape. He has taught painting and printmaking at Virginia Commonwealth University in Richmond since 1966. His work is included in the collections of the Library of Congress, the Museum of Modern Art, and the Victoria and Albert Museum, London. AQ

Catalog number: 55

David Freed, Printmaker: A Retrospective, exhib. cat. by David Freed and Ted Potter, Richmond, Anderson Gallery, Virginia Commonwealth University and others, 2001

Leonard Freed (born 1929, New York)
Son of working-class Jewish immigrant parents, Leonard Freed wanted to become a painter. In 1954, following travels to Europe and North Africa, he studied photography at Alexei Brodovitch's "design laboratory." Freed first became known as a photographer after his documentation of the American civil rights movement in the 1960s, in which he explored complex social issues such as racism and violence. His work, characterized by an uncompromising mixture of aesthetic and photojournalistic practices, has been widely appreciated. Freed is well known for his 1980 book *Police Work*, and for his photographs of the Ku Klux Klan,

landscapes in Germany, and his own Jewish roots. He became a member of Magnum Photos in 1972 and has worked on assignments for *Life*, *Look*, *Paris Match*, *Die Zeit*, *Der Spiegel*, *Stern*, *London Sunday Times Magazine*, *The New York Times Magazine*, *GEO*, *L'Express*, *Libération*, and *Fortune*. He has also created films for Japanese, Dutch, and Belgium television. PB

Catalog number: 56

Leonard Freed, *Black in White America*, New York (Grossman Publishers) 1967

Leonard Freed, *Leonard Freed: Photographs 1954–1990*, New York (W.W. Norton & Company) 1992

Lee Friedlander (born 1934, Washington)
Lee Friedlander began his career photographing for album covers and New Orleans jazz musicians, work that earned him the first of his three Guggenheim Fellowships. An extremely versatile artist, Friedlander chooses subjects such as street scenes, urban and suburban buildings, monuments, desert landscapes, social gatherings, and nudes. Adept at incorporating multiple reflections, layered shadows, and obstructed vantage points into his complex images, Friedlander examines American vernacular culture in a democratic, documentary style. The subject of three solo exhibitions at the Museum of Modern Art, his photographs are included in the collections of The Art Institute of Chicago, The Metropolitan Museum of Art, the Museum of Fine Arts, Boston, and the National Gallery of Art. EJ

Catalog number: 57

Lee Friedlander, *Lee Friedlander at Work*, New York (Distributed Art Publishers) 2002

Like a One-Eyed Cat, exhib. cat. by Rod Slemmons, Seattle Art Museum and others, 1989

Flor Garduño (born 1957, Mexico)
Flor Garduño is a photographer who draws inspiration from her Mexican heritage and extensive knowledge of world mythology and art history. The former studio assistant of acclaimed photographer Manuel Alvarez Bravo, Garduño discovered her personal vision and style in the 1980s while traveling across remote parts of Latin America to photograph indigenous cultures. These journeys lead to her first major publication, *Witnesses of Time* (1992). Soon afterwards, she gave birth to her second child, and began exploring the procreative life force through symbolic images of female nudes. Garduño's photographs are included in the collections of the J. Paul Getty Museum, the Museum of Modern Art, and the Stiftung für Photographie, Zurich, Switzerland. AQ

Catalog number: 58

Flor Garduño, *Inner Light: Still Lifes and Nudes*, New York (Bulfinch Press) 2002

Flor Garduño and Carlos Fuentes, *Witnesses of Time,* London and New York (Thames & Hudson) 1992

William Gedney (born 1932, New York — died 1989, New York)
In the early 1960s, William Gedney gave up his budding career as a graphic designer at *Time* and *Glamour* magazines to pursue freelance photography. On one of his first endeavors, he traveled to eastern Kentucky and produced an insightful body of work about poverty-stricken families of the coal-mining industry. Gedney received a Guggenheim Fellowship for this body of work, enabling him to continue to document life across the United States. In the late 1960s, while teaching photography at Pratt Institute and Cooper Union in New York, he was awarded a Fulbright Scholarship to support a year-long project in Banaras, India. In this and other work, Gedney keenly observed and sensitively portrayed cultures other than his own. His work is included in the collections of Duke University, the George Eastman House International Museum of Photography and Film, and the Museum of Modern Art. AQ

Catalog numbers: 59, 60

Margaret Sartor and Geoff Dyer (eds.), *What Was True: The Photographs and Notebooks of William Gedney*, New York (Lyndhurst Books) 2000

Laura Gilpin (born 1891, Colorado — died 1979, New Mexico)
An early woman photographer working in the American Southwest, Laura Gilpin distinguished herself from her contemporaries by focusing on humans' relationship to and impact upon the landscape. Gilpin developed an empathetic, straightforward style over a long career, which culminated in an extensive project on the Navajo, a culture she believed had best adapted to the harsh conditions, dramatic cliffs, and arid deserts of Arizona and New Mexico. She captured wide, encompassing vistas that showed the landscape in a symbiotic relationship with human settlements. This body of work has been cited for its intense cultural sensitivity as well as its intimacy and familiarity with the Navajo way of life. Gilpin's work is included in the collections of the Amon Carter Museum, Fort Worth, the Library of Congress, and the St. Louis Art Museum. EJ

Catalog numbers: 61–63

Laura Gilpin, *The Enduring Navajo*, Austin TX (University of Texas Press) 1968

Laura Gilpin: An Enduring Grace, exhib. cat. by Martha A. Sandweiss, Fort Worth TX, Amon Carter Museum, 1986

Martha A. Sandweiss, "Laura Gilpin and the Tradition of American Landscape Photography," in Vera Norwood and Janice Monk (eds.), *The Desert Is No Lady: Southwestern Landscapes in Women's Writing and Art*, New Haven CT (Yale University Press) 1987

Jim Goldberg (born 1953, Connecticut)
Jim Goldberg is an artist and writer involved in long-term collaborations with mostly invisible or misrepresented communities. Best known for his photographic books and multimedia exhibits, he has pioneered new ways to include his subjects in his art. In *Rich and Poor* he asked wealthy and impoverished people to write their thoughts and dreams on photographs of themselves, a process he expanded in later projects, including *Nursing Home*, *Raised by Wolves*, and *Hospice*. He often uses Polaroid film to make instant pictures that can be manipulated by his subjects. His work, which sometimes combines both fact and fiction, has expanded the limits of documentary art. Goldberg's fashion and editorial photographs have appeared in numerous publications, and he is a member of Magnum Photos. His photographs are in the collection of the Corcoran Gallery of Art, the Museum of Modern Art, and the San Francisco Museum of Modern Art. PB

Catalog number: 64

Jim Goldberg, *Rich and Poor*, New York (Random House) 1985

Raised by Wolves, exhib. cat. by Jim Goldberg and Philip Brookman, Washington D.C., Andover MA, and Zurich, 1995

Elijah Gowin (born 1967, Ohio)
Elijah Gowin's photographs reveal an often whimsical mix of fantasy and realism that come together in mysterious, staged tableaux. Rooted in the folk cultures and family traditions of rural Virginia, these intricately toned photographs use people and places from Gowin's past, as well as his visual memories. They depict scenes that evoke a kind of science-fiction assemblage art, suggesting a world removed from reality. He often poses people in their own environment, adding his own odd creations to adjust the tension between fact and imagination. Gowin holds a BA in Fine Arts from Davidson College, North Carolina and an MFA in photography from the University of New Mexico, Albuquerque. Recent exhibitions include those at The Light Factory, Charlotte NC, Dolphin Gallery, Gualola CA, and Robert Mann Gallery, New York. His photographs are included in the collection of the Corcoran Gallery of Art. PB

Catalog number: 65

Elijah Gowin, *Hymnal of Dreams*, New York (Robert Mann Gallery) 2001

Emmet Gowin (born 1941, Virginia)
Emmet Gowin is best known for intimate photographs of family life in rural Virginia and autobiographical images of his extended family and their relationship to the natural world. His simple yet profound view of family and community focuses on universal details of everyday life. Like a family album, his images reveal intimate moments and significant emotional details; they are sometimes composed, but nonetheless presented as true. Gowin tones his images to give each a unique, rich patina that further abstracts their documentary nature. He also transforms viewpoint by using distorting lenses or an aerial perspective. In 1980 Gowin began photographing the landscape from the air. These photographs of nuclear facilities, irrigation farming, mines, coal pits, battlefields, missile silos, and bombing test sites

convey both beauty and the offensive scars of improper land use. Gowin is a professor of art at Princeton University, New Jersey, and his photographs are in many museum collections, including The Art Institute of Chicago, the Museum of Modern Art, and the Philadelphia Museum of Art. PB

Catalog number: 66

Emmet Gowin, Changing the Earth, exhib. cat. by Jock Reynolds, New Haven CT, Yale University Art Gallery; Washington D.C., Corcoran Gallery of Art, 2002

Emmet Gowin: Photographs, exhib. cat. by Emmet Gowin and Martha Charoudi, Philadelphia Museum of Art, 1990

David Graham (born 1952, Pennsylvania)
David Graham spent his childhood in Abington PA, a rather typical American suburb roughly ten miles outside of Philadelphia. He has documented characteristic examples of the American backyard, where everyday items such as lawn furniture, tool sheds, and children's toys express both individuality and uniformity. Graham has photographed a wide range of subjects and landscapes and has collaborated with writers, poets, and other artists. His work is included in the collections of The Art Institute of Chicago, the San Francisco Museum of Modern Art, and the Bibliothèque Nationale, Paris, France. HA

Catalog number: 67

Andrei Codrescu and David Graham, *Road Scholar: Coast to Coast in the Late Century*, New York (Hyperion) 1993

David Graham, *American Beauty: Photographs by David Graham*, New York (Aperture) 1987

David Graham, *Only in America: Some Unexpected Scenery*, New York (Knopf) 1991

David Graham, *Taking Liberties: Photographs by David Graham*, Boston (Pond Press) 2001

Edward Grazda (born 1947, New York)
Edward Grazda uses photography to explore diverse cultures in new ways. His images are often unsettling and surreal. He animates different symbolic elements in his pictures by creating unusual, skewed compositions and focusing on the stark contrast between black and white. His work often expresses the feeling of bringing the viewer into the picture so that he or she sees through the photographer's eyes. In the 1970s Grazda photographed in Latin America, and in the 1980s he began working in Asia. His in-depth coverage of the changes taking place in Afghanistan since 1980 is one of the best records of these historical events. Grazda studied photography with Harry Callahan and Emmet Gowin at the Rhode Island School of Design. He has taught at Harvard University, and his photographs are included in the collections of the Corcoran Gallery of Art, The Metropolitan Museum of Art, the Museum of Modern Art, and the San Francisco Museum of Modern Art. PB

Catalog number: 68

Jerrilynn Denise Dodds and Edward Grazda, *New York Masjid/Mosques of New York*, New York (PowerHouse Books) 2002
Edward Grazda, *Afghanistan Diary: 1992–2000*, New York (PowerHouse Books) 2000

Jonathan Green (born 1955, South Carolina)
Through his paintings, Jonathan Green strives to keep the memories and traditions of his Gullah community alive. The Gullahs are a group of African Americans whose unique culture and dialect reflect their West African ancestry. In recent years, Green has witnessed the many new roads, homes, and stores that have transformed this area of South Carolina. It was not until he moved to study at The Art Institute of Chicago that he began to realize the full importance of his heritage. In his vibrant paintings, Green depicts members of this coastal area as they attend church, recount stories, farm, and go about their daily lives. His work is included in the collections of the African American Museum, Philadelphia, the Gibbes Museum of Art, and the Norton Museum of Art. AQ

Catalog numbers: 69, 70

Jonathan Green, *Gullah Images: The Art of Jonathan Green*, Columbia SC (University of South Carolina Press) 1996

Sid Grossman (born 1914, New York — died 1955, New York)
Sid Grossman is perhaps best known for his significant contribution to New York City's Photo League, a group of politically liberal and socially conscious photographers who used the medium to document and assist working-class Americans. A founding member of the League, Grossman also designed, directed, and taught at its school from 1938 until 1949. His early photographs include depictions of inner-city communities in New York and the activities of the Southern Tenant Farmers' Union in Missouri, Oklahoma, and Arkansas. He resigned from the Photo League in 1949 amid growing speculation that he and other members were closely allied with the Communist Party. His departure marked a shift in his subject matter and style, which became increasingly abstract, with a focus on the beaches and area surrounding Provincetown MA. His photographs are included in the collections of the Amon Carter Museum, the Museum of Modern Art, the National Portrait Gallery, and the Whitney Museum of American Art. AQ

Catalog number: 71

Les Barry, "The Legend of Sid Grossman," *Popular Photography*, November 1961, pp. 51–94

Lili Corbus Bezner, *Photography and Politics in America: From the New Deal to the Cold War*, Baltimore (Johns Hopkins University) 1999

Millard Lampell and Sid Grossman, *Journey to the Cape*, New York (Grove Press) 1959

Anne Tucker, "Sid Grossman," *Creative Camera*, no. 223–224, July–August 1983, pp. 1034–41

John Gutmann (born 1905, Germany — died 1998, California)
Trained in painting under German Expressionist Otto Müller, John Gutmann anticipated a career in Berlin's flourishing art scene. His plan changed, however, when he fled Hitler's Germany in 1933, heading to San Francisco under the guise of a photojournalist for Berlin's Presse-Foto agency. Fascinated with the cultural diversity and exoticism of his new home, Gutmann began seeking distinctly American subject matter, which he then sent to illustrated magazines in Europe. As an isolated foreigner, he was able to capture American culture from a unique perspective. He is best known for his street photography of the 1930s and 1940s, which depicted the optimism of the times despite the Depression and looming war. The recipient of a Guggenheim Fellowship, Gutmann taught at San Francisco State College (now San Francisco State University) for forty-seven years. His work is included in the collections of the Corcoran Gallery of Art, The Metropolitan Museum of Art, and the Museum of Modern Art. AQ

Catalog numbers: 72–74

Sandra S. Phillips, *The Photography of John Gutmann: Culture Shock*, London (Merrell Publishers) 2000

Theora Hamblett (born 1895, Mississippi — died 1977, Mississippi)
Theora Hamblett grew up in a farming community and spent her young adult life teaching in various nearby schools. In 1931 health problems forced her to retire, and she returned to her family's farm to care for her ailing mother. After her mother's death, Hamblett moved to Oxford MS, home to the University of Mississippi, where she bought a house and rented rooms to college students to support herself. In 1950 Hamblett attended an art class at the university and began to paint, often depicting childhood memories, the southern landscape, and her dreams, rooted in Christian symbolism. Her work is included in the collections of the Museum of Modern Art, the Nelson Rockefeller Collection, and the University of Mississippi Museum. AQ

Catalog number: 75

Paul Grootkerk, "The Visionary Paintings of Theora Hamblett," *Woman's Art Journal*, XI, no. 2, 1990–91, pp. 19–22

Theora Hamblett, *Theora Hamblett Paintings*, Jackson MS (University Press of Mississippi) 1975

Mary Hearne (born 1934, Arkansas)
Raised in a close-knit community of loggers and sharecroppers, Mary Hearne has lived in Arkansas and the Gulf Coast states of Texas and Florida for most of her life. She is a well-known personality in Little Rock AR, and is an active participant in the local community. Entirely self-taught, she often depicts people and scenes related to her daily life and family history. She was selected for an exhibition, organized by the Arkansas Committee, at the National Museum for Women in the Arts in Washington D.C., and her work is included in the collection of Bill and Hillary Clinton. HA

Catalog number: 76

Michael O'Sullivan, "Creative Impulses for 1997," *The Washington Post*, January 2, 1997

Chester Higgins Jr. (born 1946, Alabama)
Chester Higgins Jr. has been a staff photographer at *The New York Times* since 1975. Influenced greatly by P.H. Polk, Gordon Parks, and Romare Bearden, Higgins documents the political, cultural, and social realities confronting Africans of the Diaspora. Considering himself a cultural anthropologist with a camera, he has traveled extensively to uncover diverse traditions and expressions of spirituality. With empathy and respect, his work ennobles historically marginalized groups, including African American women and senior citizens. He has received grants from the International Center for Photography, the National Endowment for the Arts, and the Andy Warhol Foundation, among others. He has been featured in numerous solo and group exhibitions and has collaborated with PBS on a one-hour documentary entitled *BrotherMen*. HA

Catalog number: 77

Elder Grace: The Nobility of Aging, exhib. cat. by Chester Higgins Jr., New York Historical Society, 2000

Chester Higgins Jr., *Drums of Life: A Photographic Essay on the Black Man in America*, Garden City NY (Anchor Press) 1974

Chester Higgins Jr., *Feeling the Spirit: Searching the World for the People of Africa*, New York (Bantam Books) 1994

Chester Higgins Jr., *Echo of the Spirit: A Visual Journey*, New York (Doubleday) 2004

John K. Hillers (born 1843, Germany — died 1925, Washington D.C.)
A technically accomplished photographer, John K. Hillers is known for his anthropological and geographical studies of the American West. After resigning from his post with the Union Army in 1870, he met John Wesley Powell, Director of the Bureau of (American) Ethnology of the Smithsonian Institution. Hired initially as a boatman for Powell's expedition down the Colorado River, Hillers became the chief photographer for Powell's Geological and Geographic Survey of the Rocky Mountain Region and, later, the chief photographer for the United States Geological Survey. Hillers's extensive documentation of America's vanishing native cultures and majestic landscape has left a rich visual legacy. His work is included in the collections of the Denver Public Library, the National Archives, and the Smithsonian National Anthropological Archives. AQ

Catalog number: 78

Don D. Fowler (ed.), *"Photographed All the Best Scenery": Jack Hillers's Diary of the Powell Expeditions, 1871–1875*, Salt Lake City (University of Utah Press) 1972

Don D. Fowler, *The Western Photographs of John K. Hillers: "Myself in the Water,"* Washington D.C. (Smithsonian Institution Press) 1989

Lewis Hine (born 1874, Wisconsin — died 1940, New York)
Considered one of the greatest practitioners of documentary photography, Lewis Hine devoted his career to exposing social iniquity through photography. His subjects include Ellis Island immigrants, child laborers, street urchins, farmers, factory workers, and refugees and civilians in post-World War I Europe. By 1913 Hine was considered the leading social-welfare photographer in the United States, in part because of his series of photographs depicting impoverished southern farm workers. He was the chief photographer of the Works Progress Administration during the Great Depression. Hine wanted to work for the Farm Security Administration (FSA), but Roy Stryker, the director of the FSA, considered him too old-fashioned and difficult. Shortly after his death in 1940, Hine's work was rediscovered by the public and valued for effecting social change in the early twentieth century. EJ

Catalog number: 79

America and Lewis Hine: Photographs, 1904–1940, exhib. cat. by Alan Trachtenburg *et al.*, Brooklyn Museum of Art, 1977

Rita Huddleston (born 1940, Arkansas)
As a child growing up in Pine Bluff AR, Rita Huddleston's African American maid told her stories about the dolls she had played with in her youth. Many decades later, those stories inspired Huddleston to make African American dolls, some fashioned after her maid's relatives. She and her husband run a combination bed and breakfast and antique shop in Searsport ME, where she continues to make and sell crafts. AQ

Catalog number: 80

Jessie Walker, "A Countrified Condominium," *Country Living*, January 1985, pp. 80–85

Clementine Hunter (born *c.* 1886, Louisiana — died 1988, Louisiana)
The daughter of former slaves, Clementine Hunter spent most of her life as a field hand on Melrose Plantation in northern Louisiana. Her career as an artist began in the early 1940s, when she came across paints and brushes that a visitor had left behind. Hunter, who was functionally illiterate, painted rich and complex stories of plantation life. Her bold colors and patterns often depict cotton pickers, flowers, birds, and religious scenes. In 1986 she was awarded an honorary doctorate of fine arts degree from Northwestern State University in Natchitoches LA, in honor of her forty-year career as one of America's most prolific self-taught artists. Today, her work is included in the permanent collections of the Dallas Museum of Art, the High Museum of Art, Atlanta, and the National Museum of Women in the Arts, Washington D.C. AQ

Catalog number: 81

Ann Hudson Jones, "The Centennial of Clementine Hunter," *Woman's Art Journal*, VIII, no. 1, 1987, pp. 23–27

Mary E. Lyons, *Talking with Tebé: Clementine Hunter, Memory Artist*, Boston (Houghton Mifflin) 1998

Robert F. Ryan, "Clementine Hunter," *Raw Vision*, XXIV, fall 1998, pp. 54–59

James L. Wilson, *Clementine Hunter, American Folk Artist*, Gretna LA (Pelican Publishing Company) 1988

Birney Imes (born 1951, Mississippi)
Birney Imes is known for his intimate portrayal of African American communities in his native Mississippi. Interested in racial relations since his childhood in the segregated South, Imes did not pursue photography until after graduating from the University of Tennessee in Knoxville with a history degree. He attributes some of his influence to his father, the editor, publisher, and sometimes photographer for Columbus, Mississippi's daily newspaper, *The Commercial Dispatch*. In the 1970s, with the encouragement of a photographer friend, Imes took up the camera and began exploring the farms, villages, and roadside juke joints of Columbus MS. He first thought of photography as a hobby, and has since pursued the medium as a profession and an art form. AQ

Catalog number: 82

Vince Aletti, *Partial to Home: Photographs by Birney Imes*, Washington D.C. (Smithsonian Institution Press, in association with Constance Sullivan Editions) 1994

Birney Imes and Richard Ford, *Juke Joint: Photographs*, Jackson MS (University Press of Mississippi) 1990

Birney Imes and Trudy Wilner, *Whispering Pines*, Jackson MS (University Press of Mississippi) 1994

Graciela Iturbide (born 1942, Mexico)
Graciela Iturbide took an interest in photography as a child, but she pursued a career in writing. Her plans were interrupted in college when she married and started a family. The sudden death of her daughter in the early 1970s caused her to reassess her life, and she returned to school to study cinematography shortly thereafter. At this time, Iturbide met photographer Manuel Alvarez Bravo and apprenticed with him for a year and a half. She has since devoted herself to photography. Iturbide's interest in the indigenous cultures of Mexico has led her to many remote communities, where she gets to know her subjects intimately before photographing them. Her work has been exhibited at the Philadelphia Museum of Art and the San Francisco Museum of Modern Art. AQ

Catalog number: 83

Images of the Spirit, exhib. cat. by Graciela Iturbide, Philadelphia Museum of Art and others, 1996

Kenro Izu (born 1949, Japan)
In his youth, Kenro Izu's dream was to become a doctor. His interest in photography was sparked while in high school, when he used the medium as a tool to document medical specimens. He soon enrolled in Nihon University's College of Art to pursue a degree in photography. In 1979 Izu traveled to Egypt to photograph the pyramids. Inspired by the intense energy he perceived there, he has since devoted his career to photographing stone monuments at sacred sites across Asia and Europe. His work is in the collections of the Museum of Fine Arts, Boston, and the San Francisco Museum of Modern Art. AQ

Catalog number: 84

Along the Silk Road, exhib. cat. by Elizabeth Ten Grotenhuis, Washington D.C., Arthur M. Sackler Gallery, 2002

Kenro Izu, *Kenro Izu: Still Life*, Santa Fe NM (Arena Editions) 1998

Kenro Izu, *Kenro Izu: Sacred Places*, Santa Fe NM (Arena Editions) 2001

Nicario Jimenez (born 1957, Peru)
Indigenous Peruvian artist Nicario Jimenez creates brightly colored *retablos* that depict themes of religion, history, and modern life. Originally used as portable altars for medieval pilgrims in Europe, *retablos* came to Peru with the Spanish conquistadors during the sixteenth century. Today, Jimenez helps keep this evolving artistic tradition alive. His work is included in the collections of the Museum of International Folk Art, Santa Fe NM, the San Diego Museum of Man, and the Smithsonian Institution. AQ

Catalog number: 85

Rashid Johnson (born 1977, Illinois)
Rashid Johnson works with photography, video, and sculpture to explore the cultural and identity issues related to race and economics. He studied at Columbia College and the School of The Art Institute of Chicago. His straightforward studio portraits of homeless men ennoble this otherwise marginalized group. Johnson asks viewers to look directly into their faces instead of looking away, as often happens on the street. The photographs are printed by hand-coating paper with a light-sensitive emulsion, using the Van Dyke Brown process. His recent work is more conceptual in nature. Large, seemingly abstract photograms of symbolic objects, such as hair, chicken bones, and black-eyed peas, depict swirling universes made from the legacy of African American culture. His work is included in the collections of The Art Institute of Chicago, the Studio Museum in Harlem, and the Whitney Museum of American Art. PB

Catalog number: 86

Kristen Brooke Schleifer, "Rashid Johnson. GR N'Namdi Gallery," *Art on Paper*, vol. VI, no. 5, May–June 2002, p. 83

Lewis Koch (born 1949, New York)
In his photographs and assemblage pieces, Lewis Koch addresses issues of global concern such as overpopulation, rampant militarization, subjugation, and the destruction of the Earth. In 1995 and 1996, he lived and worked in northern India, near the Tibetan community of Dharamsala. His photographs from this time range from agricultural and sociological studies to autobiographical statements. In addition to the found symbols and text that figure prominently in his work, Koch pairs photographs with carefully selected texts about the region. These create a new context for the images and uncover otherwise hidden connections. His work is included in the collections of Maison Européenne de la Photographie, Paris, The Metropolitan Museum of Art, the Museum of Contemporary Art, Chicago, and the San Francisco Museum of Modern Art. AQ

Catalog number: 87

Lewis Koch. Notes from the Stone-Paved Path: Meditations on North India, exhib. cat. by Lewis Koch, University of Wisconsin-Madison Libraries, 2003

Dorothea Lange (born 1895, New Jersey — died 1965, California)
Dorothea Lange chose to pursue photography in 1913, before ever owning a camera or taking a picture. Over the ensuing years, she found support from the various studio portraitists whom she assisted. She settled in San Francisco and worked as a traditional portraitist for many years before venturing outside to photograph street life. Lange's stark depictions of migrant farm workers in California, Arizona, and New Mexico during the Depression have influenced generations of documentary photographers. Her work is included in the collections of the Library of Congress, the Museum of Modern Art, the National Archives, and the Smithsonian Institution. AQ

Catalog number: 88

Dorothea Lange, American Photographs, exhib. cat. by Theresa Thau Heyman, Sandra Phillips, and John Szarkowski, San Francisco Museum of Modern Art, 1994

Karin Becker Ohrn, *Dorothea Lange and the Documentary Tradition*, Baton Rouge LA (Louisiana State University Press) 1980

Paul S. Taylor and Dorothea Lange, *An American Exodus: A Record of Human Erosion* [1939], New Haven CT (Yale University Press) 1969

Clarence John Laughlin (born 1905, Louisiana — died 1985, Louisiana)
Clarence John Laughlin became enthusiastic about photography after reading about such luminaries as Edward Weston and Man Ray. He taught himself basic techniques and built a darkroom. Laughlin spent much of the 1930s and 1940s as a photographer for the US Army Corps of Engineers, the Office of Strategic Services, and *Vogue* magazine. After World War II, he focused on personal

projects, supporting himself as a freelance architectural photographer and lecturer. An extensive archive of his work exists at the University of Louisville in Kentucky. Laughlin's work is included in the collections of The Metropolitan Museum of Art, the Museum of Modern Art, and the Smithsonian Institution. AQ

Catalog number: 89

Clarence John Laughlin, *Ghosts Along the Mississippi*, New York (Charles Scribner's Sons) 1948

John H. Lawrence and Patricia Brady, *Haunter of Ruins: The Photography of Clarence John Laughlin*, Boston (Little, Brown & Co.) 1997

Jacob Lawrence (born 1917, New Jersey — died 2000, Washington D.C.)

Jacob Lawrence's poverty-stricken family always encouraged his artistic talents. As a teenager, he took after-school art courses and frequented major art museums. By the age of twenty-one, he secured employment with the Works Progress Administration Federal Art Project, working as a professional painter in the easel division. Throughout the 1940s, Lawrence exhibited in museums and galleries in the United States and abroad. In the 1950s, he maintained his humanistic approach to painting, even as Abstract Expressionism came into fashion. In later years, he continued to paint and taught art at the University of Washington in Seattle. Lawrence is known for his paintings of black life and history. His work is included in the collections of many major museums, including the Brooklyn Museum of Art, The Metropolitan Museum of Art, and the National Gallery of Art. AQ

Catalog number: 90

Jacob Lawrence et al., *The Complete Jacob Lawrence*, Seattle (University of Washington Press) 2000

Russell Lee (born 1903, Illinois — died 1986, Texas)

Russell Lee's degree in chemical engineering provided him with an understanding of the technical principles basic to photography. In 1936 he secured a position with the government's Farm Security Administration (FSA) and spent the next six years documenting the plight of tenant farmers across the United States. Maintaining a lifelong commitment to documentary photography, he worked for the Office of War Information during World War II and later for the Standard Oil of New Jersey Photography Project. He is best remembered as the FSA's pioneer of flash photography, which enabled him to capture graphically the indoor living conditions of tenant farmers. His work is included in the collections of the Library of Congress, the Museum of Modern Art, and the Smithsonian Institution. AQ

Catalog numbers: 91, 92

F. Jack Hurley, *Russell Lee: Photographer*, Dobbs Ferry NY (Morgan & Morgan) 1978

Helen Levitt (born 1913, New York)

From the 1940s through the 1970s, Helen Levitt captured everyday life on the inner-city streets of her native New York. Her introduction to photography came in 1931, when she assisted a commercial portraitist in his studio and darkroom. Levitt channeled her varied artistic interests into the medium, and by 1934 she had acquired a camera and was seriously considering a career in commercial photography. An energetic young photographer, Levitt attended events at the Film and Photo League, where numerous esteemed photographers and art critics, including Henri Cartier-Bresson, Walker Evans, and James Agee, exposed her to new schools of artistic thought. Subsequently, her interests shifted from commercial to documentary photography and filmmaking. While she never considered herself a photo-historian, her images, which often depict children, form a thorough pictorial record of New York as it underwent major socio-economic transformations. AQ

Catalog numbers: 93, 94

Helen Levitt, exhib. cat. by Sandra S. Phillips and Maria Morris Hambourg, San Francisco Museum of Modern Art, 1991

Helen Levitt, *Here and There*, New York (PowerHouse) 2003

Helen Levitt and James Agree, *A Way of Seeing*, New York (Viking Press) 1965

Willie Little (born 1961, North Carolina)

Born and raised in rural North Carolina, Willie Little draws on his childhood memories to produce multi-media installations that are rooted in the southern culture of a bygone era. In his critically acclaimed *Juke Joint* piece, he used original artifacts to recreate the experience of his father's illegal liquor house. During the day, this business operated as a general store. At night, it transformed into a colorful venue for drinking, dancing, and socializing. Little's installations enable him to preserve and share an important slice of African American history with a broad contemporary audience. His work has been featured at the Museum of the New South, the Smithsonian Institution, and the Tobacco Farm Life Museum, Kenly NC. AQ

Catalog number: 95

Samella Lewis, *African American Art and Artists*, 3rd edn, Berkeley CA (University of California Press) 2003

Paul Richard, "At Smithsonian's 'Juke Joint', Last Call for a Vanished South," *The Washington Post*, September 29, 2003

Whitfield Lovell (born 1959, New York)

Whitfield Lovell finds inspiration in a range of sources, including textiles from Ghana, the African American quilt tradition, prehistoric cave paintings, and the work of artists Frida Kahlo and Francisco de Goya. He is an avid collector and is fascinated by material culture. Lovell has been awarded numerous grants, residencies, and awards, and he cites Robert Blackburn's Printmaking Workshop Fellowship as a formative experience. He is well known for life-sized

charcoal drawings on wallboards and floorplanks in site-specific installations—for example, a freestanding one-room house, occupying the center of a gallery, in his piece *Whispers from the Walls*. The figures in these drawings are created from projections of anonymous nineteenth- and twentieth-century photographs. Through this process, Lovell connects us to the past and redefines the present. HA

Catalog numbers: 96–99

Whitfield Lovell, with Lucy Lippard, *The Art of Whitfield Lovell: Whispers from the Walls*, Denton TX (University of North Texas Press) 1999

Whitfield Lovell, exhib. cat. by Whitfield Lovell and Patricia Hills, New York, DC Moore Gallery, 2000

Whitfield Lovell: Embers, exhib. cat. by Whitfield Lovell and Dominique Nahas, New York, DC Moore Gallery, 2002

Whitfield Lovell: Portrayals, exhib. cat. by Whitfield Lovell and Lilly Wei, Purchase NY, Neuberger Museum of Art, Purchase College, State University of New York, 2000

Deborah Luster (born 1951, Oregon)

As an undergraduate at the University of Arkansas, Deborah Luster studied literature and creative writing, pursuits that would have a significant influence on her narrative and documentary style of photography. Since 1998 Luster has been photographing prison inmates in Louisiana as part of an ongoing series called *One Big Self: Prisoners of Louisiana*. With this project, she explores the expressive potential of portrait photography, as each inmate strikes a natural pose with self-selected props against a brightly lit, sharply detailed black backdrop. Luster's images are printed on four-by-five inch pieces of aluminum and are reminiscent of turn-of-the-century studio photography and tintypes. Her work is included in the collections of the Mint Museum of Art, The Museum of Fine Arts, Houston, the National Archives, and the San Francisco Museum of Modern Art. EJ

Catalog number: 100

Horace Brockington, "Deborah Luster, Mythic Personalities," *New York Arts Magazine*, VIII, no. 11/12, November/December 2003

Deborah Luster, *One Big Self: Prisoners of Louisiana*, Albuquerque NM (Twin Palms Publishers) 2004

Danny Lyon (born 1942, New York)

Danny Lyon has created one of the most significant documentary portraits of American society during the past forty years. He began to make photographs in 1959, while studying history at the University of Chicago. In 1963, the year he graduated, he joined the staff of the Student Nonviolent Coordinating Committee. His earliest photographs chronicle Chicago youth and the American South during the civil rights movement. His most recent project, *Indian Nations*, emerged from four years visiting the Sioux, Apache, and other western tribes. Lyon's photographs and films provide a visual record of the transformation of American culture from a racially segregated society to one with institutions that continue to struggle to redefine concepts of equal opportunity. He chronicles the lives of disenfranchised people, subjectively photographing those on the fringes of society while articulating a strong belief in the freedom of the individual and the freedom and power of his images. Lyon has produced many photographic projects and films, which are exhibited internationally. His work is included in the collections of many museums, including the Corcoran Gallery of Art and the Museum of Modern Art. PB

Catalog number: 101

Danny Lyon: Photo Film: 1959–1990, exhib. cat. by Ute Eskildsen and Terry Pitts, Essen, Germany, Museum Folkwang, Tucson AZ, Center for Creative Photography, University of Arizona, and others, 1991

Danny Lyon, *Pictures from the New World*, New York (Aperture) 1981

Mark Mann (born 1970, Oklahoma)

Postcards sent and saved from 1960s and 1970s Middle American vacations form the illusory foundation for Mark Mann's photographic art. In his two series of digital prints, *Wish You Were Here* and *Are We There Yet?*, Mann deploys images of suburban families on the road and places them in empty, imprisoning spaces. These pictures create an uneasy tension between truth and fiction. They cite artifacts from the time, such as postcards of roadside motels and generic vacation destinations that refer to memories of family journeys. However, these journeys are mixed with dreamlike symbolism to create iconic images that go beyond memory. Mann starts with vintage postcards and manipulates these reproductions using computer technology. He imitates the color and composition of his source material, but creates staged dramas that are about the loneliness and alienation that accompanies the American dream. His works are included in the collections of the Los Angeles County Museum of Art and the Norton Museum of Art. PB

Catalog numbers: 102, 103

Mark Mann: Are We There Yet? exhib. brochure, New York, Laurence Miller Gallery, 2003

"People and Nature," *Orion*, spring 2002

Sally Mann (born 1951, Virginia)

Drawing on personal experiences and the history of photography, Sally Mann creates haunting sequences about her family, coming of age, the southern landscape, and the loss of life. Her landscape photographs connect memories and history to the visual feeling of a place. One recent project, *What Remains*, explores the ineffable divide between soul and body, life and death, spirit and earth. Mann received a bachelor's degree in 1974 and a master's degree in writing in 1975 from Hollins College, Roanoke VA, and she has since won numerous awards, including National Endowment for the Arts and Guggenheim fellowships. A documentary film about her family pictures was nominated

for an Academy Award in 1993, and a feature-length follow-up spanning her career is in production. Mann's photographs have been exhibited internationally and are in the permanent collections of major museums worldwide, including the Corcoran Gallery of Art, The Metropolitan Museum of Art, and the Museum of Modern Art. *Time* magazine named Mann America's best photographer in 2001. PB

Catalog numbers: 104, 105

Sally Mann, *Immediate Family*, New York (Aperture) 1992

Sally Mann, *What Remains*, New York (Bulfinch Press) 2003

Mary Ellen Mark (born 1940, Pennsylvania)
Mary Ellen Mark is a socially conscious photojournalist who empathetically documents marginalized people in the United States and abroad. Her subjects include brothels in Bombay, the circus culture of India, runaway children in Seattle, and women in a maximum-security unit of a mental institution. She first gained recognition in the 1970s, when her film stills for movies including *Apocalypse Now*, *Silkwood*, *Catch-22*, and *One Flew Over the Cuckoo's Nest* graced the pages of established picture magazines such as *Look* and *Life*. Considered one of the most influential and respected photographers working today, Mark maintains her artistic integrity by researching and pursuing stories that genuinely interest her. The recipient of a Cornell Capa Award and a Guggenheim Fellowship, Mark's photographs are included in the collections of the Corcoran Gallery of Art, the George Eastman House International Museum of Photography and Film, the Library of Congress, and the Whitney Museum of American Art. AQ

Catalog numbers: 106, 107

Marianne Fulton, *Mary Ellen Mark: 25 Years*, Boston (Little, Brown & Co.) 1991

Mary Ellen Mark, *Falkland Road: Prostitutes of Bombay*, New York (Knopf) 1981

Mary Ellen Mark, *Streetwise*, Philadelphia (University of Pennsylvania Press) 1988

Mary Ellen Mark and Maya Angelou, *Mary Ellen Mark: An American Odyssey, 1963–1999*, New York (Aperture) 1999

Victor Masayesva Jr. (born 1951, Arizona)
Victor Masayesva Jr. is a photographer, filmmaker, and video artist whose work provides a critical perspective on traditional Native American culture and its assimilation into the white man's world. Born and raised in the Hopi village of Hotevilla AZ, Masayesva left his community to attend the Horace Mann School in New York and continued his education at Princeton University. He majored in literature and, with the encouragement of his professors, studied the history of the Hopi culture. He even wrote major papers in his native language. Upon returning to Hotevilla, he launched a number of projects, including *Imagining Indians* (1992), a film in which he examines the ways Hollywood movies have

exaggerated differences between the two cultures and perpetrated the myth that Native American traditions are easy to understand. His work addresses the commercialization, appropriation, and exploitation of Native American culture. AQ

Catalog number: 108

Fatimah Tobing Rony, "Victor Masayesva, Jr., and the Politics of *Imagining Indians*," *Film Quarterly*, XLVIII, no .2 (winter 1994–95), pp. 20–33

Elizabeth Weatherford, "To End and Begin Again: The Work of Victor Masayesva, Jr.," *Art Journal*, LIV, no. 4 (winter 1995), pp. 48–52

Ralph Eugene Meatyard (born 1925, Illinois — died 1972, Kentucky)
Best known as a photographer, Ralph Eugene Meatyard supported himself with an optometry practice throughout his career. Inspired by the birth of his son, he purchased his first camera from the photographic equipment dealer where he worked. He began studying photography seriously soon after and, in 1956, while he was still relatively unknown, his photographs were exhibited alongside those of Ansel Adams, Minor White, Aaron Siskind, Harry Callahan, and Edward Weston at the University of Kentucky. Undeniably influenced by his knowledge of optics, Meatyard also drew inspiration from Surrealism, Abstract Expressionism, and Zen Buddhism. His work is included in the collections of the George Eastman House International Museum of Photography and Film, The Metropolitan Museum of Art, Museum of Modern Art, and the Smithsonian Institution. AQ

Catalog number: 109

Barbara Tannenbaum *et al.*, *Ralph Eugene Meatyard: An American Visionary*, New York (Rizzoli International Publications) 1991

Ray K. Metzker (born 1931, Wisconsin)
Best known for his double-frame images and multiframe composites, Ray Metzker has explored various subjects throughout his career, from urban streetscapes to natural landscapes. Trained at the Chicago Institute of Design, an institution noted for its connections to the Bauhaus, he created an œuvre characterized by rich tones, high contrast, line, form, and dramatic light. Metzker's compositions often focus on one specific detail, rendering that detail almost abstract. By distorting the appearance of an everyday object, be it a building façade, a streetscape, or a drinking fountain, Metzker forces the viewer to examine the image carefully. His work is included in the collections of The Art Institute of Chicago, the Baltimore Museum of Art, The Metropolitan Museum of Art, the Museum of Fine Arts, Boston, the National Gallery of Art, and the Philadelphia Museum of Art. EJ

Catalog numbers: 110, 111

Ray K. Metzker, *Ray K. Metzker: Landscapes*, New York (Aperture) 2000

Unknown Territory: Photographs by Ray K. Metzker, exhib. cat. by Ray K. Metzker and Anne W. Tucker, Houston, The Museum of Fine Arts and others, 1984

Wayne Miller (born 1918, Illinois)

As a World War II combat photographer, Wayne Miller recorded the aftermath of the atomic bomb in Hiroshima and observed the waste of human life and resources that often characterizes war. Upon being discharged, he returned to his hometown of Chicago and, with funding from a Guggenheim grant, set out to find the bonds that tie humanity. He spent time in the South Side, where a recent influx of southern African Americans had expanded an already burgeoning community. Over a three-year period, he became a familiar figure on the neighborhood streets among day laborers and children, and was welcomed in the nightclubs, churches, and homes of his subjects. Miller created a valuable document of African American life during the mid-twentieth century that addressed common misconceptions and stereotypes, such as those of illiteracy and the negligent father. In the mid-1950s, he assisted curator Edward Steichen with his famous *Family of Man* exhibition at the Museum of Modern Art. He joined Magnum Photos shortly thereafter, and served as its president from 1962 to 1966. Retired from professional photography since 1975, Miller currently owns and maintains a redwood forest in Northern California. AQ

Catalog numbers: 112, 113

Wayne F. Miller, *Chicago's South Side, 1946–1948*, Berkeley CA (University of California Press) 2000

Leigh Richmond Miner (born 1864, Connecticut — died 1935, Virginia)

Leigh Richmond Miner graduated from New York's National Academy of Design and launched his career at Virginia's Hampton Institute in 1898 as a drawing instructor. He joined the institute's camera club, a group comprised of faculty and staff who shared an interest in photography. Of all the club members, Miner found the most success in subsequent ventures and moved to New York in 1904, where he operated his own studio. He returned to Hampton in 1907 as Director of Applied Arts. A man of many talents, Miner also pursued painting, printmaking, copper work, pottery, landscaping, and writing. His photographs illustrate a number of poet Paul Laurence Dunbar's books, including *Candle-Lightin' Time*, *Howdy, Honey, Howdy!,* and *Joggin' Erlong*. AQ

Catalog number: 114

Edith M. Dabbs, *Face of an Island: Leigh Richmond Miner's Photographs of Saint Helena Island*, Columbia SC (R. L. Bryan Company) 1970

Paul Laurence Dunbar, *Candle-Lightin' Time*, New York (Dodd Mead & Co.) 1901

To Conserve a Legacy: American Art from Historically Black Colleges and Universities, exhib. cat. by Richard J. Powell and Jock Reynolds, Andover MA, Addison Gallery of American Art and others, 1999

Richard Misrach (born 1949, California)

Perhaps best known for his hauntingly beautiful images of the American desert, Richard Misrach has focused his camera on the landscape since the late 1970s. His photographs range from politically charged depictions of the government's nuclear testing grounds to atmospheric views of the skies above. Misrach recently traveled to Louisiana, where he photographed the devastating effects of the petrochemical industry across an expansive stretch of the Mississippi River known as "Cancer Alley." Misrach established his own nuclear-disarmament agency in the 1980s, and although he has since halted the operation, he continues to contribute to the environmentalist movement through his work. He has won numerous awards, including National Endowment for the Arts and Guggenheim fellowships. His work is included in the collections of The Metropolitan Museum of Art, the Museum of Modern Art, and the Smithsonian Institution. AQ

Catalog number: 115

Bravo 20: The Bombing of the American West, exhib. cat. by Richard Misrach, Las Vegas NV, Donna Beam Fine Art Gallery, University of Nevada, 1990

Crimes and Splendors: The Desert Cantos of Richard Misrach, exhib. cat. by Anne Tucker, with Rebecca Solnit, Houston, The Museum of Fine Arts, 1996

Richard Misrach, *Desert Cantos*, Albuquerque NM (University of New Mexico Press) 1987

Richard Misrach and Susan Sontag, *Violent Legacies: Three Cantos*, New York (Aperture) 1992

Delilah Montoya (born 1955, Texas)

Delilah Montoya was born, raised, and educated in a strongly matriarchal family in the American Southwest. She makes use of cultural and spiritual icons and symbols to investigate the experience and the history of her Chicana heritage. Combining computer technology and graphic design with traditional photographic processes and rich colors, Montoya creates extremely complex, fantasy-filled images. In doing so, she explores the intersections of Spanish, Catholic, Aztec, and American cultures. In her recent projects, Montoya continues to mine her own experience for inspiration, as she incorporates photographs into mixed-media installations. Her work is included in the collections of the Mexican Museum, San Francisco, the Smithsonian American Art Museum, and the Tufts University Gallery. EJ

Catalog number: 116

Contemporary Art by Women of Color, exhib. cat. by Lucy Lippard, San Antonio TX, Guadalupe Arts Center, 1990

Intersecting Identities, exhib. cat. by Jennifer Jaskowiak, Los Angeles, Fisher Gallery, University of Southern California, 1996

Los Guardianes: Land, Spirit, and Culture, exhib. cat. by Judith Baca, Santa Fe NM, Museum of Fine Arts, Museum of New Mexico, 1992

Karl E. Moon (born 1879, Ohio — died 1948)
Karl Moon, or Carl, as he sometimes spelled his name, was one of a number of photographers who documented Native American tribes during the late nineteenth and early twentieth centuries. He first gained interest in photography as a young man and, after serving with the Ohio National Guard, he apprenticed with several photographers in Ohio, West Virginia, and Texas. In 1903, he settled in New Mexico and began making photographic "art studies" of Native American tribes of the Southwest. In 1907, amidst growing recognition, he accepted a photography position under Fred Harvey, a restaurateur who operated a chain of restaurants along the Atchison, Topeka, and Santa Fe Railroads. Committed to the romantic notion of recording the "vanishing race," his work is characterized by its soft focus and overtly sentimental style. Over the course of his career, Moon documented a total of twenty-nine tribes. His work is included in the collections of the Library of Congress and the Smithsonian Institution. AQ

Catalog number: 117

Van Deren Coke, *Photography in New Mexico: From the Daguerreotype to the Present*, Albuquerque NM (University of New Mexico Press) 1979

Robert D. Haines Jr., *Carl Moon: Photographer and Illustrator of the American Southwest*, San Francisco (Argonaut Book Shop) 1982

Abelardo Morell (born 1948, Cuba)
Abelardo Morell first used photography to express the alienation he felt as a Cuban immigrant attending Bowdoin College in Brunswick ME. His personal and creative life reached a turning point in 1986, when his first child was born. Since then, he has created a substantial œuvre, inspired, in part, by the perspective from which his child understands the world. Morell is a professor of photography at the Massachusetts College of Art, Boston. His work is included in the collections of the George Eastman House International Museum of Photography and Film, The Metropolitan Museum of Art, and the Museum of Modern Art. AQ

Catalog number: 118

Abelardo Morell, *A Camera in a Room*, Washington D.C. (Smithsonian Institution Press) 1995

Abelardo Morell and the Camera Eye, exhib. cat. by Diana Gaston, San Diego Museum of Photographic Arts, 1998

Zwelethu Mthethwa (born 1960, South Africa)
Given his strengths in math and science, Zwelethu Mthethwa planned to pursue a career in medicine. He enrolled in a science program but soon found that he was not "cut out" for the work. At his exit interview, Mthethwa was encouraged to shift his course of study to art. With some skepticism, he enrolled in a photography program. Today, he is well known for his portraits of South Africans who migrate to industrial centers in search of employment.

His success has brought him international recognition, and his work is included in the collections of the Durban (South Africa) Art Gallery, the South African National Gallery, and the Smithsonian Institution. AQ

Catalog number: 119

Liberated Voices: Contemporary Art from South Africa, exhib. cat. by Frank Herreman, New York, Museum for African Art, 1999

Osamu James Nakagawa (born 1962, New York)
Osamu James Nakagawa has divided much of his life between Japan and America, and often uses disjunctive photographic compositions and digital technology to blend elements of the two cultures. After the death of his father and the birth of his daughter, Nakagawa created a body of work that explores the cycles of familial loss and renewal. His work is included in the collections of the George Eastman House International Museum of Photography and Film, The Museum of Fine Arts, Houston, and the Tokyo Metropolitan Museum of Photography. AQ

Catalog number: 120

Anne Wilkes Tucker, "Osamu James Nakagawa," *Contact Sheet*, no. 121, 2003, pp. 46–51

Adi Nes (born 1966, Israel)
The son of Jewish immigrants to Israel from Iran and Kurdistan, Adi Nes creates theatrical photographs that comment on and critique Israeli youth, gay identity, and military culture. By referencing stories and images from Greek mythology, art history, and photojournalism, as well as his own memories, Nes makes pictures that are layered with multiple psychological meanings. He stages his photographs by scripting them; and he hires and styles models, and works with assistants to direct and light his subjects as if on a movie set. His settings are ambiguous and ironic, sometimes combining the lower-class Kiryat Gat neighborhood of his childhood with allegorical, modern-dress recreations of scenes from myths such as the Death of Adonis or the Rape of Dionysus. By merging truth and fiction, Nes's work addresses the gap that exists between our experience and imagination. His photographs are included in the collections of the Museum of Contemporary Art, San Diego, The Tel Aviv Museum, and the Israel Museum. PB

Catalog numbers: 121, 122

Adi Nes, Photographs, exhib. brochure by Toby Kamps, San Diego, Museum of Contemporary Art, 2002

Adi Nes, Recent Photographs, exhib. cat. by Adi Nes, Tel Aviv Museum of Art, 2001

Arnold Newman (born 1918, New York)
One of the most influential portrait photographers of our time, Arnold Newman has changed the way we see ourselves. Crafted with a deep understanding of the creative

process, his art is widely seen and reproduced. Through observation, communication, and collaboration, Newman finds a set of symbols that allow him to define a subject. He has created defining images of political leaders, cultural icons, and everyday people, including Pablo Picasso, Igor Stravinsky, and Lyndon Johnson. In the late 1930s, Newman studied the work of Farm Security Administration photographers such as Walker Evans and began to make his first serious photographs of people. In his best work, Newman, like Evans, situates people within structured, architectural surroundings. Working independently and on assignment since the early 1940s for picture magazines such as *Life*, *Look*, *Holiday*, and *Fortune*, as well as *The New Yorker* and *The New York Times Magazine*, Newman has inspired several generations of photographers. Recent images include landscapes and interiors that appear almost abstract. PB

Catalog number: 123

Philip Brookman, *Arnold Newman*, Cologne (Taschen) 2000

Arnold Newman and Robert Sobieszek, *One Mind's Eye: The Portraits and Other Photographs of Arnold Newman*, Boston (David R. Godine) 1974

Timothy O'Sullivan (born *c.* 1840, New York — died 1882, New York)
Timothy O'Sullivan first gained notoriety for his unflinching description of the gruesome realities of the Civil War. He trained with Mathew Brady, one of the foremost studio photographers of the mid-nineteenth century. After the war, O'Sullivan was uninspired by the possibility of a career as a studio portraitist, and so he embarked on a number of exploratory expeditions into the American West instead. Documenting the landscape with a clear, modern aesthetic, O'Sullivan captured a sense of vastness, mystery, and timelessness, a testament to the photographer's compositional skill. O'Sullivan's career was cut short by his untimely death from tuberculosis. His images are included in the collections of The Art Institute of Chicago, the Library of Congress, and the National Archives. EJ

Catalog number: 124

Rick Dingus, *The Photographic Artifacts of Timothy O'Sullivan*, Albuquerque NM (University of New Mexico Press) 1982

James David Horan, *Timothy O'Sullivan, America's Forgotten Photographer*, Garden City NY (Doubleday) 1966

Joel Snyder, *American Frontiers: The Photographs of Timothy H. O'Sullivan, 1867–1874*, New York (Aperture) 1981

Gordon Parks (born 1912, Kansas)
Gordon Parks is an American Renaissance man who has mastered many media to express an influential message of hope in the face of adversity. The youngest of fifteen children, he overcame a childhood of racism and poverty and devoted his life to exposing injustice and revealing beauty in a variety of ways. Parks, a self-taught artist,

photographed for the Farm Security Administration, the Office of War Information, and the Standard Oil of New Jersey Photography Project in the 1940s. Although best known as a photojournalist—he was on the staff of *Life* from 1948 to 1972—he is also a filmmaker, novelist, poet, and composer. With *The Learning Tree* in 1969 and *Shaft* in 1971, Parks became the first African American filmmaker to direct Hollywood features. His art is about pressing social issues such as poverty, race, segregation, and crime, as well as beauty, nature, music, landscape, childhood, fashion, and memory. His photographs are in the collection of the Corcoran Gallery of Art, the Library of Congress, and the Museum of Modern Art. PB

Catalog number: 125

Half Past Autumn: A Retrospective, exhib. cat. by Gordon Parks, Washington D.C., Corcoran Gallery of Art and others, 1997–2001

Gordon Parks, *A Choice of Weapons*, St. Paul (Minnesota Historical Society Press) 1986

Mark Power (Victor H. Carroll) (born 1937, Washington D.C.)
Mark Power has made work in a variety of media and of a myriad of subjects in a forty-year career. At times a symbolist, an allegorist, a romanticist, a latter-day surrealist, and an autobiographer of his dream states, Power's work always tends toward the evocative and the mysterious. A critic and curator as well, Power is best known as an influential educator at the Corcoran College of Art and Design in Washington D.C., a position he held from 1971 to 1999. Moving to Norwich, England, following his retirement from teaching, Power took the professional name "Victor H. Carroll" to distinguish himself from an established art and documentary photographer who shares his birth name. Power's photographs are included in the collections of the Smithsonian Institution and the Bibliothèque Nationale in Paris, among others. PR

Catalog number: 126

Mark Power: Beauty and the Beast, exhib. cat. by Jane Livingston, Washington D.C., Corcoran Gallery of Art, 1979

Brad Richman (born 1971, Delaware)
Brad Richman is a photographer living in Portland ME. He is best known for a long-term project about basketball in the United States, for which he traveled throughout the country to photograph hoops in all kinds of environments. From major urban playgrounds to rural driveways, Richman's images are about the spirit of basketball as an aesthetic experience that transcends boundaries, rather than as a competitive sport. In 1993 he received his bachelor's degree in photography from Bard College, Annandale-on-Hudson NY, where he studied with Larry Fink and Stephen Shore. His work was first published in *25 and Under/Photographers* (1996), a book showcasing twenty-five of the country's finest young photographers, and has been since featured in

periodicals such as *DoubleTake*, *Photo District News*, and *Popular Photography*. His photographs are included in many collections, including The Art Institute of Chicago, the Hallmark Photographic Collection, and the Library of Congress. PB

Catalog number: 127

Alice Rose George, *25 and Under/Photographers*, New York (W.W. Norton & Co.) 1996

Brad Richman, "Hoops: Photographs by Brad Richman," *DoubleTake*, XXII, fall 2000, pp. 40–45

Arthur Rothstein (born 1915, New York — died 1985, New York)
Arthur Rothstein first practiced photography as a hobby and started a camera club while studying medicine at Columbia University in New York. In 1935 Roy Stryker, a former college mentor, offered him a position with the photography division of the Farm Security Administration (FSA). Rothstein spent the next five years with the FSA, traveling across the country to photograph the agency's intervention in communities plagued by the Great Depression. He maintained a lifelong dedication to photography and pursued a successful career as a photojournalist with *Look* and *Parade* magazines. His work is included in the collections of the Library of Congress, the Museum of Modern Art, and the Smithsonian Institution. AQ

Catalog number: 128

Richard K. Doud, interview with Arthur Rothstein in New York, May 25, 1964; transcript in the *Archives of American Art*, Smithsonian Institution, Washington D.C.; also published in *Archives of American Art Journal*, XVII, no. 1, 1977, pp. 19–23 (including three photographs)

Arthur Rothstein, *The Depression Years as Photographed by Arthur Rothstein*, New York (Dover Publications) 1978

Dana Salvo (born 1952, Massachusetts)
Dana Salvo attributes much of his inspiration to his Italian-American upbringing. In 1985 he traveled to Mexico with plans to photograph the landscape, but instead found himself more interested in the ornate altars found in the homes of many remote villages. Salvo has since focused on documenting domestic interiors in Vietnam, India, Mexico, and his hometown of Gloucester MA. His work is included in the collections of The Metropolitan Museum of Art, the Museum of Modern Art, and the John Simon Guggenheim Memorial Foundation. AQ

Catalog number: 129

Ramon A. Gutierrez *et al.*, *Home Altars of Mexico*, Albuquerque NM (University of New Mexico) 1997

David Scheinbaum (born 1951, New York)
Since the early 1980s, photographer David Scheinbaum has focused on stone, either in its natural state or in architecture and art. Attracted to the sheer beauty of the Bisti Badlands

and other southwestern landscapes, Scheinbaum is an advocate of the land conservation movement. He has increasingly addressed the relationship between art and science in his work, exploring the connection between stone and culture in recent images of Roman ruins, Stonehenge, English cathedrals, and the American war cemeteries in Normandy, France. Scheinbaum is currently the Director of the Marion Center for Photographic Arts at the College of Santa Fe NM, and he directs a private photography firm, Scheinbaum & Russek Gallery Ltd, with his wife and colleague Janet Russek. His photographs are included in the collections of the Amon Carter Museum, the Center for Creative Photography, the Corcoran Gallery of Art, and The Metropolitan Museum of Art. AQ

Catalog numbers: 130, 131

Janet Russek and David Scheinbaum, *Ghost Ranch: Land of Light, Photographs by Janet Russek and David Scheinbaum*, Los Angeles (Balcony Press) 1997

Janet Russek and David Scheinbaum, *Images in the Heavens, Patterns on the Earth: The I Ching*, Santa Fe NM (Museum of New Mexico Press) 2004

David Scheinbaum *et al.*, *Bisti*, Albuquerque NM (University of New Mexico Press) 1987

Addison Scurlock (born 1883, North Carolina — died 1964, Washington D.C.)
Addison Scurlock operated his own highly successful photography studio in Washington D.C. from 1911 until 1964. With a reputation for meticulous craftsmanship and observative and dignified portraits, Scurlock attracted a varied clientele that included celebrities, artists, writers, professors, and political leaders of his African American community. In the 1930s, he created newsreels of Washington D.C. events that were screened at local theaters. He served as Howard University's official photographer, and his studios continued to operate under his sons until the early 1990s. AQ

Catalog number: 132

George Sullivan, *Black Artists in Photography, 1840–1940*, New York (Cobble Hill Books) 1996

Deborah Willis, *Reflections in Black: A History of Black Photographers, 1840 to the Present*, New York (W.W. Norton & Co.) 2000

Peter Sekaer (born 1901, Denmark — died 1950, New York)
Raised in Copenhagen, Peter Sekaer left home for the United States at the age of seventeen to escape his overbearing father and future employment in the family's machinery-import business. He settled in New York in 1922 and operated his own silkscreen-printing business through much of the decade. In 1929, he enrolled in the Art Students League to study painting and soon met influential artists Ben Shahn and Walker Evans. Sekaer forged a professional partnership with Evans, whom he assisted in the darkroom.

In 1936, Sekaer accompanied Evans on a Resettlement Administration assignment to photograph poverty-stricken communities throughout the South and Midwest. Sekaer's photographs from this journey evidence his individual style, which, when compared with that of Evans, is marked by liberal sympathies and a focus on humanity. This work brought him recognition and, in the following years, he found employment with the government's Rural Electrification Administration, United States Housing Authority, and the Red Cross, among others. He grew increasingly frustrated with the propagandistic nature of his assignments and spent the last five years of his life producing commercial work for Bell Telephone, Kodak, and picture magazines such as *Glamour*, *Vogue*, and *Ladies' Home Journal*. His photographs are included in the collections of the Addison Gallery of American Art, the Library of Congress, and The Metropolitan Museum of Art. AQ

Catalog numbers: 133, 134

Peter Sekaer: American Pictures, exhib. cat. by Allison Kemmerer and Shelia Schwartz (eds.), Andover MA, Addison Gallery of American Art, 2000

Ben Shahn (born 1898, Lithuania — died 1969, New York)
In 1906 Ben Shahn's Jewish family fled Tsarist Russia and settled in Brooklyn. He developed a strong socio-political conscience. He studied lithography and painting and began creating murals for various political causes. Originally, he used photographs as guides for his murals, which often depicted well-known public figures. Encouraged by friend and roommate Walker Evans, Shahn pursued photography and worked for the federal Farm Security Administration from 1935 to 1938. In the 1950s and 1960s the focus of his work shifted from social protest to broader humanitarianism. Today, his work is included in the collections of Harvard University's Fogg Art Museum, the Library of Congress, and the Museum of Modern Art. AQ

Catalog numbers: 135, 136

Ben Shahn's New York: The Photography of Modern Times, exhib. cat. by Deborah Martin Kao *et al.*, Cambridge MA, Fogg Art Museum, Harvard University, 2000

Common Man, Mythic Vision: The Paintings of Ben Shahn, exhib. cat by Susan Chevlowe *et al.*, New York, Jewish Museum and others, 1998

Davis Pratt (ed.), *The Photographic Eye of Ben Shahn*, Cambridge MA (Harvard University Press) 1975

Fazal Sheikh (born 1965, New York)
Fazal Sheikh is known for his photographs of refugees from Sudan, Rwanda, Somalia, Ethiopia, and Afghanistan, who have settled in Kenya and Pakistan, the countries of his ancestors. His work is included in the collections of the George Eastman House International Museum of Photography and Film, The Metropolitan Museum of Art, and the San Francisco Museum of Modern Art. AQ

Catalog number: 137

Fazal Sheikh, *A Sense of Common Ground*, New York (Scalo) 1996

Fazal Sheikh, *The Victor Weeps*, New York (Scalo) 1998

Malick Sidibé (born 1936, Mali)
Malick Sidibé opened his own photography studio in 1962, just as Mali was gaining independence from France. Sidibé, who originally planned to study jewelry-making, became fascinated with photography while apprenticing with a studio portraitist in the mid-1950s. Today, he is known for his innovative studio portraits and images of urban nightlife, which depict Mali during a historic time of liberation. Sidibé has exhibited throughout Europe and the United States and was recently featured at Harvard University's Fogg Art Museum. AQ

Catalog numbers: 138–44

You Look Beautiful Like That: The Portrait Photographs of Seydou Keïta and Malick Sidibé, exhib. cat. by Michelle Lamunière, Cambridge MA, Fogg Art Museum, Harvard University, 2001

Mike Smith (born 1951, Germany)
Mike Smith was born in Germany, where his father was stationed with the US Army's post-World War II reconstruction effort. At the age of two, he returned to the United States, where his family continued to move frequently. By the age of twenty-five, Smith had lived in twenty-five locations. This experience continues to inform his work, which is rooted in his desire to understand better the place in which he lives. Smith's photographs are included in the collections of The Metropolitan Museum of Art, the Museum of Modern Art, and the Whitney Museum of American Art. AQ

Catalog number: 145

Raymond Merritt and Miles Barth, *A Thousand Hounds*, Cologne (Taschen) 2000

Visualizing the Blues: Images of the American South, exhib. cat. by Wendy McDaris and John Grisham, Memphis, Dixon Gallery and Gardens, 2000

W. Eugene Smith (born 1918, Kansas — died 1978, Arizona)
As a teenager, W. Eugene Smith used photography to aid his aeronautical-engineering studies. During his first year in college, he realized that his calling was to document the "action of the world" through photographs. He studied at the New York Institute for Photography and landed his first job with *Newsweek* magazine in 1937. Over the next two decades, he held several photojournalism positions with major picture magazines, including *Life*. In 1954, amid growing frustration over the restraints of his premeditated assignments, Smith left his prominent position to pursue a freelance career. He is remembered as a pioneer in photojournalism who always aspired to convey his subjects

truthfully. His work is in the collections of the Museum of Modern Art, and the Museum of Fine Arts, Boston, and the University of Arizona's Center for Creative Photography, Tucson. AQ

Catalog numbers: 146, 147

Dream Street: W. Eugene Smith's Pittsburgh Project, exhib. cat. by Sam Stephenson (ed.), Pittsburgh, Carnegie Museum of Art and others, 2001

Gilles Mora and John T. Hill (eds.), *W. Eugene Smith: Photographs 1934–1975*, New York (Harry N. Abrams) 1998

W. Eugene Smith, *W. Eugene Smith, His Photographs and Notes*, New York (Aperture) 1969

Jack Spencer (born 1951, Mississippi)

Born in central Mississippi and raised in Louisiana, Jack Spencer is a self-taught photographer who specializes in extremely sensitive views of the people, places, and animals that populate the rural South. His work is characterized by a high level of intimacy between subject and photographer. His photographs are heavily manipulated during the printing process, which results in photographic images that resemble paintings or monotypes in their deep tonality, smudged use of light and shadow, and obscured forms. Spencer continues to photograph rural parts of Mississippi, Louisiana, Tennessee, and South Carolina and, more recently, has started to photograph rural areas of Mexico. His work is included in the collections of the Birmingham Museum of Art, the Mississippi Museum of Art, and The Museum of Fine Arts, Houston. EJ

Catalog number: 148

Ann Marie Rousseau, "Of Heaven and Hell: Another Day in L.A.," *Photo Metro*, XVI, issue CL, 1998

Jack Spencer, *Native Soil*, Baton Rouge LA (Louisiana State University Press) 1999

Louis Stettner (born 1922, New York)

Louis Stettner's photographs of Europe and the United States combine a keen sense of visual discovery with the magical possibilities of making pictures on the street. The son of Jewish immigrants, Stettner grew up in Brooklyn NY, where he connected his passion for images of everyday life with a growing political awareness brought on by the rise of fascism in Europe. As a child he was given a box camera, and he studied photographs in the collection of The Metropolitan Museum of Art. Inspired by Alfred Steiglitz and Paul Strand, he began photographing with a large-format camera. Though mostly self-taught, Stettner studied briefly at the Photo League in New York, establishing a long affiliation with the group. He became a combat photographer during World War II, and then until 1952 lived in Paris, where he met Brassaï, Robert Frank, and others. In 1958 he photographed people in New York's Penn Station, a series of low-light compositions that express the joy and wonder of the world around him. PB

Catalog number: 149

Louis Stettner, *Louis Stettner's New York 1950s–1990s*, New York (Rizzoli International Publications) 1997

Louis Stettner, *Louis Stettner: Wisdom Cries Out in the Streets*, Paris (Flammarion) 2000

Seneca Ray Stoddard (born 1843, New York — died 1917, New York)

A skilled visual artist, writer, and entrepreneur, Seneca Ray Stoddard is best known for his photographs of the landscape and communities of the Adirondack Mountains. He combined his many talents to create a series of illustrated guidebooks, which were instrumental in attracting tourists to the recently settled region of upstate New York. Through his photographs, Stoddard was able to preserve and share his love for the vast wilderness, chasms, lakes, and villages with present and future generations. His work is included in the collection of the Chapman Museum, Glens Falls. AQ

Catalog number: 150

Jeanne Winston Adler (ed.), *Early Days in the Adirondacks: The Photographs of Seneca Ray Stoddard*, New York (Harry N. Abrams) 1997

Jeffrey Horrell, *Seneca Ray Stoddard: Transforming the Adirondack Wilderness in Text and Image*, Syracuse NY (Syracuse University Press) 1999

Seneca Ray Stoddard: Adirondack Illustrator: An Exhibition at the Adirondack Museum, exhib. cat. by William Crowley, Adirondack Museum, Blue Mountain Lake NY, 1981–82

Renée Stout (born 1958, Kansas)

As a child, Renée Stout attended art classes every Saturday at the Carnegie Museum in Pittsburgh. In 1980 she earned a bachelor's degree in fine arts from Carnegie Mellon University. A shift in her painting style and the discovery of the expressive potential of assemblage coincided with her relocation to Washington D.C. in the mid-1980s. Stout strongly identifies with African history, culture, and storytelling and is interested in ritual, religion, and the passage of time. Her work is included in many collections such as the Baltimore Museum of Art, the Corcoran Gallery of Art, and the Smithsonian American Art Museum. HA

Catalog number: 151

Astonishment and Power: Kongo Minkisi and the Art of Renée Stout, exhib. cat., intro. by Sylvia H. Williams and David C. Driskell, Washington D.C., National Museum of African Art, 1994

Dear Robert, I'll See You at the Crossroads, A Project By Renée Stout, exhib. cat. by Marla Berns, Santa Barbara CA, University Art Museum, University of California, 1995

Readers, Advisors, and Storefront Churches: Renée Stout, A Mid-Career Retrospective, exhib. cat. by Michelle A. Owen-Workman and Stephen Bennett Phillips, Kansas City MO, University of Missouri, 2002

Mose Tolliver (born 1920, Alabama)
Mose Tolliver was one of twelve children born to sharecroppers on Pike Road in Montgomery County AL. He helped to support his own large family, including his eleven children, by working as a carpenter, housepainter, and manual laborer, carving utilitarian and root sculptures in his spare time. Tolliver began painting in his late forties, after an accident at the furniture company where he worked left him disabled. His compositions feature human figures, animals, and objects common to his daily life, and use bold outlines and bright color. HA

Catalog number: 152

Paul Arnett and William Arnett (eds.), *Souls Grown Deep: African American Vernacular Art of the South*, Atlanta (Tinwood Books) 1999

Common Ground/Uncommon Vision: The Michael and Julie Hall Collection of American Folk Art in the Milwaukee Art Museum, exhib. cat. by Russell Bowman *et al.*, Milwaukee Art Museum, 1993

Mose Tolliver, *Mose T's Slapout Family Album*, Montgomery AL (Black Belt Press) 1996

William Tolliver (born 1951, Mississippi — died 2000, Georgia)
The second oldest of fourteen siblings, William Tolliver worked in the cotton fields of Mississippi until moving to California alone at the age of fourteen. His mother taught him to draw as a small child and introduced him to art books at the public library. He found great inspiration in masters such as Vincent van Gogh, Paul Cézanne, and Pablo Picasso. Tolliver's own experience inspired his subjects as well. Laborers at work and scenes from the Old Testament figure prominently in his work. Tolliver's versatility in style, genre, and medium has led to his wide appeal, and he has exhibited in the rotunda of the United States Senate Building. HA

Catalog number: 153

John Hart, "William Tolliver: Folk/Fine Artist," *International Review of African American Art*, VII, no. 3, pp. 17–23

Shomei Tomatsu (born 1930, Japan)
As a teenager during World War II, Shomei Tomatsu watched from his bedroom window as enemy aircraft approached overhead. Surprisingly unfazed by the imminent danger, he found beauty in the awesome display of power and light. In many ways, this early experience has formed a basis for much of his photographic work. Tomatsu's unique blend of realism and symbolism has earned him a reputation as one of Japan's most influential documentary photographers. AQ

Catalog number: 154

Ian Jeffrey, *Shomei Tomatsu*, London and New York (Phaidon Press) 2001

Bunichiro Sano (ed.), *Hiroshima-Nagasaki Document 1961*, Tokyo (Japan Council against Atomic and Hydrogen Bombs) 1961

Jerry Uelsmann (born 1934, Michigan)
An innovative and technically brilliant photographer and darkroom printer, Jerry Uelsmann creates images that associate dissimilar elements in meaningful ways. Wrought with symbolism, his photographs have been described as surreal, mythic, mysterious, and psychological. He began creating the work for which he is now well known in the 1960s, when he rejected the "straight" approach to photography, a tradition lead by such luminaries as Ansel Adams, Edward Weston, and Paul Strand. With layered imagery, Uelsmann challenges conventional notions of reality. A professor of photography at the University of Gainesville FL for over thirty years, Uelsmann's photographs are included in the collections of The Art Institute of Chicago, the George Eastman House, International Museum of Photography, the Museum of Modern Art, and the Philadelphia Museum of Art. AQ

Catalog number: 155

James L. Enyeart, *Jerry N. Uelsmann: Twenty-Five Years, A Retrospective*, Boston (Little, Brown & Co.) 1982

Jerry Uelsmann, *Uelsmann/Yosemite*, Gainesville FL (University Press of Florida) 1996

Jerry Uelsmann and A.D. Coleman, *Jerry Uelsmann: Photosynthesis*, Gainesville FL (University Press of Florida) 1992

Doris Ulmann (born 1882, New York — died 1934, New York)
Doris Ulmann studied at the Clarence White School of Photography in New York, and much of her early work reflects White's pictorialist sensibilities. While she made portraits of celebrities throughout her career, her work arguably reached its full potential late in her life, when she began photographing people in rural areas in the eastern United States. The University of Oregon maintains an extensive archive of her photography. Her work is included in the collections of the George Eastman House International Museum of Photography and Film, the Library of Congress, and the Philadelphia Museum of Art. AQ

Catalog numbers: 156, 157

Robert Coles, *The Darkness and the Light: Photographs by Doris Ulmann*, New York (Aperture) 1974

David Featherstone, *Doris Ulmann, American Portraits*, Albuquerque NM (University of New Mexico Press) 1985

James VanDerZee (born 1886, Massachusetts — died 1983, Washington D.C.)
One of the foremost street and portrait photographers of the Harlem Renaissance, James VanDerZee's images helped to form a modern identity among African Americans in New York and other communities. Growing up in a family that encouraged his artistic interests, he pursued both photography and music as a young adult. In 1906 he moved to New York to study the violin, and he was soon performing with well-established orchestras. Unable to support his family with the meager income the music

profession provided, VanDerZee turned to photography and opened his own portrait studio in 1916. Over the next fifteen years, he built his reputation and operated one of the most successful portrait studios in all of Harlem. VanDerZee remained relatively unknown until 1969, when The Metropolitan Museum of Art featured his work in *Harlem on My Mind*, an exhibition that chronicled the history of Harlem. AQ

Catalog numbers: 168, 169

James VanDerZee, *The Harlem Book of the Dead*, Dobbs Ferry NY (Morgan & Morgan) 1978

VanDerZee, Photographer: 1886–1983, exhib. cat. by Deborah Willis-Braithwaite, Washington D.C., National Portrait Gallery, 1993

Willard Van Dyke (born 1906, Colorado — died 1986, Tennessee)

Willard Van Dyke was a part-time photographer, student, and gas-station attendant when he met established photographer Edward Weston in 1928. Over the following years, Van Dyke and Weston became close friends, and Weston's strikingly detailed images inspired Van Dyke to move away from his soft-focus pictorialist style. In 1932 Van Dyke helped form Group f.64, a society of photographers that advocated the use of large-format cameras and small apertures to achieve images of the sharpest clarity attainable. In 1938 Van Dyke set aside his photography career to focus on filmmaking. He worked variously as a cameraman, director, producer, and scriptwriter for over thirty years. An extensive archive of his photographs and papers exists at the University of Arizona's Center for Creative Photography in Tucson. His work is included in the collections of The Museum of Fine Arts, Houston, the Museum of Modern Art, and the George Eastman House International Museum of Photography and Film. AQ

Catalog number: 170

Leslie Squyres Calmes, *The Letters Between Edward Weston and Willard Van Dyke*, Tucson AZ (Center for Creative Photography, University of Arizona) 1992

Seeing Straight: The f.64 Revolution in Photography, exhib. cat. by Therese Thau Heyman (ed.), Oakland CA, Oakland Museum, 1992

Roman Vishniac (born 1897, Russia — died 1990, New York)

At the age of seven, Roman Vishniac received a camera and a microscope, which he crafted into a tool that allowed him to make microphotographs. Vishniac continued to pursue his interests in science and photography as an adult, earning a doctorate in zoology and gaining wide acclaim for his photographs of Jewish life in pre-World War II Europe. A Jew himself, Vishniac spent several months interned in a French concentration camp before leaving with his family for New York in 1941. He pursued a career in microphotography and was appointed research associate at the Albert Einstein College of Medicine in the Bronx, NY.

Vishniac explored his artistic interests as well, working as a freelance portrait photographer for a time and later as a visiting artist at the Pratt Institute, New York, and the University of Rhode Island. His photographs are included in the collections of the Museum of Modern Art, the Louvre, and the Smithsonian Institution. AQ

Catalog number: 171

Roman Vishniac, *A Vanished World: Roman Vishniac*, New York (Farrar, Straus & Giroux) 1983

Marion Wiesel (ed.), *To Give Them Light: The Legacy of Roman Vishniac*, New York (Simon & Schuster) 1993

George Kendall Warren (born 1832, Massachusetts — died 1884, Massachusetts)

George Kendall Warren managed photographic studios in Lowell, Cambridge, and Boston, Massachusetts. He was one of the leading photographers of college photo albums during the 1860s and 1870s. His albums were illustrated with various prints of many images he made depicting students, faculty members, and campus landscape scenes. Warren was the chief photographer for a number of universities, including Harvard, Yale, Princeton, and the U.S. Military Academy at West Point. He began photographing in 1851 in Lowell as a daguerreotypist and by 1858, he began making salted paper prints, a process that allowed him to begin making albums. He set up temporary studios on campuses to allow clients to view and order prints on the spot. He also became known as a photographer of celebrities, selling *carte-de-visite* portraits of renowned politicians, writers, actors, and singers, including Senator Charles Sumner, Louisa May Alcott, Henry Wadsworth Longfellow, and P.T. Barnum. PB

Catalog number: 172

Mary Panzer, "The George Kendall Warren Photography Collection: National Museum of American History," *History of Photography*, vol. XXIV, no. 1, spring 2000, p. 24

Patricia Rodgers, Charles M. Sullivan, *et al*., *A Photographic History of Cambridge*, Cambridge MA (MIT Press) 1984, pp. 133–46

Weegee (born 1899, Austria — died 1968, New York)

Born Usher Fellig, and later called Arthur Fellig, Weegee is best known for his gritty tabloid photographs of criminals, lovers, victims, policemen, and residents of New York's Bowery. First exposed to photography as a teenager, Weegee worked as a tintype operator to support his immigrant family. He soon became a darkroom assistant at *The New York Times* and later at Acme Newspictures. He created his most significant body of work in the late 1930s and early 1940s, when, equipped with an officially authorized police radio, he would travel to and photograph crime scenes, often arriving before the police. In later years, he pursued fashion, advertising, and special-effects motion-picture photography. His work is included in the collections of the George Eastman House International

Museum of Photography and Film, The Metropolitan Museum of Art, and the Museum of Modern Art. AQ

Catalog number: 173

Usher H. Fellig, *Weegee by Weegee*, New York (Ziff-Davis Publishing Company) 1961

Louis Stettner, *Weegee*, New York (Knopf) 1977

Weegee, exhib. cat. by Peter Martin, San Francisco Museum of Modern Art, 1984

Weegee's World, exhib. cat. by Miles Barth (ed.), New York, International Center of Photography, 1997

Carrie Mae Weems (born 1953, Oregon)
Carrie Mae Weems is a photographer and folklorist whose images depict her personal cultural history. She draws strongly from her identity as an African American woman to confront issues of class, gender, and race from a politically conscious perspective. In practice, her work is visually stunning, tranquil but with an inescapable sense of foreboding. Weems often incorporates text into her prints, which enables her to manipulate and deepen the meaning of her images. Her best-known series include *The Kitchen Table Project* (1996) and *The Hampton Roads Project* (2000), and she has been featured in exhibitions at the Contemporary Arts Museum, Houston, the Museum of Modern Art, and the Virginia Museum of Fine Arts, Richmond. EJ

Catalog number: 174

The Hampton Project, exhib. cat. by Carrie Mae Weems, Williamstown MA, Williams College Museum of Art, 2000

Eudora Welty (born 1909, Mississippi — died 2001, Mississippi)
Although most famous as a Pulitzer Prize-winning writer, Eudora Welty enjoyed a prolific career as a photographer, at least until she lost her camera in 1950 and gave up the medium altogether. She was employed as a photographer by the Works Progress Administration during the Great Depression and traveled around Mississippi, recording some of its hardest-hit victims. Her images seem spontaneously composed and quickly shot, yet her subjects command respect and display a strong sense of dignity, despite their impoverished economic status. As a photographer, Welty brought a level of sensitivity and observation that keeps these images from being simple records of a specific place and time. She was featured in photography exhibitions in 1936 and 1937 and in an exhibition at the Museum of Modern Art in 1973. Her work was the subject of a one-woman exhibition at the National Museum of Women in the Arts, Washington D.C., in 2003. EJ

Catalog number: 175

Eudora Welty and Reynolds Price, *Eudora Welty: Photographs*, Jackson MS (University Press of Mississippi) 1989

Edward Weston (born 1886, Illinois — died 1958, California)
Known for essentialist and revelatory still lifes, landscapes, and portraits, Edward Weston pursued photography with single-minded fervor from the pictorialist period of the early 1910s through the institutional and public acceptance of the medium as an art form in the mid-nineteenth century. His images from the late 1920s and early 1930s of vegetables, shells, and other simple objects rendered with rectilinear clarity are still justly celebrated for their extraordinary craftsmanship and evocation of quintessence. Beyond this pioneering work, Weston set a lasting example for future generations of photographers with his extensively published journals. The journals chronicled myriad affairs, his adventures among the avant-gardes and bohemias of revolutionary Mexico and Depression-era California, and the development of an individualist, purist, even monastic methodology of art-making. Weston extensively photographed California as the first photographer to receive a Guggenheim Fellowship in 1937. PR

Catalog numbers: 176, 177

Beaumont Newhall and Amy Conger (eds.), *Edward Weston Omnibus: A Critical Anthology*, Layton UT (Gibbs M. Smith Books) 1984

Nancy Newhall (ed.), *The Daybooks of Edward Weston*, vol. 1: Mexico, vol. 2: California; Rochester NY and New York (George Eastman House and Horizon Press) 1961–66

Edward Weston and Charis Wilson, *California and the West*, New York (Duell, Sloan & Pierce) 1940

Willie White (born *c.* 1908, Mississippi — died 2000, Louisiana)
Willie White is known for his bright felt-marker drawings of prehistoric creatures, horses, donkeys, birds, watermelons, tomatoes, skyscrapers, rocket ships, planets, and religious subjects. Raised on a farm outside Natchez MS, he left home in 1929 to work on the Mississippi River as a porter. He acquired an interest in art in the late 1950s. While working as a janitor in a New Orleans nightclub, he observed someone sketching. Curious to try, he began using house paint to create images of neighborhood churches and crosses that he displayed on his front porch and fence. White found encouragement from visitors who praised and often purchased his works. He later drew inspiration from "God and movies of faraway places" that he saw on his black-and-white television. He is represented by numerous galleries in Louisiana, and his works are included in the collections of The Louisiana State Museum and the New Orleans Museum of Art. AQ

Catalog number: 178

Betty-Carol Sellen and Cynthia J. Johanson, *Self-Taught, Outsider, and Folk Art: A Guide to American Artists, Locations and Resources*, Jefferson NC (McFarland & Co.) 2000

Alice Rae Yelen, *Passionate Visions of the American South: Self-Taught Artists from 1940 to the Present*, New Orleans (New Orleans Museum of Art) 1993

Fred Wilson (born 1954, New York)
A fundamental belief in the power of the museum motivates Fred Wilson. Raised in the Bronx, reared near New York's venerable art museums, and trained as a curator at the Bronx's Longwood Arts Project, Wilson's experience very much informs his work. Institutions such as the Maryland Historical Society in Baltimore and the Museum of Contemporary Art, Chicago, have invited Wilson to create installations from their collections. The result is often an entire reworking of conventional display techniques, with rewritten wall text, repositioned object labels, and rearranged meaning. In presenting his work in this way, Wilson aims to reveal, rather than subvert, traditional processes of collecting, which establish the museum as keeper of collective memory and arbiter of taste. He has taught in the curatorial studies program at the California College of Arts and Crafts and represented the United States in the 50th Venice Biennale in 2003. HA

Catalog numbers: 179–181

Fred Wilson: Objects and Installations, 1979–2000: Issues in Cultural Theory, exhib. cat. by Maurice Berger, Baltimore, Center for Art and Visual Culture, University of Maryland, 2001

Memory: Insight—In Site—In Sight—Incite: Artist and the Community—Fred Wilson, exhib. cat. by Fred Wilson, Winston-Salem NC, Southeastern Center for Contemporary Art, 1994

Mining the Museum: An Installation by Fred Wilson, exhib. cat. by Fred Wilson, Baltimore, Maryland Historical Society and The Contemporary, 1994

Fonville Winans (born 1911, Missouri — died 1992, Louisiana)
Fonville Winans photographed the culture and landscape of southern Louisiana during the 1930s and early 1940s. Raised in Texas, he became fascinated with the neighboring state while exploring its bayous as a young man. Employed in his father's struggling construction business, Winans pursued photography and music on the side. Photography soon became his primary interest and, in the years that followed, he made many return trips to the coastal community of Grand Isle LA to capture the everyday lives of its citizens. After a creative ten-year period, Winans turned to commercial work, specializing in portraits, weddings, and advertising. In 1990, the Foundation for Historical Louisiana presented him with its prestigious Preservation Award for his extensive visual record of Louisiana's culture. AQ

Catalog number: 182

Cyril E. Vetter, *Fonville Winans' Louisiana: Politics, People, and Places*, Baton Rouge LA (Louisiana State University Press) 1995

Marion Post Wolcott (born 1910, New Jersey — died 1990, California)
Marion Post Wolcott came of age during a time of mounting social and political tension across the United States and Europe. After teaching young children for a year, she decided to take a more active role in the tumultuous events that were shaping history. She soon landed a job photographing the social landscape for the federal government's Farm Security Administration. Her assignments sent her to the South and the Northeast, where she documented how the Depression was affecting farming communities. After an extended period during which she put down her camera and raised a family, she traveled extensively with her husband, photographing parts of the Middle East, India, and Pakistan. Her work can be seen in the Library of Congress, The Metropolitan Museum of Art, the Museum of Modern Art, and the Smithsonian Institution. AQ

Catalog numbers: 183, 184

F. Jack Hurley, *Marion Post Wolcott: A Photographic Journey*, Albuquerque NM (University of New Mexico Press) 1989

Marion Post Wolcott, intro. by Sally Stein, *Marion Post Wolcott: FSA Photographs*, Carmel CA (Friends of Photography) 1983

Jeffrey Wolin (born 1951, New York)
Born and raised in a predominantly Jewish suburb of New York, Jeffrey Wolin is known for his photographs of Holocaust survivors. Although his family emigrated from Eastern Europe before World War II, he grew up hearing stories about relatives who had perished under the Nazi regime. In the mid-1980s, he began writing thoughts and memories about his parents directly on to their portraits. This project evolved into his seminal body of work, in which he located, interviewed, and photographed Holocaust survivors in the United States and France, and later transcribed their stories directly on to the surface of his prints. The recipient of a National Endowment for the Arts grant and a Guggenheim Fellowship, Wolin's work is included in the collections of the George Eastman House International Museum of Photography and Film, The Metropolitan Museum of Art, and the Museum of Modern Art. AQ

Catalog number: 185

Jeffrey A. Wolin, *Written in Memory: Portraits of the Holocaust*, San Francisco (Chronicle Books) 1997

Donald Woodman (born 1945, Massachusetts)
Donald Woodman began his career in the early 1970s as an architectural photographer, documenting the works of such luminaries as Philip Johnson, Paul Rudolph, and I.M. Pei, among others. He strengthened his creative abilities and knowledge of photo history soon after, while assisting renowned photographer Minor White teach workshops at the Massachusetts Institute of Technology. Woodman has since pursued commercial and fine art photography as well as documentary film and experimental video projects. From 1985 to 1993, he collaborated with his wife, artist Judy Chicago, on *The Holocaust Project: From Darkness into Light*, an acclaimed exhibition that fused painting and photography to explore underlying issues of the Holocaust. His work is included in the Albuquerque Museum, the Musée

d'Art et d'Histoire, Fribourg, Switzerland, and the Victoria and Albert Museum, London. AQ

Catalog number: 186

Judy Chicago and Donald Woodman, *The Holocaust Project: From Darkness into Light*, New York (Penguin Books) 1993

Reid Yalom (born 1956, New York)
With a classical sensibility, Reid Yalom exhibits two divergent themes in his work. Drawn to the empty spaces and uncluttered compositions of exotic settings, whether a shadowed doorway in San Luis Potosi or an empty terrace in Jalapa, Yalom captures the quiet solitude of the moment. Also an experienced commercial photographer, Yalom pursues a modernist aesthetic with his images of urban landscape. His work is included in many private collections and he is represented by galleries in Los Angeles, New York, and San Francisco. AQ

Catalog number: 187

Reid Samuel Yalom, *Colonial Noir: Photographs from Mexico*, Stanford CA (Stanford University Press) 2004

Credits:

1: © used with permission of The Trustees of The Ansel Adams Publishing Rights Trust. All Rights Reserved • 3: © Ken D. Ashton • 4: © Shimon Attie, courtesy of Jack Shainman Gallery, New York • 7: © Eldridge Bagley, 1998 • 9: © Radcliffe Bailey • 11: © David Bates • 13: © Virginia Beahan and Laura McPhee • 16: © Margaret Bourke-White/Time Life Pictures/Getty Images • 17: © ESTATE BRASSAÏ-R.M.N. • 18: FSA/OWI Collection, Prints and Photographs Division, Library of Congress, Washington D.C. • 19, 21: © Beverly Buchanan • 24: © Debbie Fleming Caffery • 26: © University Library, University of Texas at El Paso • 28, 29, 30: © William Christenberry • 31, 32: © William H. Clarke • 34: © William Clift • 36: © Courtesy Arthur Roger Gallery • 37, 38: © Linda Connor • 39: © Roy DeCarava, 1955 • 40: © Roy DeCarava, 1963 • 42: © David Driskell • 44: © William Dunlap • 46: © Eggleston Artistic Trust/Art + Commerce Anthology/Cheim + Read • 49: © Walker Evans Archive, The Metropolitan Museum of Art • 50, 51, 52: © FSA/OWI Collection, Prints and Photographs Division, Library of Congress, Washington D.C. • 53: © Beverly Finster • 54: © Robert Frank, courtesy Pace/MacGill Gallery, New York • 56: © Leonard Freed/Magnum Photos • 57: © Lee Friedlander • 58: © Flor Garduño • 59: © Duke University • 61, 62, 63: © 1979 Amon Carter Museum, Fort Worth, Texas • 64: © Jim Goldberg • 65: © Elijah Gowin, courtesy Robert Mann Gallery • 66: © Emmet Gowin • 67: © David Graham • 68: © Edward Grazda • 69: © Jonathan Green • 71: © Miriam Grossman Cohen/courtesy Howard Greenberg Gallery, New York • 72: © Collection Center for Creative Photography © 1998 Arizona Board of Regents • 75: © University Museums, University of Mississippi • 76: © Mary Hearne • 77: © Chester Higgins Jr. All Rights Reserved • 81: © Thomas N. Whitehead, Cane River Art Corporation • 82: © Birney Imes • 83: © Graciela Iturbide • 84: © Kenro Izu • 86: © Rashid Johnson, courtesy moniquemeloche Gallery, Chicago • 88: The Dorothea Lange Collection, Oakland Museum of California, City of Oakland • 89: © The Historic New Orleans Collection • 90: © 2004 Gwendolyn Knight Lawrence/Artists Rights Society (ARS), New York • 93, 94: © Helen Levitt. All rights reserved • 97, 99: © Whitfield Lovell • 100: © Deborah Luster • 101: © Danny Lyon, courtesy Edwynn Houk Gallery • 103: © Mark Mann, courtesy Laurence Miller Gallery, New York • 104, 105: © Sally Mann • 106: © Mary Ellen Mark • 108: © Victor Masayesva Jr. • 109: © The Estate of Ralph Eugene Meatyard, courtesy Fraenkel Gallery, San Francisco • 110: © Ray K. Metzker • 113: © Wayne F. Miller • 115: © Richard Misrach • 116: © Delilah Montoya • 118: © Abelardo Morell • 119: © Zwelethu Mthethwa

• 120: © Osamu James Nakagawa • 121, 122: © Adi Nes • 123: © Arnold Newman/Getty Images • 125: © Gordon Parks • 127: © Brad Richman • 128: FSA/OWI Collection, Prints and Photographs Division, Library of Congress, Washington D.C. • 129: © Dana Salvo • 130: © David Scheinbaum, courtesy of Scheinbaum & Russek Ltd, Santa Fe, New Mexico • 132: © Scurlock Studio Records, Archives Center, National Museum of American History • 133: © Peter Sekaer Estate/courtesy Howard Greenberg Gallery, New York • 135, 136: FSA/OWI Collection, Prints and Photographs Division, Library of Congress, Washington D.C. • 137: © Fazal Sheikh, courtesy Pace/MacGill Gallery, New York • 138, 142: © Malick Sidibé • 145: © Mike Smith • 146, 147: © Estate of W. Eugene Smith/Black Star • 148: © Jack Spencer • 149: © Louis Stettner, courtesy Bonni Benrubi Gallery, New York • 151: © Renée Stout • 154: © Shomei Tomatsu, courtesy Tepper Takayama Fine Arts • 155: © Jerry Uelsmann • 168: © Donna M. VanDerZee • 170: © Courtesy Willard Van Dyke Estate, 2000 • 171: © Mara Vishniac Kohn, courtesy International Center of Photography • 173: © Weegee/International Center of Photography/Getty Images • 174: © Carrie Mae Weems, courtesy PPOW Gallery, New York • 175: © Eudora Welty LLC; Eudora Welty Collection, Mississippi Department of Archives and History • 176 © 1981 Center for Creative Photography, Arizona Board of Regents • 179, 180, 181: © Fred Wilson • 182: © Meriget Winans Turner • 183: FSA/OWI Collection, Prints and Photographs Division, Library of Congress, Washington D.C. • 185: © Jeffrey Wolin • 186: © Donald Woodman

Page 21: Zwelethu Mthethwa quoted in Bongi Dhlomo, "Zwelethu Mthethwa Talks About His Photographs," in *Liberated Voices: Contemporary Art from South Africa*, exhib. cat. by Frank Herreman (ed.), New York, Museum for African Art, 1999, pp. 65–66.
Page 49: Beverly Buchanan quoted in *New History: Beverly Buchanan, Mel Edwards, Maren Hassinger, Sculptural Installations*, exhib. cat. by Kinshasha Holman Conwill, The Atlanta College of Art, 1990.
Page 81: Emmet Gowin quoted in *Emmet Gowin Photographs*, exhib. cat. by Emmet Gowin and Martha Charoudi, Philadelphia Museum of Art, p. 16.
Page 115: William Christenberry quoted in unpublished interview with Philip Brookman, 2001.
Page 145: Eudora Welty quoted in Eudora Welty, *One Time, One Place: Mississippi in the Depression: A Snapshot Album*, New York (Random House) 1971, p. 8.

First published 2004 by Merrell Publishers Limited

Head office
42 Southwark Street
London SE1 1UN

New York office
49 West 24th Street, 8th floor
New York, NY 10010

www.merrellpublishers.com

in association with

Corcoran Gallery of Art
500 17th Street, NW
Washington, D.C. 20006

www.corcoran.org

Published on the occasion of the exhibition
Common Ground: Discovering Community in 150 Years of Art,
Selections from the Collection of Julia J. Norrell
organized by the Corcoran Gallery of Art, Washington D.C.
October 23, 2004 — January 31, 2005

Common Ground: Discovering Community in 150 Years of Art
is sponsored in part by The President's Exhibition Fund.

A catalog record for this book is available from the Library of Congress

British Library Cataloguing-in-Publication Data:
Common ground : discovering community in 150 years of art
1. Art, Modern – 20th century 2. Art, Modern – 19th century
3. Manners and customs in art
I. Brookman, Philip
709'.04

ISBN 1 85894 265 9

Produced by Merrell Publishers
Curated by Philip Brookman and Jacquelyn Days Serwer
Edited by Philip Brookman
Photography by Mark Gulezian, Quicksilver Photographers, Takoma Park MD
Designed by Robert Villaflor
Copy-edited by Laura Hensley and Tom Neville
Printed and bound in China

Front jacket: Louis Stettner, *Penn Station*, 1958 (cat. 149)
Back jacket: Theora Hamblett, *Two Trees with Blowing Leaves*, 1967 (cat. 75)